LOS ANGELES CENTRAL LIBRARY

To Sheldon & Victoria
with my very best
wishes.
Arnold Schoenberg
2016

To Sheldon + Victoria
Best Wishes
Stephen Gee
2016

THE · WORLD · IS

LOS ANGELES CENTRAL LIBRARY
A History of its Art and Architecture

Photographed by
Arnold Schwartzman

Written by
Stephen Gee

Foreword by
John F. Szabo
City Librarian

ANGEL CITY PRESS

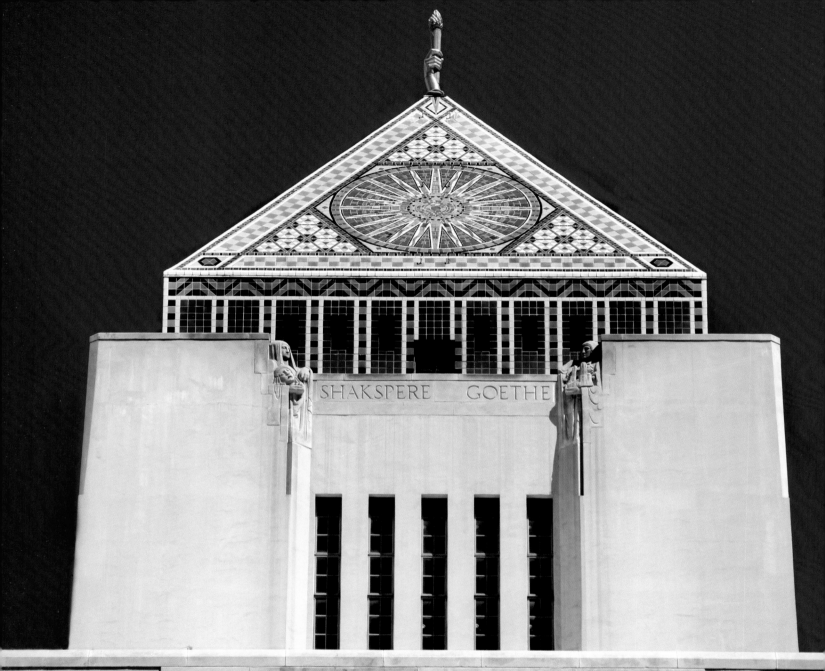

SHAKSPERE GOETHE

ET · QVASI · CVRSORES
VITAI · LAMPADA · TRADVNT

CONTENTS

FOREWORD John F. Szabo, City Librarian

Access to knowledge is the superb, the supreme act of truly great civilizations. Of all the institutions that purport to do this, free libraries stand virtually alone in accomplishing this mission. No committee decides who may enter, no crisis of body or spirit must accompany the entrant. No tuition is charged, no oath sworn, no visa demanded.
TONI MORRISON

From Lee Lawrie's black marble and bronze sphinxes, to the east wing atrium's whimsical chandeliers by Therman Statom, the Los Angeles Central Library is in many ways as diverse and eclectic as the multicultural, international city it serves.

In the limestone façade, one can find evidence of the egalitarian principles of the American public library with allusions to Moses, Mohammed, and Buddha; quotes such as "Books invite all; they constrain none;" and references in the garden to citizenship and civil liberties. This is L.A.'s public library, arms open wide, striving every day to serve all Angelenos.

With the Italian cypress and gentle pools of Jud Fine's *Spine*, a stroll through the Maguire Gardens approaching Bertram Goodhue's Egyptian Revival library can feel a bit like the Boboli Gardens in Florence. Resplendent and majestic, though not ostentatious, the Central Library feels approachable and appropriate in scale and creates a profound impression without overwhelming. Goodhue's amalgam of styles—abstract Spanish Colonial Revival, Byzantine, Islamic—all a departure from his Gothic and Classical early years, create a very L.A. experience. Likewise, in odd and interesting juxtaposition, the murals, sculpture, inscriptions, and artistic decoration inspired by the iconography of Nebraskan Hartley Burr Alexander speak to the strength and personal enrichment that comes from learning.

The celebrated American novelist Toni Morrison once said of public libraries, "Of the monuments humans build

for themselves, very few say touch me, use me, my hush is not indifference, my space is not barrier. If I inspire awe, it is because I am in awe of you and the possibilities that dwell in you." This effectively captures the spirit of Bertram Goodhue's grand but accessible Los Angeles Central Library and the dramatic east wing designed by Norman Pfeiffer of Hardy Holzman Pfeiffer Associates.

Through all of this splendid history, Stephen Gee provides a captivating biographical tour through the life of this Los Angeles landmark. He offers the reader insights into the motivations and competing interests of the city's leaders, extensive details on building materials, stories of conflict between stakeholders, and even a detailed list of the fascinating contents of the building's cornerstone. He also illustrates how intertwined the architect and the building are, with Goodhue's name and image in a carving at the Hope Street tunnel and with the Library shown in Lee Lawrie's arched frieze over Goodhue's tomb in the Church of the Intercession in New York City.

Libraries are often described as windows to the world. Gee's research illustrates that this is more than an analogy, as he informs us, of the Library's influence from Goodhue's travels in Persia and Mexico, his fascination with Egypt, and that he was an Anglophile employing British draftsmen. And then there's the Indiana limestone, fountain stone from New Mexico, and many languages of Ries Niemi's *The Literate Fence*.

Much loved and revered by Angelenos, the Central Library has withstood efforts supporting its demolition, a proposed sale to corporate interests, relocation out of downtown Los Angeles, and battles over its public art and architectural design. Amid these challenges, it is not only the edifice that stands strong, but the mission and values of the institution as well. Rooted in a commitment to access, equity, empowerment, and opportunity, the Los Angeles Public Library continues to be the vibrant, essential institution that, in the late nineteenth and early twentieth century, prompted its leaders to advocate and work toward a permanent home on Normal Hill. Today, the Central Library offers its patrons all of the nostalgia one expects from a ninety-year-old magnificent public library; but also provides new experiences in digital learning spaces, citizenship services for New Americans, and innovative, nationally recognized programs addressing financial literacy, public health, and workforce development. The Los Angeles Central Library also contains a digitization lab where archivists and librarians make the collections (which were started and nurtured by City Librarian Charles Fletcher Lummis and John D. Bruckman, the first Collection Development Officer), searchable and accessible throughout the world.

The tremendous affection the city has for its Central Library plays an important role in the connection people feel to the institution and its mission. Beautiful, well-designed public space, inspiring architecture, and majestic public art all contribute to the success of the Library over nine decades.

Whether peeking through skyscrapers in a flyover shot in David Lynch's *Mulholland Drive*, shining in a nighttime image of downtown Los Angeles behind Jay Leno's *Tonight Show* desk, in the path of a bus dangling from a helicopter in the action film *Swordfish*, or a reimagined mosque for Billy Ray's *Secret in Their Eyes*, the never-camera-shy Central Library is frequently featured in film and television and is regularly the subject of tourist photographers. Few, however, have captured the iconic Library's architectural detail and adornments as Arnold Schwartzman has in this richly illustrated book. From exceptional vantage points, Schwartzman presents both the beauty and intrinsic message of the Los Angeles Central Library superbly.

I trust that readers will treasure this laudable survey of the art and architecture of one of the world's great public libraries. My hope is that it will inspire everyone to pass through Lee Lawrie's bronze doors and personally experience this stunning gem in the City of Angels.

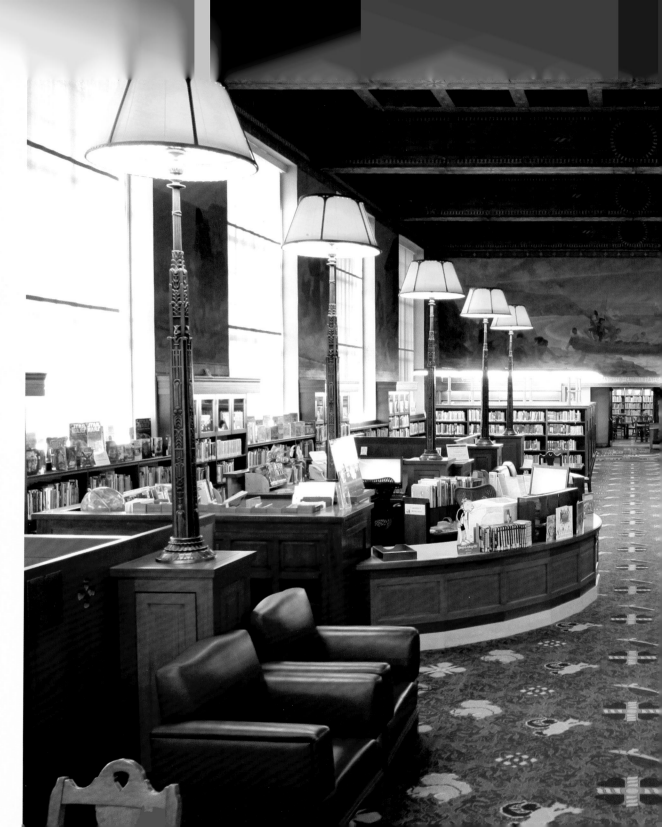

To my wife Isolde,
with grateful thanks for
her unwavering dedication
to the design and
art production
of this book.
AS

To Dorothy and Harry Gee
SG

8

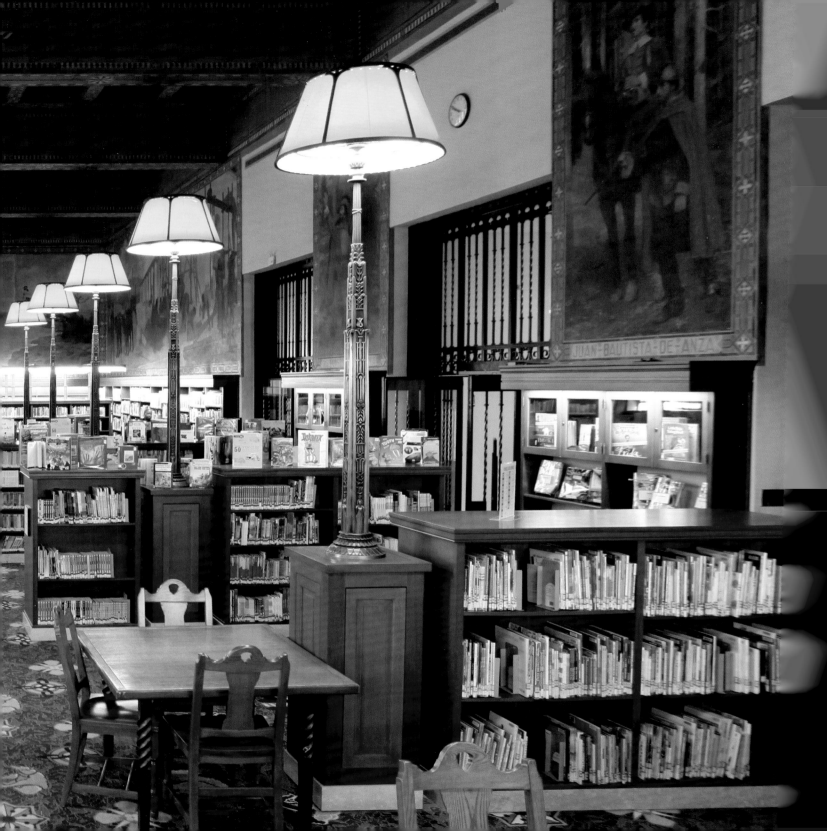

INTRODUCTION

The newly completed Los Angeles Public Library stands not only as a monument to the genius of its designer, the late Bertram Goodhue, but as a symbol of the progressive thought and the solid determination of a city to turn the sneers and jibes and jokes that made it hang its head into a volume of praise for having created something altogether new in library architecture, construction and convenience.

AMERICAN BUILDER, JUNE 1, 1928[1]

More than any other building in Los Angeles, the Central Library tells the story of the city and reflects the values of the people who live in it. This information can be found not only in the Library's many thousands of books and archives, but also in the history of the building itself.

How city leaders at the dawn of the twentieth century responded to the idea of whether or not to build a central library and how they dealt with the issue of the building's decline in the 1960s and 1970s speaks volumes about the wider social and economic forces driving the city.

Why, for example, when so many other emerging American cities were invested in building their own libraries did Los Angeles lag behind, allowing its library collection to be shuttled between a series of temporary locations? Los Angeles built a world-class stadium capable of competing for the Olympic Games even before it had its own permanent library.

Funds were finally raised for a central library, but controversy ensued. Recruiting New Yorker Bertram Goodhue instead of a local designer was a bold statement by the Library Board. The famed architect seized the opportunity to set a standard in creative architecture in Southern California. Harmonizing elements of romantic and modern design, he imagined a structure that confounded critics who marveled at its block-like massing and asymmetrical façades. "To a public long steeped in classical orders of architecture. . . this building comes as a distinct shock," critic Merrell Gage

wrote shortly after it opened. "Like all creative Art, it is disturbing; it leaves an impression that is satisfying yet mystifying."[2]

Goodhue understood his mission was to inspire Angelenos to better themselves. When designing the building, he urged his colleagues "to make people scratch their heads—not all

10

scratch their heads and give it up, but find out what it's all about."[3] Unexpectedly, Goodhue died before construction began and we can only imagine how his design might have evolved had he lived to guide the project to completion. Instead, it was left to his colleague and associate architect, Carleton M. Winslow, to bring his vision to life.

Winslow chose to work with artists who not only understood Goodhue's vision but the importance of their own contribution as well and thus were prepared to work for much less than their normal rate. In return, they expected future generations would treasure and continue to be inspired by their work long into the future.

When Librarian Everett Perry dedicated the building in 1926 as a refuge from "the petty distractions of the earthly pilgrimage," he understood that what the building represented was so much more than a place to enjoy books. The singular structure he had struggled so long to bring to life was the spiritual heart of the city and its most important public monument.

Why, then, when it became overcrowded and inefficient in the 1960s did so many politicians and librarians clamor to tear it down and move it to a less prestigious location? The debate over what to do with the Library would spark an unprecedented preservation movement in the city and forever change the way we look at historic buildings.

The Central Library has been damaged by earthquakes, twice been the victim of arsonists and twice risen from its own ashes. It now boasts a sympathetic contemporary wing that embraced Goodhue's original design and more than doubled the library's existing space. Designed by Hardy Holzman Pfeiffer Associates, the addition breathed new life into the beloved institution and enabled the city's considerable collection of books—and its special collections of such valuable materials as vintage photographs, rare maps, menus, sheet music, and more—to be reorganized and rediscovered for generations to come.

The Central Library remains a place where citizens, regardless of their economic status, can educate themselves and share in the power of the written word. It survives thanks to the efforts of all those who recognized the true importance of what the Library offers to the city and its people. It is so much more than a collection of books. It is a statement about who Angelenos are and what we care about. It's fitting that its art and architecture speak to creativity and timelessness and be celebrated in these pages.

11

1 A PERMANENT HOME—THE FIGHT TO BUILD THE LIBRARY

We wish to assure you in all earnestness that this beautiful edifice has been and will be peculiarly near to our hearts, that we have struggled for it by day and dreamed about it by night, and now that it has taken tangible shape and form, we shall exert ourselves to the utmost to make it a vital factor in the lives of our citizens.

EVERETT R. PERRY, LIBRARIAN, JULY 15, 1926[1]

A new century on the horizon found many American cities full of hope and dreaming large. On the nation's West Coast, sunny Los Angeles was expanding more rapidly than its civic leaders could handle. Struggling to keep up with exponential population growth, by 1920 the city constructed a new port, built an aqueduct to bring water from Colorado, watched its first skyscraper alter the skyline, and imagined an Olympics-ready sports stadium. Arts and culture temporarily took a back seat to creating the infrastructure necessary for a world-class city. The Los Angeles Public Library remained cramped in a series of temporary locations, hampering any civic effort of properly providing books to the public, as Los Angeles relentlessly pursued its dream as a burgeoning metropolis.

▲▲▲

The journey toward a permanent home for the library had begun way back in 1844 in what was then El Pueblo de Nuestra de Señora la Reyna de Los Angeles, a remote Mexican outpost with a population of two thousand. In an adobe on North Main Street, near what is now the city's famed Olvera Street, a society named Los Amigos del Pais (the friends of the country) organized a modest reading room, offering a limited supply of donated books and newspapers, in the corner of a dance hall.

The enterprise ended after six months as funds ran out, and by the time the Mechanics' Institute, a subscription-based reading room, opened in 1856, California had joined the Union. Located on the southeast corner of North Spring and Court Streets, it survived as a place for immigrants to learn new skills until 1858.

The following year, another reading room, where patrons could enjoy a limited supply of dated newspapers, was established this time in the Arcadia Block at the intersection of Arcadia and Los Angeles Streets. However, as the looming Civil War cast a shadow over the nation, the endeavor slipped into debt and closed.

It wasn't until 1872, four years before the transcontinental railroad reached Los Angeles, that its citizens made real progress. On December 7, a crowd, two hundred strong, gathered in the Merced Theatre on Main Street to discuss the formation of the Los Angeles Library Association. Buoyed by their enthusiasm, John G. Downey, who had served as California's seventh American governor, agreed to donate two rooms in the Downey Block on the northwest corner of Main and Temple Streets, rent-free for the first three months. Soon afterwards, New Englander John Littlefield was appointed the city's first librarian.

In 1878, the Enabling Act paved the way for the establishment of the Los Angeles Public Library as the first municipal public library on the West Coast. That was just in time. Los Angeles had grown into a decent-sized town approaching 11,000 people with several small hotels, the three-story Pico House being the largest and most important. The new law allowed for a small tax to be charged to support the mainte-

Everett R. Perry, City Librarian, 1911 to 1933.

nance of the Library that would now be governed by a Board of Regents selected by the mayor.

Littlefield was replaced as librarian by Patrick Connolly, who himself was later shown the door when his attendance became an issue. Connolly's departure cleared the way for a series of innovative female librarians. The first was eighteen-year-old Mary E. Foy, a recent graduate of Los Angeles High School. In an era when women were often prohibited from pursuing government careers, Foy tripled the Library's collection to three thousand volumes and introduced a card catalog system. She was ousted in 1884, however, when the mayor and City Council determined Jessie A. Gavitt, whose father had recently died, was more deserving of the salary.

In 1889, a new city charter placed control of the Library in the hands of a five-member Board of Library Directors appointed by the mayor and approved by the City Council. The same year, Gavitt, who doubled the Library's collection, was replaced by Lydia A. Prescott, and just four months later, Tessa L. Kelso, who had arrived in Los Angeles in hope of pursuing a career in journalism, took over the helm.

Known for her love of cigarettes and scandalously short hair, Kelso's tenure saw the abolition of subscription fees and the relocation of the Library's collection to new quarters in City Hall on the east side of Broadway between Second and Third Streets. Built in 1888, the red-and-brown brick City Hall was designed by architects Eugene Caukin and Solomon Haas, who specialized in Richardsonian Romanesque architecture.

When Kelso resigned in 1895, Clara B. Fowler was hired. Two years later, Harriet Child Wadleigh, who had worked as an assistant librarian in Springfield, Massachusetts, became

the first person to hold the position with any previous experience. By the time Mary L. Jones was hired in 1900, the city's population had grown to more than 102,000. Jones oversaw the establishment of branches in Vernon, the Arroyo Seco district, Hollywood, and Pico Heights.

The Library was supported by gifts and appropriations until 1902, when the city charter allowed for revenue of four cents on every hundred dollars of taxable property. The following year, concerns over whether the Library's collection may have outgrown City Hall led to architects John Parkinson and John C. Austin being recruited to investigate if the weight of books being stored could cause the building's tower to collapse.[2]

Parkinson would join fellow local architects Octavius Morgan and Sumner P. Hunt on an advisory committee tasked in 1904 with examining the best place to build a new Central Library building. Established by Mayor Meredith P. Snyder and the Library Board, the committee concluded Central Park (now Pershing Square) would make the most sense and recommended the building should cost no less than $450,000, encroach as little as possible on the park ground, and incorporate an art gallery and museum.[3]

Later the same year, when the question was put to voters, "Shall the city erect a public library building in Central Park?"

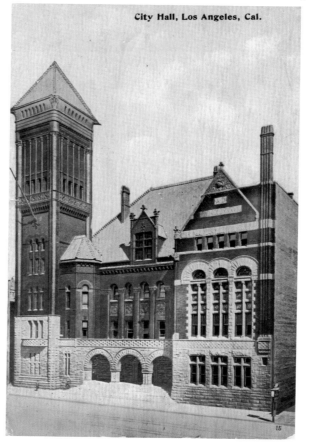

City Hall, Los Angeles, Cal.

▲ *Los Angeles City Hall on Broadway.*

an overwhelming majority voted in favor. However, a legal challenge by apartment-house owner J.H. Spires, who argued the park was dedicated to the public and putting a library in it was a "violation of the dedication,"[4] did enough to derail the project. The dispute made its way to the California Supreme Court, which upheld the vote, but by this time, the Library Board had begun considering other options, including the acquisition of a lot fronting Figueroa, Flower, and Eleventh Streets.[5] But, the City Council shunned the effort for financial reasons, since they had recently invested funds to reinforce City Hall with giant steel columns.

In the following months, numerous alternatives were considered, including a scheme to rent part of the newly built Huntington Building at Sixth and Main Streets; a bid to acquire a vacant plot north of City Hall on Broadway, favored by Librarian Jones; and the acquisition of a lot facing Central Park on the southwest corner of Fifth and Olive Streets.

The mission to find a permanent home for the Library was further complicated in 1905 when Librarian Jones was controversially replaced by historian, author, and former city editor of the *Los Angeles Times*, Charles F. Lummis. When told of her dismissal, she initially refused to leave, leading to a tense standoff, which ultimately

ended when she handed over the keys with "chilling dignity."

Although Lummis had no experience as a librarian, he was considered "the best-known bookman in California." An expert on the Spanish Southwest, he had promoted a romanticized image of Southern California in his books and periodicals and would take a particular interest in expanding the Library's Western history and California collections. It was his idea to brand the most expensive books, "Property of the Los Angeles Public Library," to prevent theft.

Lummis would later blame the influential Friday Morning Club, which protested Jones's dismissal, for launching a "Library War" and hounding him and the board of directors, making it impossible to negotiate for a permanent home for the Library. In 1906, he oversaw the relocation of the Library's collection to new quarters in the Homer Laughlin Annex on Third and Hill Streets.

The two-story structure, designed by architect Harrison Albright, offered storage in the basement and a roof-garden reading room. Within two years' time, the space was used up and the Library moved again, this time to the newly built Hamburger's Department Store building at Broadway and Eighth Street. Designed by Alfred F. Rosenheim, the five-story Beaux Arts structure, commissioned by A. Hamburger & Sons Co., cost two million dollars to construct. Covering almost half the block, it was billed as the largest department store west of Chicago.

The expensive lease Lummis signed put a considerable strain on the Library's finances, and in 1910, he was replaced by Purd B. Wright, former librarian of the Free Public Library of St. Joseph, Missouri. When Wright resigned the following year to become City Librarian in Kansas City, Everett R. Perry took charge. Born in Worcester, Massachusetts, in 1876, Perry was a graduate of Harvard University and the New York State Library School. A veteran of the Astor Branch of the New York

Public Library, he had worked alongside its director to create a classification system for its 900,000 volumes. Perry began his tenure in Los Angeles by organizing the Library into subject departments.

In 1914, when he oversaw the Library's move to the Metropolitan building on the northwest corner of Fifth and Broadway, critics snipped that Perry had traded a location above a department store for another above a drugstore, but he vowed the Library's next move would be to a permanent location.

The Library leased 50,000 square feet that comprised the top three floors of the nine-story Beaux Arts structure designed by Parkinson & Bergstrom—fully a third more space than afforded at the Hamburger building. The increase in space, however, came at a price, as the cost of rent rose from $18,000 to $22,000 a year. "This fact alone is one of the greatest arguments for a permanent library building owned by the city, for the rental would be a good way toward paying interest on the cost of a million dollar library building," the *Los Angeles Examiner* argued in a front page report.[6]

A popular feature of the new building was the open-shelf arrangement allowing the Library's 75,000 patrons to make their own reading selection. Critics praised the "beautifully lighted" reference room on the eighth floor that stretched across the Broadway front. But, the location was, as the *American Builder* noted, "in the very midst of all the confusion and jangle of street car, automobile and pedestrian traffic, not unmixed with the rat-a-tat-tat of the bevy of riveters at work on newer buildings on all sides."[7]

The Library Board's desire for a "centrally located" new building of "architectural beauty"[8] was expressed in an open letter delivered to the City Council in 1917. The same year, the board threw its support behind a bid to acquire a lot bounded by Olive Street, Fifth Street, and Grand Avenue, and it also embraced a design for a new library included in a civic center

proposal for Central Park produced by architect Siegfried Goetze. Neither effort materialized.

The end of World War I spurred an economic boom that only intensified the civic embarrassment caused by the failure to secure a permanent home for the Library. Perry, who had looked on with envy while major cities such as San Francisco, Portland, Indianapolis, St. Louis, St. Paul, and New York all opened large central library buildings, saw his opportunity to spearhead a campaign to propose bond measures to pay for a new library.

"Los Angeles is the largest city on the Pacific Coast and yet it is the only one without a building for its Public Library," Perry told the *Los Angeles Times*. "For fifty years the Los Angeles

Public Library has been looking forward to a time when it could have a home of its own, when no longer one of the biggest items on its budget would be rent. The time has come to stop dreaming and take action. It is no longer possible to house properly one of the city's largest educational institutions in office space at so much per foot. The Public Library has not only outgrown its present quarters, but it has outgrown any quarters at office rates for which it could pay."[9]

To prepare for its campaign, the Library Board consulted with architect, William J. Dodd, from the firm Dodd & Richards, who suggested the budget for a new building should be $3,750,000. To help secure funds, Dodd created a sketch of two Beaux-Arts structures to be used in publicity material. Dodd's design would be criticized in the *Los Angeles Times* by former

▼ *The Public Library moved to Los Angeles City Hall in 1889.*

librarian Charles Lummis, who called it, "Graeco-Carnegie," a reference to the classic architecture chosen for many of the branch libraries funded by tycoon Andrew Carnegie's donations. Lummis argued the Library needed the conveniences offered by a modern office block.[10]

By 1921, daily attendance at the Library often reached 10,000 people and circulation had grown to 3,334,895. The City Council, after much persuading, agreed to place on the June election ballot a $2.5 million bond initiative to build a new Central Library Building and Branch Buildings as needed.

Campaigners appealed to the electorate with slogans such as "Grow up, Los Angeles! Own your own library and take your place with progressive cities!" and ultimately won over the electorate, which voted 33,064 in favor and 13,214 against.[11]

In early November, the Library Board held a special meeting to determine the location of the new building. When Reverend Francis J. Conaty called for a vote on whether to locate the structure in Pershing Square, he was the sole member who voted in favor of it. The board was then asked whether to locate the building at a site on Normal Hill. All except President Orra Monnette, who argued the site lacked sufficient grandeur, voted in favor. Monnette conceded, "I shall vote in favor of the resolution to the City Council to show there is no friction on this board."[12]

On November 8, 1921, the Library Board forwarded a resolution to the City Council requesting Normal Hill, the former site of the State Normal School, the forerunner of

▼ *The Hamburger's Department Store building housed the Public Library from 1908 to 1914.*

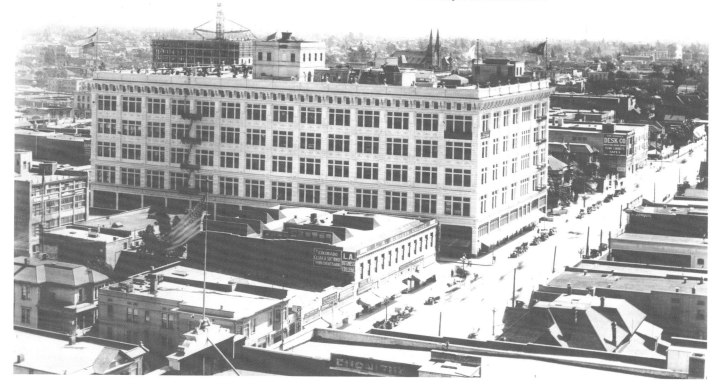

PUBLIC LIBRARY

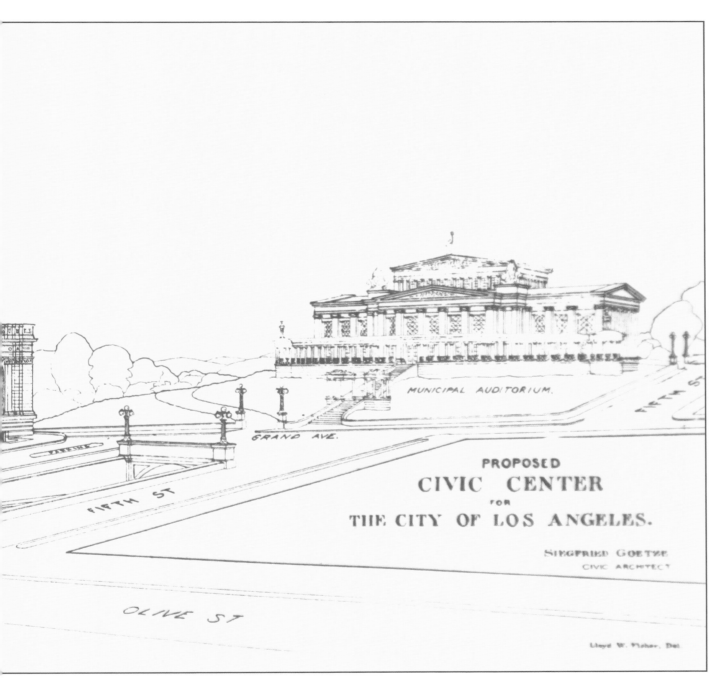

MUNICIPAL AUDITORIUM.

GRAND AVE.

FIFTH ST

OLIVE ST

PROPOSED
CIVIC CENTER
FOR
THE CITY OF LOS ANGELES.

SIEGFRIED GOETZE
CIVIC ARCHITECT

Lloyd W. Fisher, Del

▲ *The State Normal School in downtown Los Angeles.*

Proposed

Projected H

▲ *Architects Dodd & Richards design for a new Central Library in the Los Angeles Times.*

ign for Needed Public Building.

he Los Angeles Public Library. Dodd & Richards, Architects.

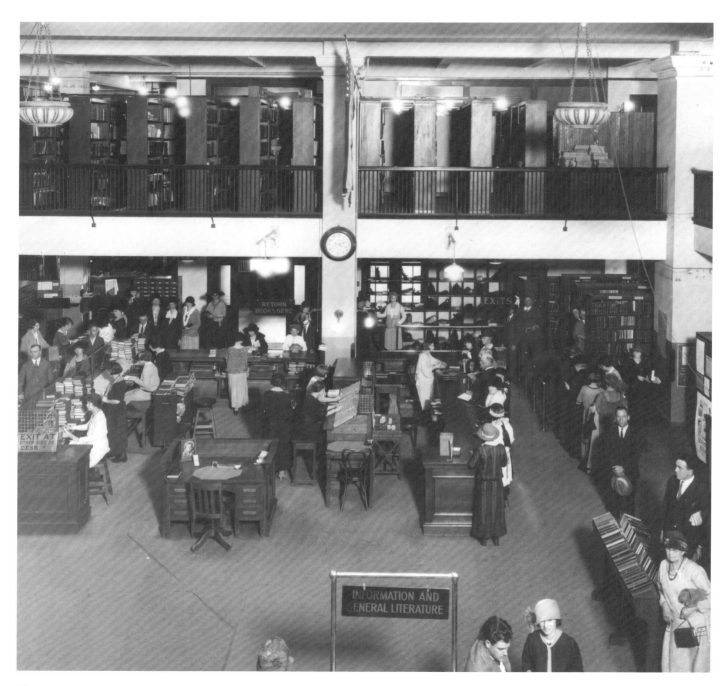

▲ *This image appeared alongside an editorial in the June 4, 1921 edition of* The Record.

◀ *The Metropolitan Building housed the Public Library from 1914 to 1926.*

the University of California, Los Angeles (UCLA), be turned over to the board as the site for a new library. In explaining its decision, the board acknowledged public opinion was against using Pershing Square for anything other than a park. Members also argued the Normal Hill site was less congested and when graded would offer a comparatively level lot.

The location, first suggested as a potential site for the Library by civic planner Charles Mulford Robinson in his 1907 *Los Angeles City Beautiful* report, had been acquired by the City of Los Angeles in 1918 and was favored by the City Planning Commission and many members of the City Council.

In October 1922, the City deeded the Normal Hill site to the board, and in exchange, the Library Board agreed to pay $100,000 to the City Treasury. The City appropriated $5,000 to raze the existing structure and the Fifth Street Improvement Association pledged $50,000 for the "cutting through" and widening of Fifth Street to begin in the fall of 1922. Architects Sumner P. Hunt, Henry F. Withey, L.E. Behymer, and Lyman Farwell would serve on a building committee tasked with drawing up tentative plans for the location.

2 CHOOSING AN ARCHITECT—A PREFERRED CANDIDATE

When the Spanish style was chosen, the appointment of Bertram Grosvenor Goodhue and Carleton Monroe Winslow as architect and associate architect was a natural result. Both Mr. Goodhue and Mr. Winslow are known as authorities on Spanish architecture, and their work was before us in the San Diego Exposition buildings and in the California School of Technology.

LIBRARIAN EVERETT R. PERRY[1]

Librarian Everett Perry first worked with architect Bertram Goodhue to design an elaborate Spanish Colonial Revival style library in Los Angeles shortly after Goodhue's celebrated work at the 1915 Panama-California Exposition in San Diego. Since financial resources weren't readily available, the project was shelved, but in 1921, when Perry finally obtained the necessary funds, he set about securing his preferred architect.

In September, he appealed to the City Council for the Library Board to be given permission to hire an architect without holding an expensive, drawn out competition. John Parkinson and other prominent local architects appeared at City Hall to urge members of the Public Welfare Committee to deny Perry's request and instead hold an open competition decided by a jury made up of impartial experts.

After seeking legal advice, it was determined an open-bidding process was required, however the library board had the authority to select the winner. When the board formally advertised for bids in November, John Parkinson, John C. Austin, and Albert C. Martin offered to design the building and supervise construction for 6.7% of the total contract; the Allied Architects Association, made up of thirty leading architects, bid 5.8%; Dodd & Richards 5.5%; Lyman Farwell 3% and Bertram Goodhue 7.5%.

Although Goodhue, who was based in New York City, was the highest bidder, the board voted unanimously to award him the contract in December, along with his Los Angeles associate, Carleton M. Winslow. Dodd & Richards was given a contract to design a new $100,000 branch library on the corner of Hollywood Boulevard and Ivar Street in Hollywood, at the same time.

Perry defended the board's decision, explaining:

> Mr. Goodhue is an architect of national, it might be said of international reputation, as in addition to many notable buildings in different sections of the United States he has planned several churches in Cuba and is a recognized authority on Mexican architecture, a most interesting and important development of the Spanish style, which is favored by the Library Board for the new building. . . Mr. Goodhue is not unfamiliar with the requirements of successful library planning, having designed libraries for several New England cities and has recently secured the contract for the Sterling Memorial Library at Yale University. This record of important buildings that he has planned would not be complete without mention of the Nebraska State Capitol, the award for which he recently won in competition with several of the best-known architects of the United States. It is felt by the Library Board that reliance can be placed on him to plan for the City of Los Angeles a most beautiful and successful structure for the new Library. [2]

While the Library Board was delighted to have landed such a highly regarded architect, Los Angeles Mayor George E. Cryer was unconvinced. "I have in mind instances in which

the city of Los Angeles has made mistakes along this line due to the fact that they have employed eastern men who are totally unacquainted with the climate conditions that prevail at all times on the Pacific Coast," he wrote to the board.[3] When Perry pointed out Goodhue had worked on, not only structures for the Panama-California Exposition in San Diego, but also on the California Institute of Technology in Pasadena and maintained a summer home in Montecito, the mayor adopted a more conciliatory tone.

Perry told the *Los Angeles Times*,

> I venture to say that after the building is completed and Mr. Goodhue has paid from his fee Mr. Winslow and other local experts and engineers to be employed by him, not more than $50,000 or the total fee of $112,000 will go to Mr. Goodhue for his services. Wherever possible, contracts for all materials will be awarded to Los Angeles firms, so that the building will be strictly a Los Angeles-made product.[4]

Perry's argument did little to impress the Los Angeles Merchants and Manufacturers Association, which represented local commercial and industrial interests. "The new Library building is to be constructed from a bond issue voted by the people of this community and will be paid by the citizens of this city," they wrote to Perry. "San Francisco in the erection of its public buildings stipulates that only architects who are residents of that city will be allowed to supervise their construction."[5]

In his response, Perry stressed the importance of Carleton Winslow to the project. "Apparently it is assumed that his part will be unimportant, but we rely upon Mr. Winslow to determine with myself as librarian, the arrangement of departments and the practical details that go with this which are so essential for the convenience of patrons," he explained. "Mr. Goodhue who, perhaps, has no superior in beautiful buildings, will be relied upon for the exterior chiefly."[6]

In March 1923, work grading down Normal Hill to the level of Grand Avenue began in an effort to make the approach to the Library easier. Preparing the site was expected to take six months and would require excavating prehistoric strata of seashells at the southwest corner to prevent the building from slipping. The location presented Goodhue with several challenges, not least of which was how to avoid the building being dwarfed by the nearby Biltmore Hotel and the Bible Institute.

Goodhue arrived in Los Angeles shortly before City Attorney Jess E. Stephens announced the architect's contract had been voided due to the inadequate bond he submitted, and so the City planned to re-advertise for bids. The bond was required to protect the City from any loss as a result of the architect's failure to carry out the work outlined in his contract. The $11,250 bond Goodhue submitted, Stephens argued, was normally intended "to protect employers from loss due to theft or embezzlement by their employees."[7] When the City Council passed a resolution urging the Library Board to hire a local architect, it looked for a brief moment that Goodhue might be out of luck.

The bids received in late February were as follows: Dodd & Richards 5.5%; Robert D. Farquhar 6.5%; Goodhue & Winslow 7.5%; W.E. Woolett 7.5%; L.H. Hibbard 4.95%, Weeks & Day 6%, and the Allied Architects Association 5.8%. John Parkinson submitted a bid of 6% that included a condition that the Library Board use $35,000 of the commission to establish an architectural and structural engineering library in memory of late Library Board member Walter Lindley. Aleck E. Curlett's bid included four qualifying conditions with a clause stating his cost would not exceed 5% of the estimated $1.5 million cost of the building.[8] The bidding process proved to be a legal formality, however, and Goodhue and Winslow were ultimately

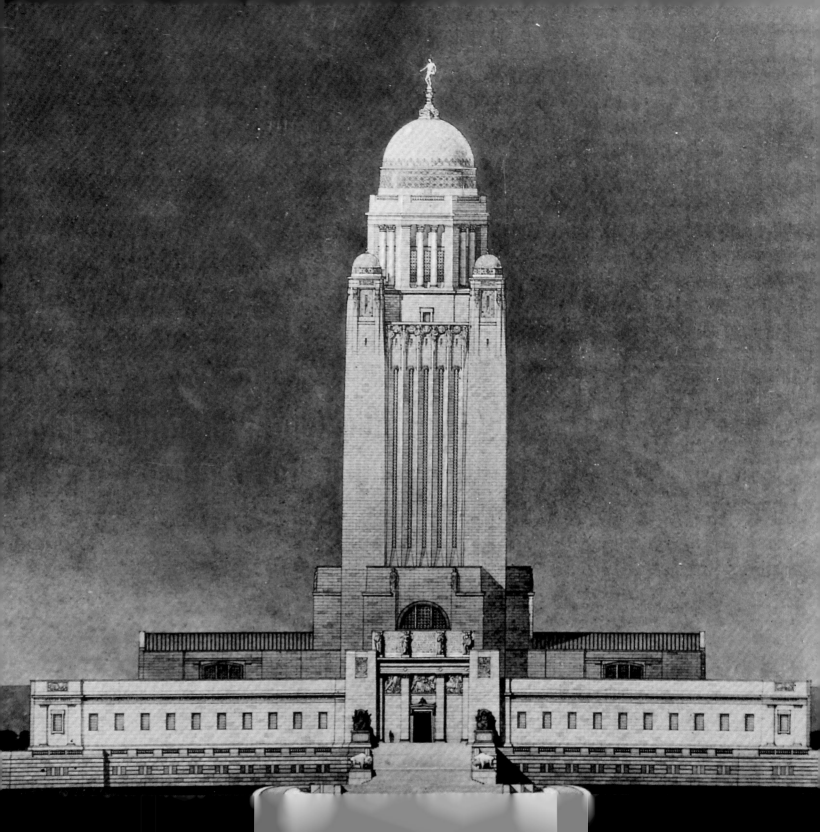

awarded a new, almost identical contract.

The city charter required the Municipal Art Commission to give approval to all architectural plans for city-owned buildings. After reviewing the architect's plans for the Library, the commission adopted a resolution rejecting them as "insufficient" and "not satisfactory" to the commission or the "future needs of the City of Los Angeles."[9]

Frustrated, Goodhue wrote to Frederick W. Blanchard, president of the commission:

> Will you not be good enough to ask the Art Commission to put their objections in more concrete form . . . I am sincerely sorry to learn the architecture and plan are not satisfactory; but surely I am within my rights asking why. If by the use of the word "architecture" the Commission means that it disapproves the architectural style, what style does it approve? I understand from you and your board that the Library should be Spanish in style—at least in spirit; therefore it is distinctly disconcerting to learn that both my clients and I were apparently misinformed.
>
> As for the plan, this has been a very difficult one to work out. Your own requirements were fairly exacting considering the amount of money to be expanded, while the nature and sloping grades of the lot added to this difficulty. I felt, however, that the solution first it seems to me, at any rate, very good indeed. The ordinary rectangular library in the east and north is one thing and has been brought about largely by the price and shape of most of our city lots. Los Angeles, however is a very different matter and we have tried, by means of courts, roof-terraces, etc. to take advantage of the local climate and conditions.[10]

◀ *Bertram Goodhue's competition drawing of front elevation, Nebraska State Capitol.*

Stunned by the architect's criticism, members of the Commission penned a letter to the Library Board eager to clarify their position,

> . . .it is perfectly evident that complete plans were not submitted to this Commission, and that it was justified in its non-approval, the sketches submitted being deemed insufficient . . . It appears from Mr. Goodhue's letter that your librarian directed him to provide plans for a Spanish-style building. This Commission had nothing to do with this decision. If such were his orders from your board—then the best in Spanish style of architecture should be rendered. In the opinion of this Commission, the sketches submitted do not provide for the best style of Spanish architecture …Mr. Goodhue would receive about $120,000 for his work in this behalf, but he will have to present to this Commission a full set of plans for a main library building, designed to fulfill and fulfilling the architectural requirements of this city before this Commission will pass favorable upon them.[11]

In July when Goodhue attended a meeting of the commission to confront their concerns, it quickly became clear the most passionate objections related to the location of the new Library rather than its design. Many members remained tied to the idea the Library should be in Pershing Square.

"It would be the worse thing that could happen to Los Angeles to build any building in Pershing Square," Goodhue argued. "Nothing should go in that park, nothing more than a bandstand anyway. But aside from that, I prefer the Normal Hill site. It lends itself to the building. You are going to have high buildings around the Library where ever it is placed. Besides a building of this kind should not be placed in the center of a park. It should face a park."[12]

When Orra Monnette, president of the Library Board, and also a member of the commission, suggested Goodhue design

Weymouth Crowell, and paid tribute to H.A. Nelson, the supervising engineer, and Royal Dana, the architect's superintendent, whom he complimented for his "extreme watchfulness" and level-headed temperament.[23] Winslow presented the building to the Library Commission's President Monnette who spoke to "The Universality of Education."

Librarian Everett R. Perry told the crowd, "Our gathering here today to me has all the solemnity and sacredness of a religious rite, because on this occasion we are dedicating a temple to the people."[24]

The public who were allowed to enter the building at four o'clock that afternoon may not have realized that this first day was the end of an eighty-year journey. The Los Angeles Public Library system finally had a permanent home. The Central Library was complete.

▶ *Los Angeles Central Library, East Lawn.*

30

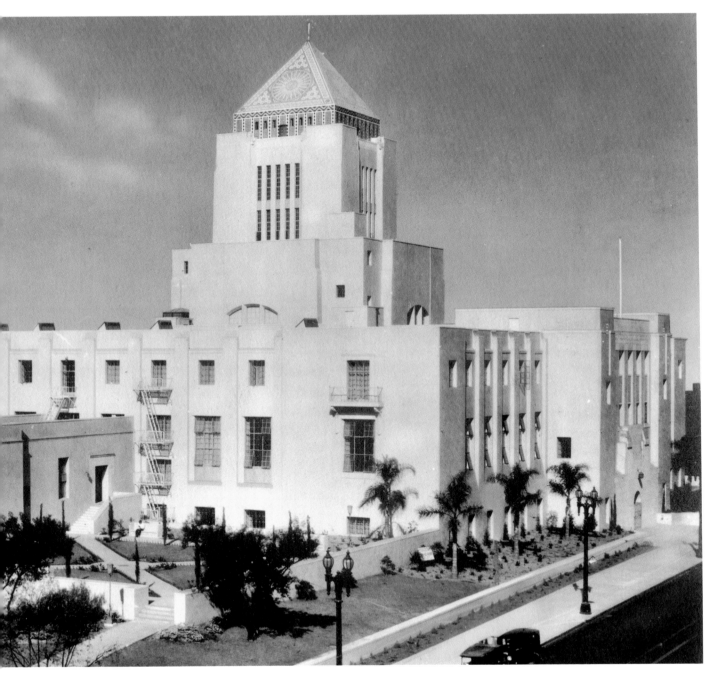

3 THE ARCHITECT—BERTRAM GROSVENOR GOODHUE

I should like to be merely one of three people to produce a building, i.e., architect, painter, sculptor. I should like to do the plan and the massing of the building: then I should like to turn the ornament over to a perfectly qualified sculptor, and the color and surface direction to an equally qualified painter the designing triumvirate.

BERTRAM GROSVENOR GOODHUE[1]

New York City architect Bertram Grosvenor Goodhue, was a controversial choice to design the flagship library for Los Angeles, yet there was no disputing his towering achievements. As one of the most inventive, eclectic artists of his generation, his legacy and profound influence on American architecture was firmly entrenched long before he was recruited to design the Los Angeles Central Library.

Librarian Everett Perry and Orra Monnette, president of the Library Board, renewed discussions with Goodhue about designing the Library soon after he won the commission to design the Nebraska State Capitol. His strikingly original plans, a dramatic fusion of functional design and Moderne styling, cemented his celebrity status and reinvigorated his career. Perry and the board were convinced Goodhue's expanding international reputation would greatly enhance their desired goal of creating a structure of national significance despite the limited budget. He was, in their eyes, "one of the greatest geniuses of architecture that our country has produced."[2]

Fiercely independent, Goodhue was an opinionated, creative, larger-than-life talent who was "devoted to architectural principles but skeptical of binding stylistic rules."[3] He hid doubts about his own ability and was frequently torn between the romantic and practical forces that drove his personality. Colleagues remembered him as capable of being both "exuberantly enthusiastic" and "moody and dispirited,"[4] however few who worked alongside him ever questioned the genius of his natural-born talent.

"All things of beauty were art to him," sculptor Lee Lawrie remembered.[5] "He did not exercise the mechanics of the painter's and sculptor's arts, yet he had the special gifts of perception necessary to both, and could criticize their work with unforgettable epigrams.[6] . . .As a friend he was warm and tender, as an architectural chief, uncompromising. He could not slight work, no matter how small and comparatively unimportant it might be."[7]

Goodhue regularly worked seven days a week at his penthouse office high above West 47th Street. Beneath ornate ceilings, he endlessly smoked cigarettes while designing an array of architectural gems, including the United States Military Academy at West Point, St. Bartholomew's Church in New York City, the National Academy of Sciences building in Washington, D.C., and the California Institute of Technology in Pasadena.

An Anglophile who could proudly trace five ancestors among the Mayflower party, Goodhue's core team of draftsmen was dominated by British expatriates who labored long hours in the informal environment he created. In a speech to his staff in 1922, he proclaimed, "I believe it makes for happiness that men's work should be interesting and not always mere work, like that of the men ruled by an 'efficiency' fanatic—therefore, it's perfectly well understood that anybody can look at books, smoke, talk, and sing—especially the latter. Often, going into the drafting room, I find myself in a perfect 'nest of singing birds'."[8]

Born on April 28, 1869 in the village of Pomfret, Windham County, Connecticut, to "country gentleman" farmer Charles Wells Goodhue and the former Helen Grosvenor Eldredge, he was schooled at home by his well-educated mother whose love of history, sketching, and painting left a lasting impression on him. At age nine, he first declared his desire to become an architect shortly before enrolling at Russell's Collegiate and Military Institute in New Haven. A classmate later recalled he was an average student whose "devotion to his drawings was far greater than to his studies."[9]

Although young Goodhue showed early artistic promise, his parents, whom he described as "poor but honest,"[10] lacked the resources to advance his formal education. So in 1884 the teenager set out for New York City to work as an apprentice at the architectural firm of Renwick, Aspinwall and Russell. Highly regarded for Gothic Revival work, James Renwick was the lead architect of St. Patrick's Cathedral on 5th Avenue.

At a time when the architectural establishment revered formal education and above all, time spent at École des Beaux-Arts in Paris, the fifteen-year-old Goodhue was getting hands-on experience and quickly secured a reputation as an excellent draftsman. He later reflected, "I believe that an architect, like a poet, is born and not made. In fact, a good architect is a poet. I disapprove of architectural schools. This doesn't mean disapproval of education. Far from it! But, the learning of how to make an architectural drawing is an easy enough matter, something that ought to be accomplished in a year—in an office."[11]

Goodhue's confidence grew as his sketches were published in trade journals, and he soon attempted to make

▶ *Drafting Room B at Bertram Goodhue's office on West 47th Street, New York City.*

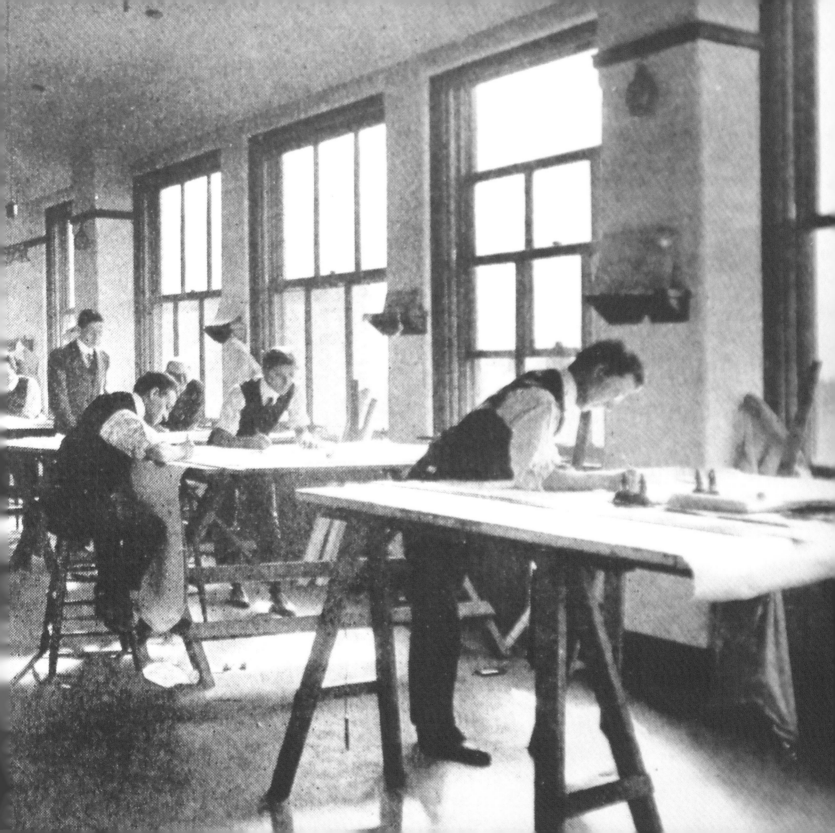

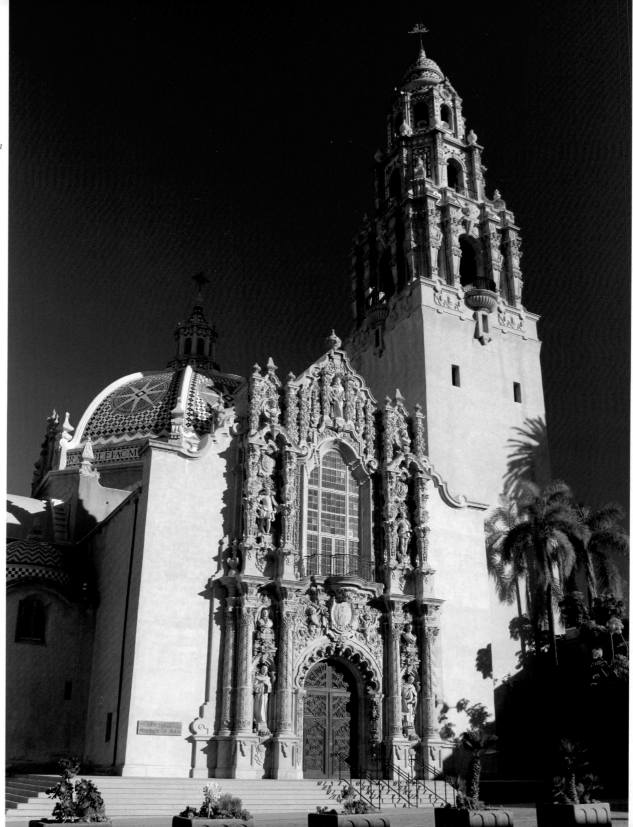

▶ *The California Building in San Diego's Balboa Park served as the entrance to the 1915 Panama-California Exposition.*
The domed roof resembles Goodhue's early design for the Central Library.

36

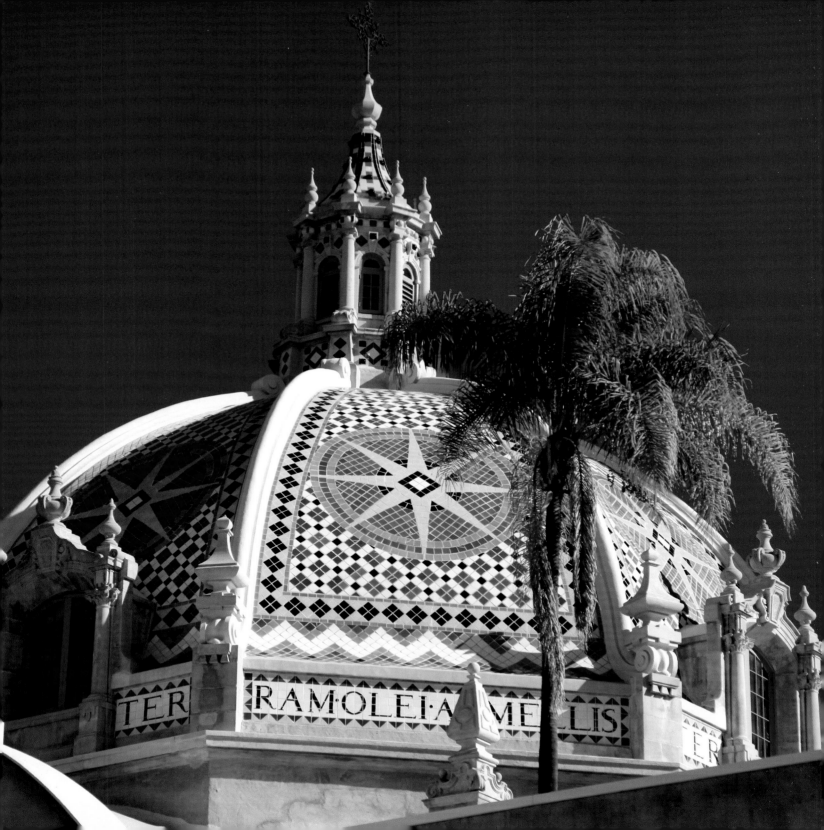

a name for himself by entering architectural competitions. A talented artist, he excelled not only in architecture, but also in typography and book design. In 1891, when he won a competition to design the Cathedral of St. Matthew in Dallas, Goodhue approached the Boston practice of Ralph Adams Cram and Charles Francis Wentworth about collaborating on the project. He joined the firm as chief draftsman, and a year later he became a partner in Cram, Wentworth and Goodhue. When Charles Wentworth died in 1897, Cram recruited Frank Ferguson as an engineer and business manager, and they renamed the practice Cram, Goodhue and Ferguson. Cram later wrote, "It was now that Goodhue began to exert his extraordinary powers over ornament and detail in ecclesiastical architecture."[12]

The firm gained critical acclaim using modern methods to design churches, homes, and colleges in medieval styles. Cram, who was five years older than Goodhue, considered himself to be an expert in the composition of structure and Goodhue to be "a master of decorative detail of every sort."[13] Both Cram and Goodhue, who initially worked well together, were popular figures among Boston's bohemian elite.

On April 8, 1902, Goodhue married Lydia Thompson Bryant, a native of Kentucky, who shared her husband's passion for music and theater. As his personal life flourished, so too did his professional reputation when Cram, Goodhue and Ferguson won the competition to design the United States Military Academy at West Point. To manage the project, the firm established a New York City office, where Goodhue would eventually move and take charge. In 1904, Lydia gave birth to a daughter, Frances Bertram Goodhue, and a year later a son, Hugh Grosvenor Bryant Goodhue.

In 1905, returning to the city where his professional life began, Goodhue guided the design of several church buildings, including St. John's in West Hartford, Connecticut, Christ

Church in West Haven, and the First Baptist Church in Pittsburgh, Pennsylvania. Cram later noted that after Goodhue left Boston, the firm's work "became almost completely divided."[14]

At the beginning of a new year in 1911, Goodhue embarked on a project across country that would leave an indelible imprint on California architecture and ultimately bring him to the attention of the Los Angeles Library Board of Directors. He was hired as the supervising architect for the 1915 Panama–California Exposition in San Diego. The Exposition was established to celebrate the completion of the Panama Canal and promote San Diego, the first port of call in the United States for ships traveling north after passing westward through the canal. It would be held in City Park, renamed Balboa Park for Spanish explorer Vasco Nuñez de Balboa, who had

Sketch Which Ar

LOS ANGELES CENTRAL LIBRARY

discovered the Pacific Ocean and claimed the west coast of the Americas for Spain in 1513.

The decision to celebrate California's colonial past presented Goodhue with a unique opportunity. Although organizers originally wanted the exposition to focus on architecture inspired by California's missions, Goodhue managed to convince them the Mission style was too limited. Instead he argued Spanish-Colonial architecture would be better suited to the colorful, joyful nature of an exposition, while still providing historical context in a form appropriate to the climate.

Goodhue had developed a passion for Spanish Colonial design during a journey to Mexico, documented in his 1892 book, *Mexican Memories: The Record of a Slight Sojourn Below the Yellow Rio Grande*, along with subsequent trips to Spain.[15] He later used what he had learned studying cathedrals adorned with extravagant Churrigueresque stucco detailing, a Spanish Baroque style that began in the seventeenth century, as inspiration for the design of the Holy Trinity Cathedral in Havana.

The fairytale Spanish-style buildings he envisioned for the exposition, culminating in the California Building, the dramatic entrance to the park, were reminiscent of missions found in Southern California as well as Mexican and Spanish palaces. With white stucco walls and red tile roofs, they were a dramatic departure from the Beaux-Arts, classical Greek- or Roman-inspired structures more commonly seen at fairs.

Although critics in Mexico described Goodhue's romantic interpretation of California's Spanish-influenced past as "Hollywood Spanish,"[16] it caused a sensation in California architecture. Architects of the time widely imitated Goodhue's new style, eager to develop something uniquely Californian. In March 1920, the *Architectural Forum* declared Goodhue's design "the greatest single factor influencing the present growth of good Spanish Colonial architecture in California."[17]

The exposition also had a significant impact on Goodhue's career for another reason: it brought him into contact with architect Irving Gill, who would briefly work as his assistant. Gill, whose minimalist designs were based on ancient geometric designs, would prove to be a significant influence on his colleague's later work.

Goodhue had informed Cram and Ferguson that he wanted out of their partnership in December of 1913. He had grown increasingly uncomfortable with the tension in their relationship and decided it was time to move on. "I do not think two personalities can appear successfully in one design," he told

Goodhue's second scheme for the library appeared in the Herald-Examiner, *July 1923.*

► *Goodhue's design for the Central Library evolved from a low ribbed dome (left) to a high baroque dome (center, right) and eventually a truncated tower crowned by a tiled pyramidion.*

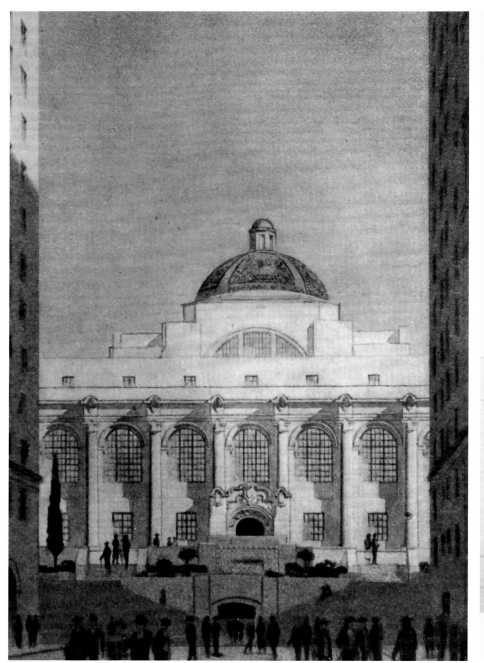

40

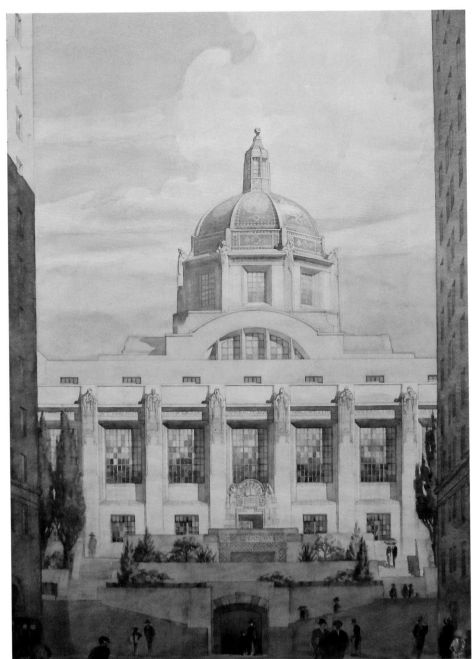

THE ARCHITECT—BERTRAM GROSVENOR GOODHUE

the *New York Times*. Cram concurred, "Each of us came to look on himself as an individual designer with a definite desire to work things out, each in his own way."[18]

The Los Angeles Central Library was one in a series of prominent West Coast commissions that came to Goodhue following the success of the Panama–California Exposition which also included the campus for Throop College of Technology in Pasadena, later renamed the California Institute of Technology. Goodhue was selected by Trustee George Hale who wrote, "I discovered Bertram Goodhue when I looked across the great causeway that leads to the San Diego Exposition."[19]

Although Goodhue was referred to as "the greatest American Gothicist," he outgrew his love affair with Gothic architecture.[20] In 1924 while hard at work on designs for the Sterling Memorial Library at Yale University, he wrote to British architect Giles Gilbert Scott, "Of course, it has to be in the 'Gothic manner.' Anyhow, most of the other buildings at Yale are—or their authors and owners think they are. I've lost my taste for 'straight' Gothic, so I am hoping to 'put over' something that won't be, although it will look like, Gothic. Burn a candle for me to St. Anthony."[21]

Goodhue's interest was shifting toward the simplicity eventually manifested in the Los Angeles Central Library. In 1920, when he had unexpectedly won the commission to design the Nebraska State Capitol, he seized the opportunity to embrace a new architectural sensibility. Rejecting unnecessary ornamentation, he embraced the romantic age of the skyscraper, developing a more abstract and geometric interpretation of Spanish Colonial architecture.

As Nebraska historian Robert Ripley explains, "It was the first capitol building in the United States to radically depart from copying the federal capitol in Washington D.C. as its design prototype. It was the first capitol to have a high-rise tower, the first skyscraper state capitol."[22]

The Nebraska State Capitol would have a profound influence on American architecture and dramatically influence the design of the Los Angeles Public Library.

Philosopher Hartley Burr Alexander wrote in 1925, "As Goodhue came to realize that in the Nebraska Capitol he had created a new style, it became his ambition to develop it. His sketches for the Yale Library look in this direction, though the only other building in the Nebraska spirit for which there is promise of completion is the Los Angeles Library. In this later he himself believed that he had made certain distinct advances, and it is very likely that he found in the Spanish suggestion of Southern California a natural kinship with what he had conceived for Nebraska."[23]

Before either project was completed, Goodhue died unexpectedly days before his fifty-fifth birthday. His death had a profound impact on the development of the Library (which was in full swing), and of course on his family and colleagues. The loss was particularly difficult for sculptor Lee Lawrie, who wrote to Alexander, "It will be difficult for me to go on without him. This is the twenty-ninth year that I have worked with him. I am the only one who really needs his help, for while my part is the sculpture, it is really his architecture in plastic form."[24]

Goodhue's widow, Lydia, offered words of comfort, "You and Bertram worked so as one." She continued, "It seems more dreadful to me every day that he should have died at this time. The only thing that consoles me is that he was not awfully well and felt tired out, and it is a hideous thing to grow old and perhaps suffer. It is better to have lived and to have died doing great things, I believe. Of course no one has the slightest idea how much I miss him. I can't and I don't talk about it."[25]

Although Goodhue had reached the pinnacle of his

profession, his death would reveal the financial cost of his industrious devotion to his practice. "You may be interested in knowing that with the exception of life insurance and an unpretentious place in California, he left no wealth," Lawrie wrote to Alexander a month after the architect passed. "I was at first surprised, but I should not have been. He did a great mass of work in his lifetime, but he was always fearfully extravagant in carrying it out. I happen to know that in the Nebraska and Los Angeles drawings, he did them over a number of times, even after they had been practically approved to satisfy himself."[26]

At the time of his death in 1924, Goodhue's office was juggling projects on both coasts, in the Midwest and Hawaii. His three senior assistants, Francis L.S. Mayers, Oscar Murray, and Hardie Phillip reorganized the architect's practice as Bertram Grosvenor Goodhue Associates in an effort to manage the ongoing projects. As the legal heir to the work at the Los Angeles Central Library, it was Carleton M. Winslow who inherited the responsibility of making sure Goodhue's vision would be fulfilled.

▼ *Goodhue's tomb in the north transept of the Chapel of the Intercession, New York City.*

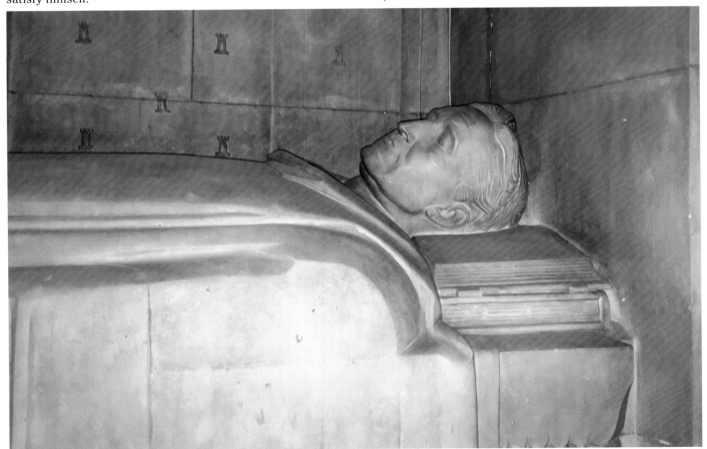

4 THE ASSOCIATE ARCHITECT—CARLETON MONROE WINSLOW

In part and in detail the building recalls numerous ancient styles, for no building, particularly a Library, can disregard the accumulation of architectural experience of the past.

CARLETON M. WINSLOW[1]

Bertram Goodhue's death left the Library project in an unexpected predicament, but not for very long. The responsibility for bringing Goodhue's design to life and persuading the Library Board to conform to the architect's wishes would fall upon his trusted Los Angeles based associate, Carleton Monroe Winslow.

Plans for the Los Angeles Central Library and the excavation work were close to being completed, yet important decisions about the artists who would decorate the building and who the contractor would be remained unsettled.

Stepping in to fill the critical void, Winslow took on the task with the blessing of Goodhue's widow, Lydia, who wrote to him shortly after her husband's death, "My husband was always fond of you as you know."[2] He would loyally follow Goodhue's plans and seek to hire artists whom he believed were most capable of interpreting the late architect's vision. "I have tried to see through Mr. Goodhue's eyes and carry to completion the building as nearly to the Goodhue ideal as possible,"[3] Winslow reflected in 1926.

"In referring to this building as being Mr. Goodhue's, it is doubtful if one appreciates the extent of the collaboration between Mr. Goodhue and Mr. Carleton M. Winslow of Los Angeles, associate architect," Merrell Gage wrote in *Artland*. "Mr. Winslow, in co-operation with Mr. Everett R. Perry, Librarian, drew the ground plan. It was on this plan, which materially affects the design of the whole building, that Goodhue raised the present structure."[4]

A respected church architect, Winslow designed First Baptist Church in Pasadena, the Community Presbyterian Church in Beverly Hills and St. Mary of Angels in Los Angeles. His many works also included Fullerton High School and Cottage Hospital in Santa Barbara.

Born in Damariscotta, Maine, in 1876 to Edwin Harvey Winslow and Clara Araminta (Hunt) Winslow, he traced his family's roots in the small town to John Winslow, who arrived from the Massachusetts Colony around 1750. "The old gentleman was a Tory and would not fight against the king although he had four brothers who did ," Winslow later wrote. "Possibly I have inherited some of his conservatism."[5]

Educated in Brunswick, Maine, Winslow's career as an architect began as an office boy and a junior draftsman in the Chicago office of Thomas H. Mullay. He later joined the firm of Shepley, Ruan and Coolidge, where "a new world of architectural taste and culture opened out" for him.[6] "During these years I kept on with studies, mathematics, French, Italian, drawing at the Art Institute, watercolor under Burch Burdette Long,"[7] he recalled.

Winslow moved to New York City in 1900 to work with Charles Eliot Birge, whom he described as a "brilliant designer and man of great culture."[8] He would go on to join the office of Harold Van Buren Magonigle before heading overseas and spending eighteen months exploring Europe. "During a winter in Paris I worked at Atelier Pascal and Atelier Chifflot Frires and taking mathematics, free hand drawing, French language and watercolor with outside tutors and instructors," he remembered.[9]

Winslow returned to New York City to work for a year at the firm of Heins & LaFarge, best known for their work on

New York's Cathedral of St. John the Divine. He then joined the Boston office of Cram, Goodhue and Ferguson, of which Winslow later reflected, "Here I entered into a life long friendship with Bertram Goodhue to whom I owe obligations which I shall never be able to repay."

In September 1910, Winslow married Helen Hume of Warsaw, New York. Life would quickly change for the newlyweds the following year when architect Irving Gill resigned as Goodhue's assistant for the Panama–California Exposition. Goodhue instructed Winslow to head cross-country to San Diego to take over the work. "I was on my own there excepting that my work was under the supervision of Mr. Goodhue who besides being supervising architect of the Exposition, designed through his firm, the California State and Fine Arts Building, handing me the job of superintending its construction," he explained.[10]

Winslow designed many of the temporary buildings for the Exposition, including the Administration Building, Botanical Building, Science and Education Building, as well as the Indian Arts and Kansas Buildings. He later produced a book, *The Architecture and the Gardens of the San Diego Exposition*, with an introduction penned by Bertram Goodhue.

In 1914, Winslow won a competition to design the city of San Diego's official seal. Although he only received the thanks of the city as a reward, he would surely be gratified to know the seal is still in use these many years later.[11] Winslow received his state license to practice architecture in California the following year and got to work opening an office in San Diego.

◀ *Carleton Monroe Winslow.*

▶ *Carleton Winslow, left, in the drafting room, at work on plans for the 1915 Panama-California Exposition.*

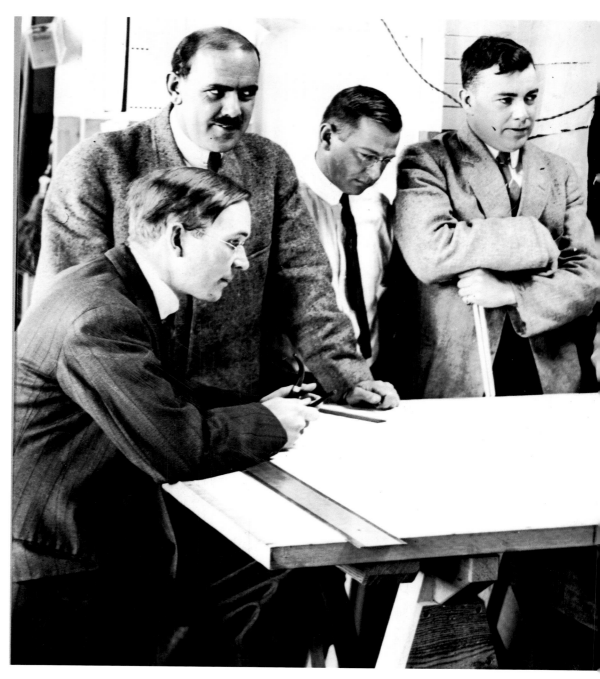

THE ASSOCIATE ARCHITECT—CARLETON MONROE WINSLOW

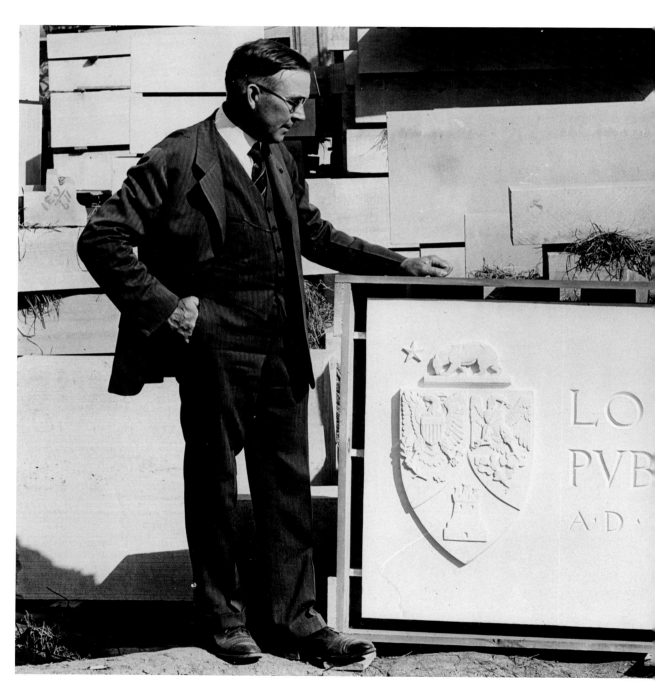

▶ *Carleton Winslow admiring the corner-stone he designed.*

Laying down roots on the West Coast, Winslow opened a practice in Los Angeles in 1917 and the following year a branch office in Santa Barbara. An Episcopalian and a Republican, he loved to collect antiques and stamps and spent his spare time painting, indulging his passion for genealogy and restoring California Missions. In 1919, Winslow became a father when he and his wife welcomed a son, Carleton M. Winslow, Jr.

Winslow worked tirelessly to guide his colleague Goodhue's vision for the Los Angeles Central Library to completion. He paid meticulous attention to the day-to-day operation of construction, dealt with various contractors, negotiated contracts and regularly attended meetings of the Art Commission. He made important recommendations on everything from the plumbing and heating to the world-renowned artists hired to decorate the building. When the Library of Commissioners appointed him as architect for a new branch library on Wilshire Boulevard, Librarian Perry questioned whether the appointment might prove a distraction from his important work on the Central Library.[12] The commission was eventually awarded to Allen Ruoff.

Winslow's design experience was put to good use when he was invited to design the Library's official seal, which would appear first on the building's cornerstone and later be incorporated into its official stationery.

The design, one of three he submitted for consideration, is an adaptation utilizing details from the Coat of Arms of the City of Los Angeles and the Coat of Arms of the United States of America. From the Coat of Arms of Los Angeles, Winslow used the Castle of Castile from the Arms of Spain, representing Los Angeles under Spanish control, 1542–1821; an eagle holding a serpent from the Arms of Mexico, representing the period of Mexican rule, 1822–1846; and the Bear and Star from the Bear Flag of the California Republic of 1846.

From the Coat of Arms of the United States of America, Winslow incorporated the American Eagle; a shield with thirteen bars, one for each of the thirteen states; an Olive Branch; a bundle of arrows, representing "our common defense of our Constitution and Laws, of our lives, and our faith and honor as indicated in the Olive Branch. Once released, it means war and becomes the swift messenger of death to the destroyer's of our peace."[13][14]

Several months in advance of the ceremony to lay the cornerstone, the Library's Board of Commissioners established a committee to determine what should be placed inside. After drawing up a short list, it was agreed the items would include a statement from Winslow; a history of the Los Angeles Public Library; photographs of the various quarters occupied by the Library; a list of Directors and Librarians; photographs of the Library Board and Librarian; a list of Los Angeles Public Library employees; a financial statement of the Library from March 1925; a copy of *Twenty-five Years of Branch Library Service,* an account of the branches in the Los Angeles Public Library system; a copy of a resolution adopted by the Library Board on May 2, 1924, honoring Bertram Goodhue; old and new city charters; early and new maps of Los Angeles; a copy of *Los Angeles City Government* 1923–1925; reports from the mayor and various city departments; copies of local newspapers; yearbooks from various societies; coins; and the contents of the cornerstone taken from the Normal School building.[15][16]

At 3 p.m. on Sunday May 3, 1925, Winslow joined more than a hundred Library staff, Frank H. Pettingell, vice-president of the Library Board, and Librarian Perry at a ceremony to mark the laying of the cornerstone. Before the dedication, the artifacts collected were placed inside a copper box that rested in a specially carved compartment inside the stone. Pettingell paid a special tribute to Bertram Goodhue and told the crowd

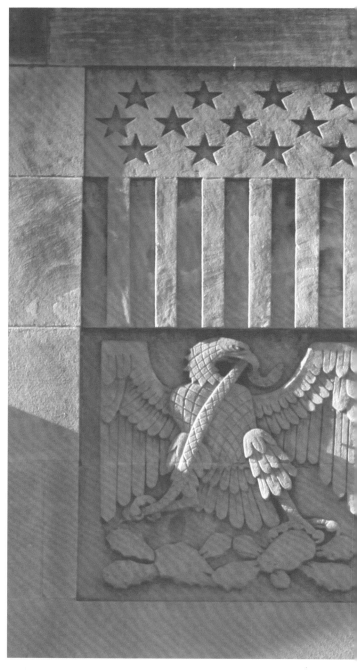

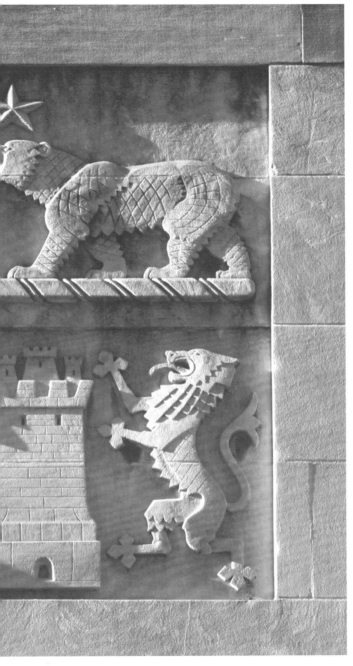

it would be the "cornerstone of the first Central Library that the City of Los Angeles has ever owned."[17]

Winslow's dedication to his work at the Library earned him the respect of Mayor John C. Porter, who moved to appoint him to the Municipal Art Commission following the resignation of architect Donald B. Parkinson in 1930. After his appointment was confirmed by the City Council, Winslow wrote to Perry, "I almost feel that I have taken on more responsibility than I am capable of handling but the work seemed laid out for me to do and I took it up without hesitation."[17] By the time the Municipal Art Commission was called upon to review Dean Cornwell's murals in the Library rotunda in 1933, Winslow was serving as the Commission's president

Although his schedule was ever demanding, Winslow made an effort to keep Goodhue's widow, Lydia, abreast of developments in Los Angeles. He wrote to her in February of 1927,

> Almost everybody whose opinion is worth noticing likes the building. Some of course, do not understand it, and are naturally prejudiced. I suppose it is natural on the part of the average American critic to be opposed to that which he doesn't understand. He usually is irritated with a novel mental experience. The important thing is that the Library Board and other officials are entirely satisfied with it. Mr. Perry expressed himself to me the other day to the effect that he would not have a single thing changed even though he had another million dollars to spend upon it.[18]

◄ *The* Seal of the City of Los Angeles *above the Central Library's Fifth Street entrance.*

5 THE DESIGN—A TWENTIETH CENTURY MASTERPIECE

*It would break my heart at fifty-four years of age, to go back to the period of the San Diego Fair.
It is not enough that a building should be beautiful, it must also be logical.*

BERTRAM GROSVENOR GOODHUE[1]

Bertram Goodhue promised Librarian Everett Perry a building that was "Spanish in style—at least in spirit."[2] What he delivered in the end was an exotic blend of Spanish, Egyptian, Byzantine, and Islamic influences, the vision of an architect at his peak unconfined by expectation. He abandoned traditional, conservative library architecture and embraced minimalist, cubistic forms to design what would later be viewed, alongside the Nebraska Capitol, as his finest work and an enduring landmark for Los Angeles and California.

Goodhue's early designs for the Library revealed an overtly classical Spanish Colonial Revival structure with a tiled dome and much ornamentation, however his focus was evolving beyond complicated antiquated forms. In March 1924, he wrote to British architect and writer William Lehaby, "Next month I shall be fifty-five, and for almost thirty-five of these years I have been working at architecture doing all sorts and kinds of dreadful things—Classic, Gothic, and Goodness-Knows-What—and I still do. However, my Gothic is no longer anything like historically correct, and my Classic. . . is anything but classic. . . At Los Angeles, I have a Public Library in the same strange style I have been telling you about."[3]

Ready for a new chapter in his career, Goodhue's inspired vision for the Library saw him replacing rounded arches with austere, geometric forms comparable to those expressed at the Nebraska State Capitol. "It must have been hard for anyone who loved subtle and complicated forms, as Mr. Goodhue did from his earliest days as a designer of bookplates, to strip off one by one all these delicate acquisitions and to begin with fresh surfaces and planes, boldly modeled around the plan itself," Lewis Mumford wrote in *Architecture*.[4]

The design of the Los Angeles Central Library was influenced by Goodhue's travels to faraway places. "He brought his own interpretation to historical styles and adapted them to fit the project and the period in which the building was being constructed," his biographer Romy Wyllie explains.[5] Along with exploring Mexico, Persia, and Europe, Goodhue also had a keen interest in Egyptian history and his work on the Library coincided with Howard Carter and George Herbert's 1922 discovery of the tomb of Tutankhamun. "As I grow older I am more and more impressed by Egyptian ornament," he wrote to Alexander. "The Egyptians were masters."[6]

Constructed of reinforced concrete and surfaced with weathered ivory stucco and Bedford limestone trimmings, the three-story main structure measured 200 by 239 feet and was intersected on its long axis by corridors leading to a central lobby on the first floor and a large rotunda on the second. Built into the main building, a two-story wing on the east side measured 89 by 129 feet and was surrounded on three sides by an open court. Goodhue's plans allowed for the addition of a future wing on the Flower Street side.

Hartley Burr Alexander's iconographic program for the building, the Light of Learning, celebrating inspirational literary and historical figures, received the "enthusiastic" support of both the Library Board and the Los Angeles Municipal Art Commission.[7] The sculpture work it inspired, crafted by Lee Lawrie, served to relieve the great plain walls, as associate

architect Carleton Winslow explained, "A conception of such simplicity would result in sternness were it not for the softening influence and adorning of the carved and sculptured stonework and the color of the tile work, both of which are integrally and structurally a part of the design."[8]

The neutral tone of the exterior was further relieved by

replacing the dome with a tower offered a practical solution to two pressing problems: it was more cost effective than a dome and a splendid way of preventing the building from being overpowered by the neighboring Biltmore Hotel and the Bible Institute. Conveniently, it also offered additional space to store books.

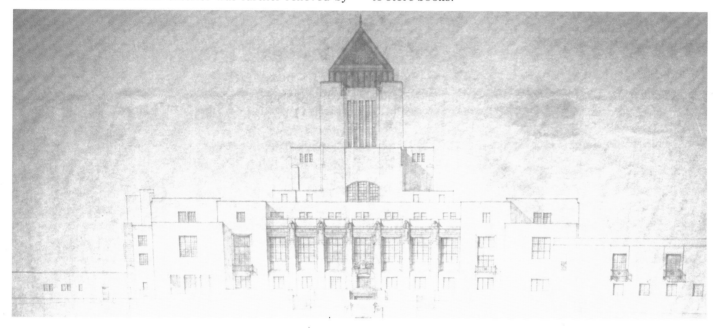

▲ *Bertram Goodhue's third scheme for the Library.*

"the highly colored, glazed tile of the pyramidal upper portion of the tower, the pools, the fountains, and by the sculptured bronze work of the doorways."[9] Rectangular windows also broke the markedly plain walls.

The architect's mastery of various design forms was evident since his plans for a low ribbed dome as the Library's defining feature evolved into a high baroque dome and ultimately a truncated tower crowned by a colorful glazed-tile pyramidion. As well as reflecting Goodhue's desire for a simpler design,

The tower design was in part a byproduct of Goodhue's search for a new form of American skyscraper and was influenced by a concept he submitted in a 1922 competition to design a new building for the *Chicago Tribune*. The contest marked the seventy-fifth anniversary of the publication and attracted 263 submissions from twenty-three countries. Goodhue was convinced his entry, which included a stepped tower, simple lines, and understated ornamentation was good

▶ *Traveling by train
from Los Angeles
to New York City
in April of 1924,
Bertram Goodhue
sketched View of the
(Poorer) Business
Quarters of the City
of Sarras on the
flyleaf of a book he
was reading.
The tower bears a
striking resemblance
to his design for the
Central Library.*

▶▶ *Goodhue's 1922
competitive design
for the Chicago
Tribune Tower.*

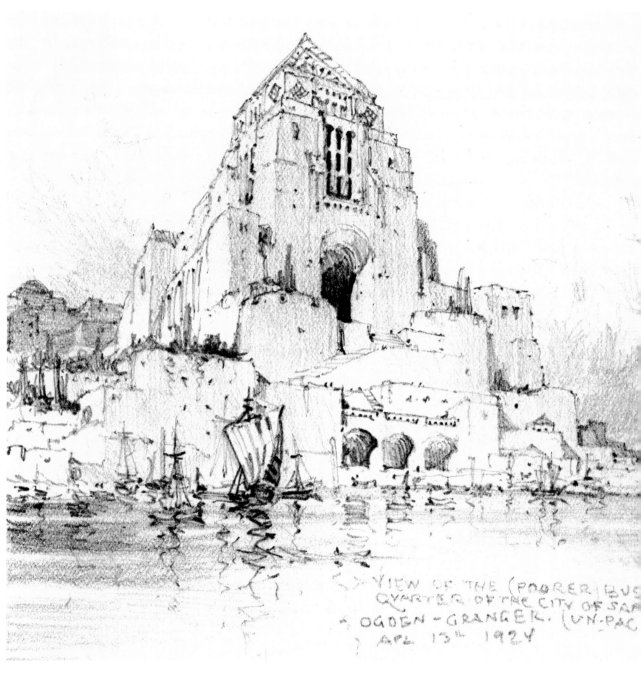

VIEW OF THE (POORER) BUS
QUARTER OF THE CITY OF SAR
OGDEN · GRANGER. (UN·PAC
APL 13ᵗʰ 1924

54

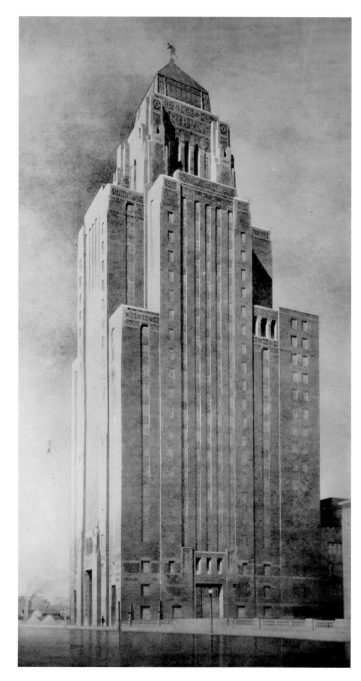

▶ *A cross-section of Goodhue's design.*

▶▶ *Goodhue anticipated the south entrance to the Library to be the busiest and described it as "architecturally, the best."*

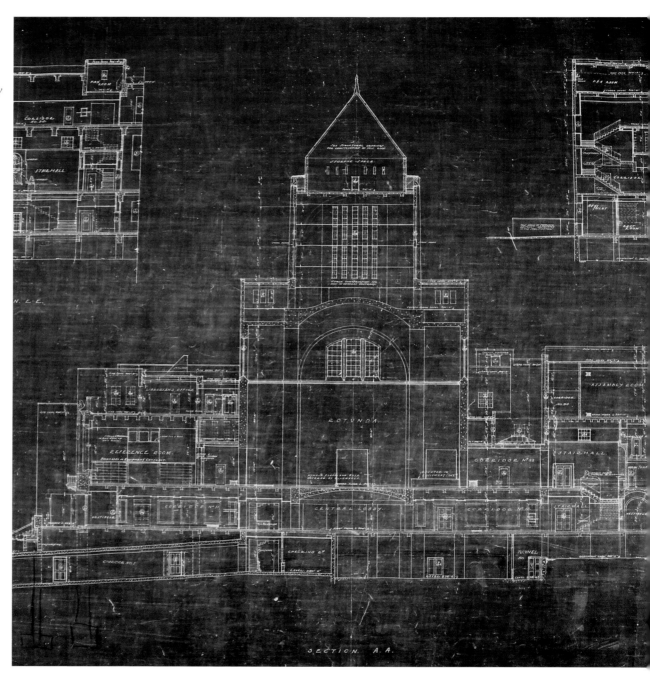

SECTION. D.D.

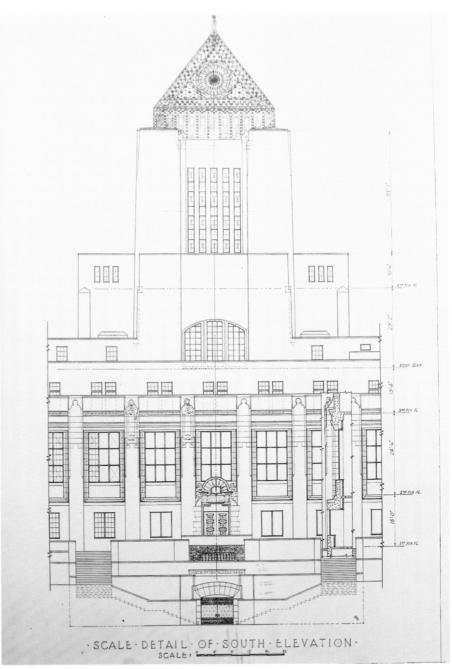

·SCALE·DETAIL·OF·SOUTH·ELEVATION·
SCALE:

THE DESIGN—A TWENTIETH CENTURY MASTERPIECE

▶ *The Central Library under construction as viewed from Fifth Street.*

▶▶ *The view from Hope Street.*

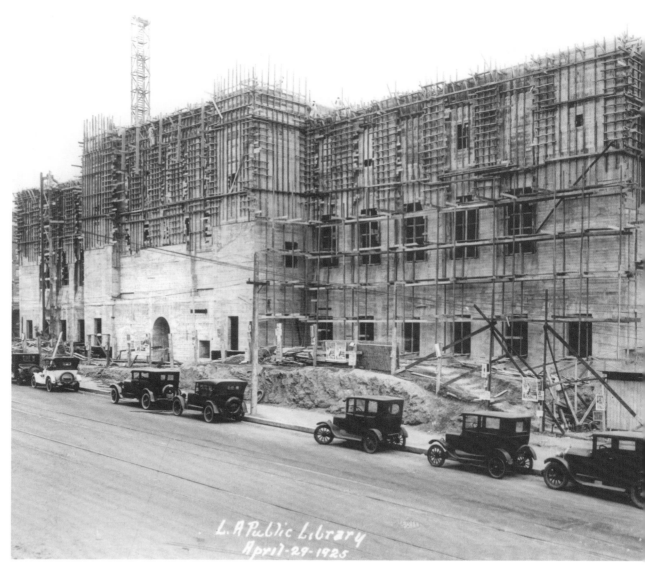

L.A Public Library
April-29-1925

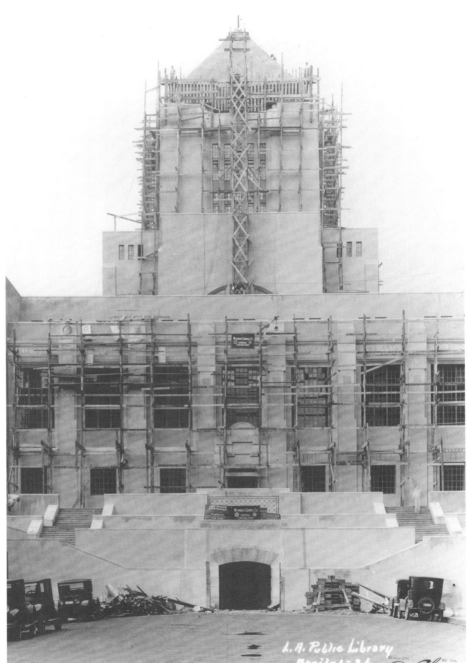

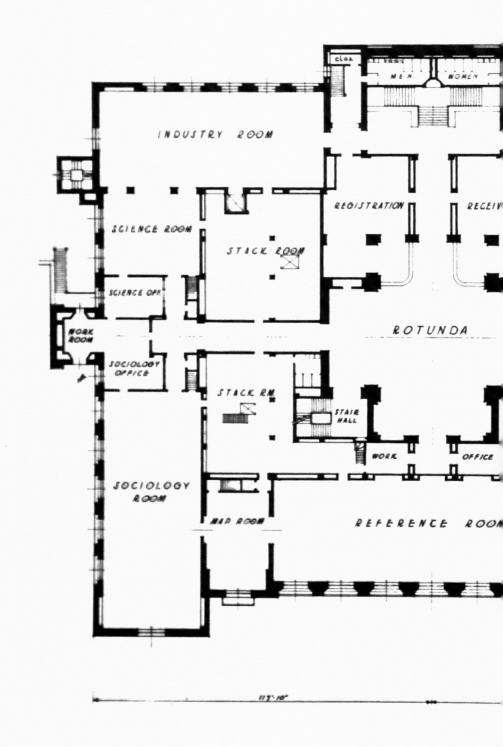

▶ *Librarian Everett Perry and Associate Architect Carleton Winslow imagined a grand rotunda as the heart of library activities on the second floor.*

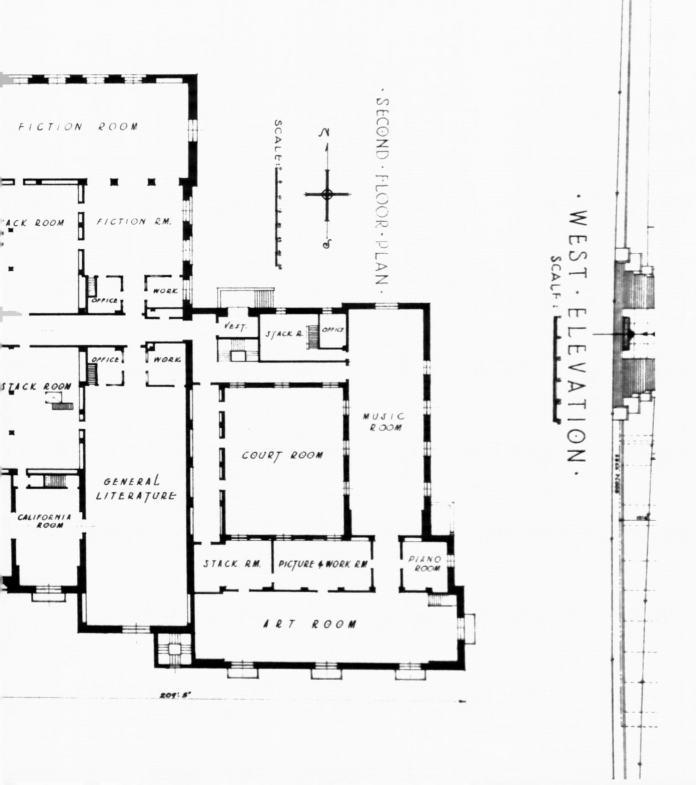

FICTION ROOM

FICTION RM.

STACK ROOM

OFFICE

WORK

· SECOND · FLOOR · PLAN ·

SCALE:

N

S

OFFICE

WORK

STACK ROOM

VEST.

STACK R.

OFFICE

MUSIC ROOM

GENERAL LITERATURE

COURT ROOM

CALIFORNIA ROOM

STACK RM.

PICTURE & WORK RM.

PIANO ROOM

ART ROOM

209' 5"

· WEST · ELEVATION ·

SCALE:

► *An aerial view of the new Central Library. Goodhue believed the addition of a tower rather than a dome as the Library's central feature would prevent it from being overpowered by the neighboring Bible Institute.*

enough to win, however he would have to console himself with an honorable mention.

The Library tower rose 188 feet above Hope Street and terminated in a finial in the form of a human hand entwined with the Serpent of Knowledge holding a golden torch. The apex featured 30,000 ceramic tiles arranged in an elaborate sunburst pattern devised by Goodhue Associates. Although the architect had initially envisioned a tiled pinnacle, he changed his plans to include a copper roof.[10] "Mr. Goodhue wished to have this work carried out in colored tile but did not believe that the tile could be specified fearing that the building in general would run over the appropriate," Carleton Winslow explained to the Library Board after the architect's death.[11]

While the Library Board debated whether they could afford to implement Goodhue's original concept, supervising engineer H.A. Nelson wrote to the board, stating the sample tiles supplied by the American Encaustic Tiling Co. were "the best colors the writer has ever seen in tile work."[12]

The American Encaustic Tiling Co. would also supply the colored decorative tile used in the niches of the drinking fountains and the fountains on the west side of the building that recalled the California heritage of Spanish Colonial architecture and "the scholarly influence of a more eastern heritage."[13] The courts and interior passages featured an unglazed red tile from Gladding, McBean & Co.

City regulations required doorways on all sides of the building, so Goodhue adapted his design to include six entrances on four streets; Hope, Grand, Fifth, and Flower. "It is difficult to say which is the most important entrance; nobody can say, in fact," he remarked to Alexander in March of 1924. "The south door is, architecturally, the best, and it is where the greatest number of visitors will come. Immediately within the archway, on the street level, is a sloping tunnel that goes up to the center of the building. Few people will use the entrance on the terrace above. The north entrance is very much more convenient after you get inside the building, but there isn't any great amount of traffic on this street. . .On the east (or since one entrance faces north, I should say north) there are two entrances, one from the terrace, and the other for the children who will chiefly occupy the wing."[14]

To stay within budget, Goodhue had been forced to reduce the size of the building from a proposed 400,000 cubic feet to 260,000. He also had to abandon plans for a $50,000 bridge across Fifth Street that would have provided Bunker Hill visitors direct access to the second floor.

When completed, the Library boasted fifteen public reading rooms with 1,200 seats, as well as lecture rooms and a book capacity of 1,125,000 volumes. The floor plan was devised in collaboration with Librarian Perry who undertook a thorough study of East Coast libraries before submitting "tentative diagrams and scheduled requirements of the different departments"[15] to the architects. "We wanted our building to express warmth, hospitality, attractiveness, and invitation," Perry explained. "If it took some courage to go counter to established tastes in library architecture, it was with even greater trepidation that we discarded the usual interior arrangement and substituted a plan which makes ours unique among libraries of the country with the exception of Cleveland which, though dissimilar in detail, furnished part of our inspiration."[16]

The Cleveland Public Library was designed by local architects Frank R. Walker and Harry E. Weeks, who envisioned a structure built around a hollow square with reading rooms on the outer perimeter of the building. Perry imagined a similar concept in Los Angeles where, instead of positioning the book stacks at one end of the building, they were arranged between the reading rooms and the central rotunda, preserving valuable lighted space.

▶ *The newly completed Central Library viewed from Flower Street.*

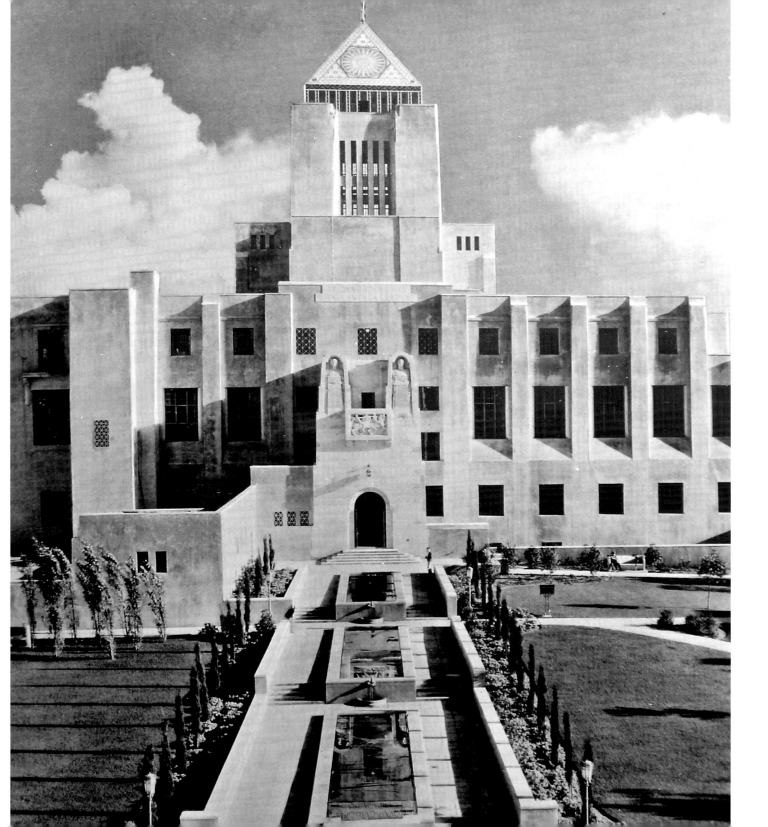

▶ *Entrance to the Children's Wing.*

▶▶ *Lee Lawrie designed the panels featuring legendary characters in the entrance to the Children's Wing.*

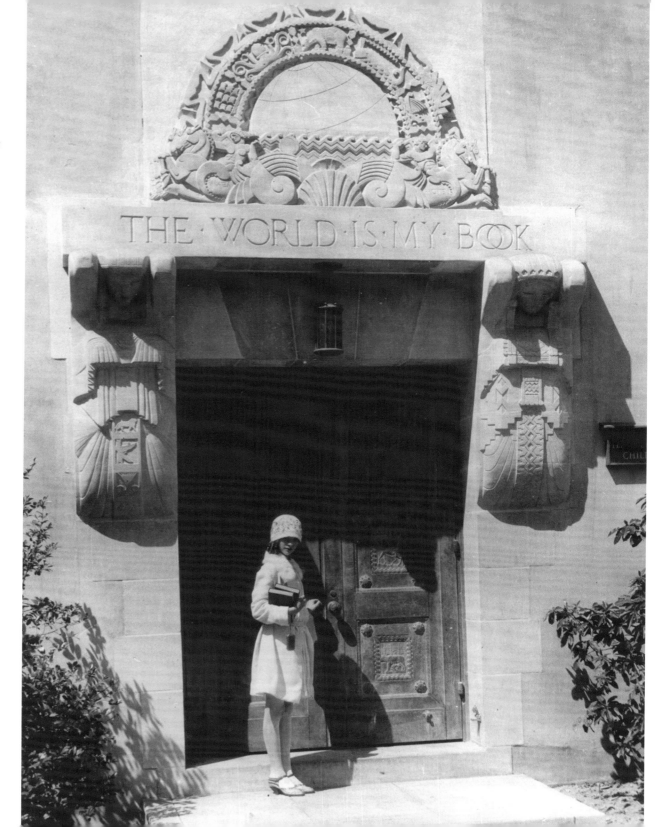

THE · WORLD · IS · MY · BOOK

66

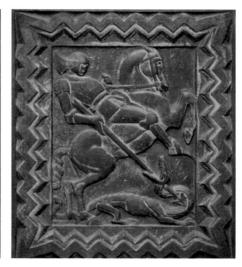
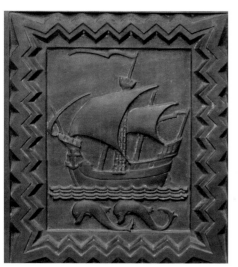
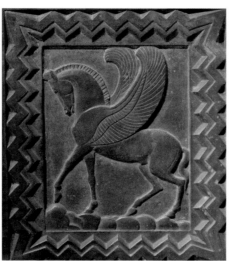
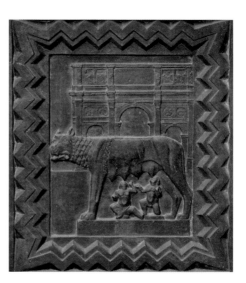

On the first floor, the Newspaper and Periodical Rooms; the Patents, Foreign, and Bindery Rooms; and the Civics and Exhibits Rooms could be explored. The School and Teachers and Children's rooms in the first-floor wing were given separate street entrances, as were the exhibit and lecture hall.

On the second floor, the grand rotunda served as a center of Library activities. Here new subscribers would register, return books, or stop by the information desk on their way to various departments, including Science and Industry, Fiction, General Literature, and Sociology. They could also find the California, Map or Reference Rooms, as well as the Art and Music Rooms on the second floor. The mezzanine above the second floor offered space for scholars to take advantage of reference materials.

Adjoining the Music Room was a sound-proof piano room where music lovers could enjoy selections from the vast sheet music collection. In the Art Room, an alcove beneath the balcony was equipped with drafting tables, and in the adjoining picture room, patrons could explore illustrations, clippings, and a selection of 20,000 mounted photographs organized into searchable categories.

The third floor housed the executive offices, board room, the headquarters for branch libraries, cafeteria, dining room, and Catalogue and Order Departments. It also included a photographing or photostat department where patrons could make copies of documents that could not be removed from the Library.

Illuminated by natural light from four clerestory windows, the rotunda was the primary decorative and structural feature of the building. Its arches spanned forty-two feet, rising from four eight-foot six-inch square concrete piers.

The concrete pour for the rotunda was one of the largest in the city's history beginning at 5 a.m. and lasting for twenty-one hours in the midst of continuous rainfall. Approximately 24,000 cubic yards of concrete were placed in the structure.

The rotunda floor was covered in Levanto and Rosato marble squares with a border of Champville and Westfield Green and Golden Travis strips. The original desks and catalog cases were a "rich walnut brown" and the chairs, desks and tables, "quarter sawed white oak" finished in walnut tones.[17]

By night, the magnificent bronze chandelier designed by Goodhue Associates and modeled by Lee Lawrie illuminated the rotunda. With a ring of forty-eight bulbs, it weighed one ton and represented the solar system. The Earth, a globe of translucent blue glass tipped on its axis, was produced by the Judson Art Glass Co. of Pasadena and suspended sixty-four feet above the marble floor. The canopy represented the sun; the breaks in the chain, the stars and the crescent moon. Nine feet in diameter, it could be lowered for maintenance using a winch in the attic above the dome.

"The rotunda chandelier appears to fit in its surroundings as an old Moorish lamp fits in a Spanish chapel," J. K. Strickley wrote in *Artland*. "But it does much more, for it gently and naturally draws the visitor's eye to the beautiful design of the rotunda itself, and to its unique decoration."[18]

The chandelier design mirrored the rotunda's geometric sunburst ceiling painted by Julian Garnsey who, along with A.W. Parsons, was responsible for painting many other rooms on the second floor. Howard Verbeck was responsible for the ceilings in the Foreign, Genealogy, Periodical and Newspaper departments. The J.B. Holzclaw Co. decorated the ceilings in what would become the Philosophy and Religion department. Celebrated artist Dean Cornwell painted the historical murals that circled the rotunda, and Albert Herter created the murals that appeared first in the Hope Street tunnel and later in the Reference Room.

Beyond its architectural work, Goodhue Associates also designed the grilles, ironwork, and furniture. For the Reference Room, the largest of the reading rooms stretching

almost the entire length of the building, they created two rows of tables and chairs and the vertical cast bronze lighting standards done in a natural verde antique finish that were modeled by Lee Lawrie. The furniture was built by Library Bureau, which supplied the majority of fittings, while Thomas Day Co. was awarded a $40,000 contract to produce the lighting.

Lee Lawrie would also model the north stair hall lanterns and help design the artificially aged bronze doors produced by the A.J. Bayer Co., including the entrance to the Children's Room, carved in relief panels, featuring Aladdin, Romulus and Remus, Pegasus, and other storybook characters. Barker Bros. supplied the draperies while the Southern California Hardwood & Manufacturing Co. produced the interior doors and woodwork, and Earle Hardware Manufacturing made the hardware. The building included a state-of-the-art ventilation system capable of handling 180,000 cubic feet of air per minute through five miles of steel ducts weighing 250,000 pounds.

Goodhue valued the integration of architecture and landscape, and central to his vision was the blueprint of a building in a park. His ideas for landscape surrounding the Flower observed how water was treated as a "rare and precious thing to be carefully cherished and used. . .over and over again."[19] Persian pools, he noted, were often rectangular, shallow, and tranquil, and the surrounding walks and terraces more peaceful than the "tortuous sinuosities of late Italian work."[20]

He wrote to Alexander, "My clients set a great deal by the Flower Street entrance, and here I have used long stepped pools, Persian fashion, with a double row of cypresses, the entrance being two hundred feet from the sidewalk."[21] While more traditional structures were ringed by green lawns and flowerbeds, Goodhue turned to what, for him, had become a signature design, a structure approached by reflecting pools, flanked by concrete walkways and steps, and surrounded by exotic greenery.

A low wall, interrupted by paths leading to the various entrances, surrounded the property. Along the entranceways, stone seats designed by Goodhue Associates and manufactured by the Bly Stone Co. invited visitors to rest. The landscaping contract and the responsibility for creating an oasis filled with laurel, olive, palm and cypress trees, was awarded to Beverly Hills Nurseries, whom Winslow described as "thoroughly reliable."[22]

The landscape team that would craft the more traditional gardens around the Grand and Hope Street entrances played an important role in softening the impact of the neighboring Bible Institute. They were asked to scale back plans for a row of eucalyptus trees, however, when the California Club acquired a neighboring lot and its members planned to erect what the Library Board foresaw as a "beautiful" new building designed by architect Robert Farquhar.[23]

The Children's Room was reached through a patio surrounded by trees in colorful Spanish-tiled basins, and at the center was a fountain modeled by Lee Lawrie. In 1934, Charles Kassler II was commissioned to create *The Bison Hunt*, a fresco in the spirit of the "olden, golden West", covering the two upper stories of the east wall of "The Court of Childhood." Executed in earth tones with hints of blue (Kassler made the pigment from finely ground lapis lazuli, a semiprecious stone he was given by a friend.), it was originally hoped the work, part of the Public Works of Art Project, would stretch across all four walls of the court, but government funds never materialized. It was painted over in early 1963 after suffering water damage.

Another Public Works of Art Project executed in 1934 by Los Angeles artist Gail Cleaves suffered a similar fate. Cleaves' decorative map of the Public Libraries in Los Angeles, showing the branch libraries in miniature, graced the south wall of the Fifth Street foyer until it too was painted over in 1965.

The Los Angeles Central Library, equipped and furnished, cost $2.3 million from start to finish. Critics marveled at how the "clear, flat walls lacked any distraction for the reader" and decoration was restricted to "colorful geometric patterns on ceilings and concrete beams." The *Los Angeles Times* noted, "Throughout the building the square is employed for decoration as the only angle appropriate to a building constructed in cubes." The newspaper observed in a subsequent report, "Those who like prettiness in their art—and there are many such—will be appalled at its simplicity—'bareness,' they call it."[24]

"As the first civic building in this city of permanent nature, this Library sets a stride that others will do well to follow," Merrell Gage wrote in *Artland*.[25] While *American Builder* magazine raved, "Architecturally, there are few buildings of its size and character that compare in originality of design with the Los Angeles Public Library."[26]

The most important critique came from the Library Board of Directors, which noted in its 1926 annual report:

> In architecture it ranks as one of the masterpieces of Bertram Grosvenor Goodhue and his associates, and as one of the most distinctive buildings in America. In its elaborate and unified decorative scheme, its statues and inscriptions, through art and symbolism, it kindles the mind to a spark of aspiration struck from the flame of wisdom and knowledge. In its space and dignity and ample provisions for intensive use and extensive service, it enables the Public Library to assume its rightful place as the greatest civic agency for universality of education, offering a curriculum broader, more inexhaustible and more freely available than any college or university can present. In a word, it combines in the highest measure of expression the practical, the ornamental, the utilitarian and the artistic.[27]

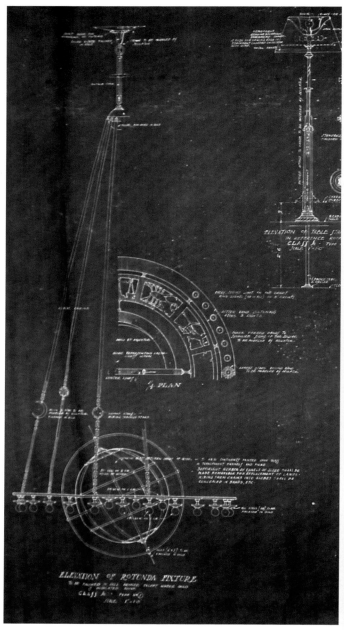

▲ ▶ *The rotunda chandelier by Goodhue Associates, modeled by Lee Lawrie.*

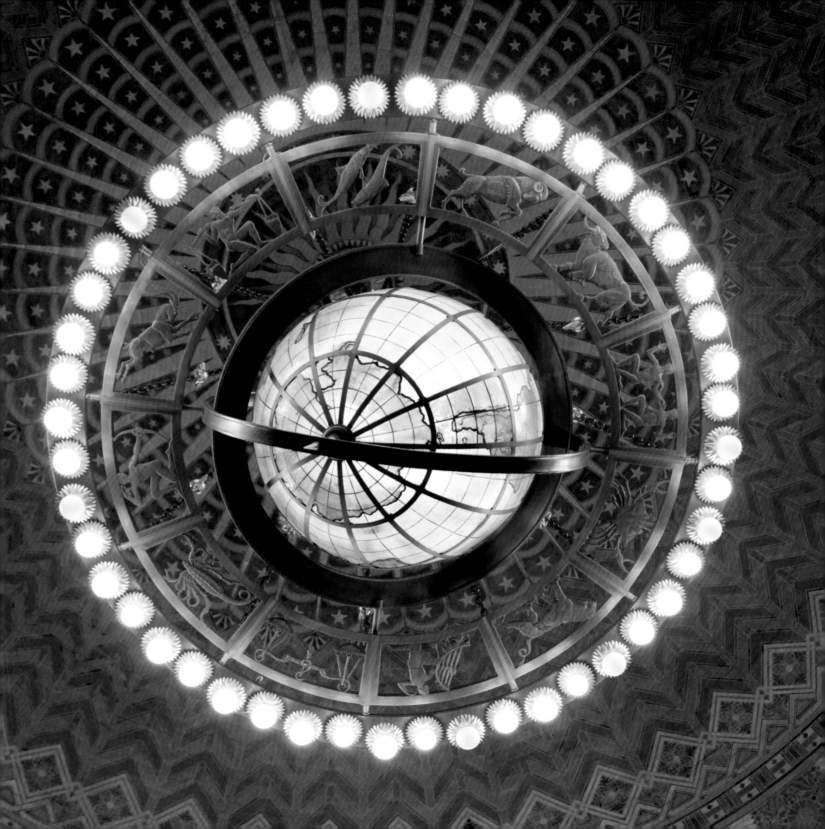

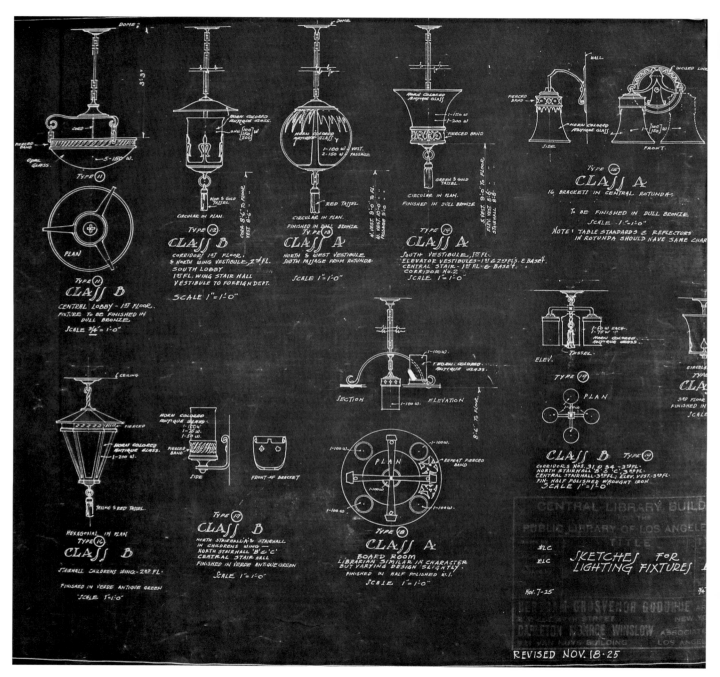

◄ *Many light fixtures such as those in the rotunda, were reproduced from original blueprints. The rotunda lights were originally designed to point downward, toward the floor.*

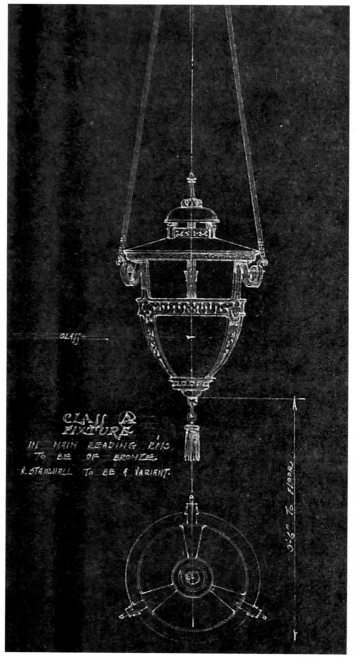

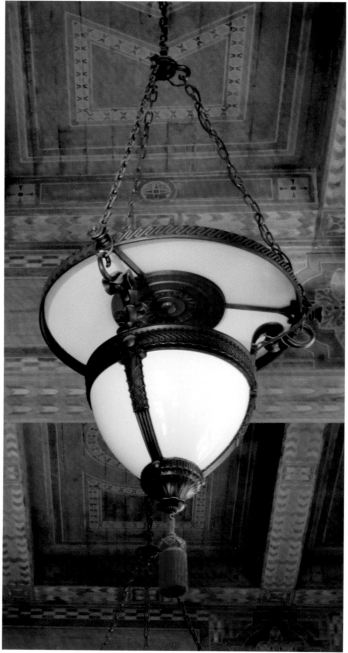

74

◀ *A light fixture above the Hope Street tunnel entrance.*

◀◀ *A light fixture above what was once the Fiction Room, now Teen'Scape, on the second floor.*

▶ *The Thomas Day Co. manufactured the light fixtures in the Science Reading Room.*

▶▶ *The same company produced the light standards in the Reference Room.*

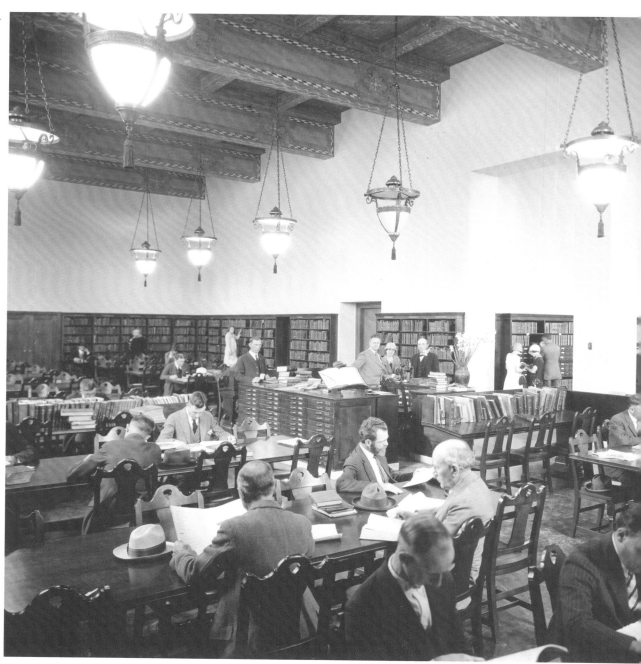

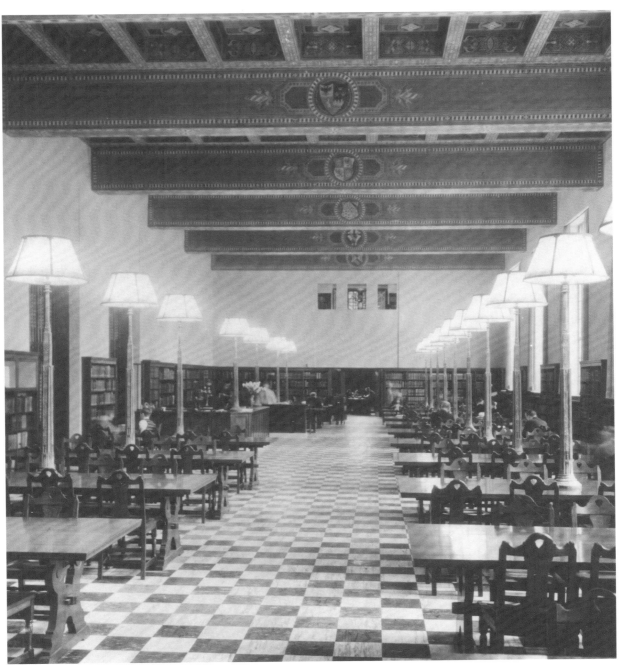

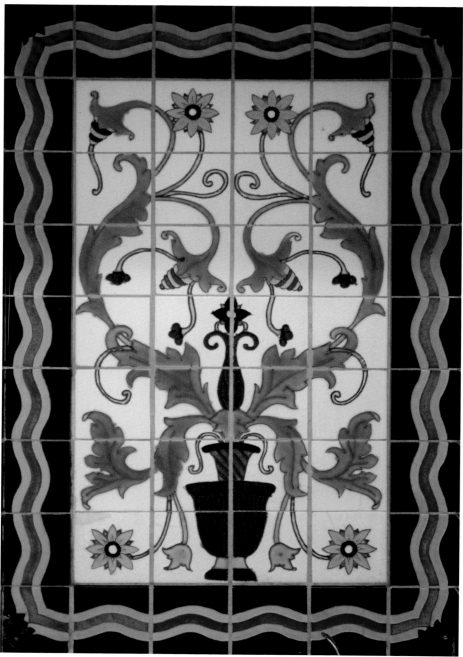

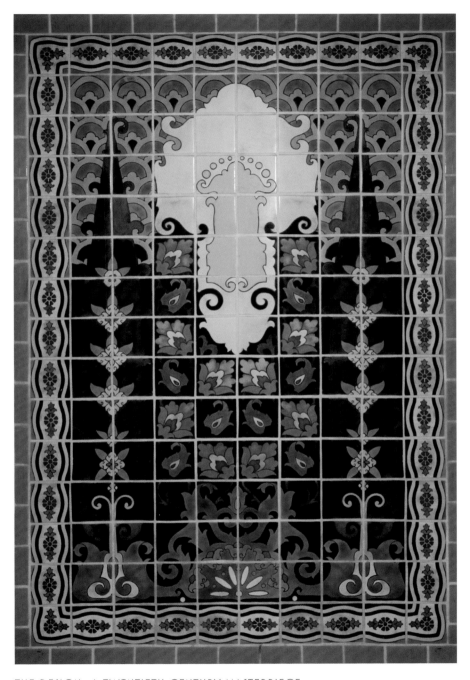

The Goodhue Associates designed the Library's tile work.

◀ An earth-toned panel adorns the north entrance.

◀◀ A vivid floral pattern can be found on the second-floor tiled panel.

◀◀◀ The Goodhue office carefully specified the designs on blueprints.

THE DESIGN—A TWENTIETH CENTURY MASTERPIECE

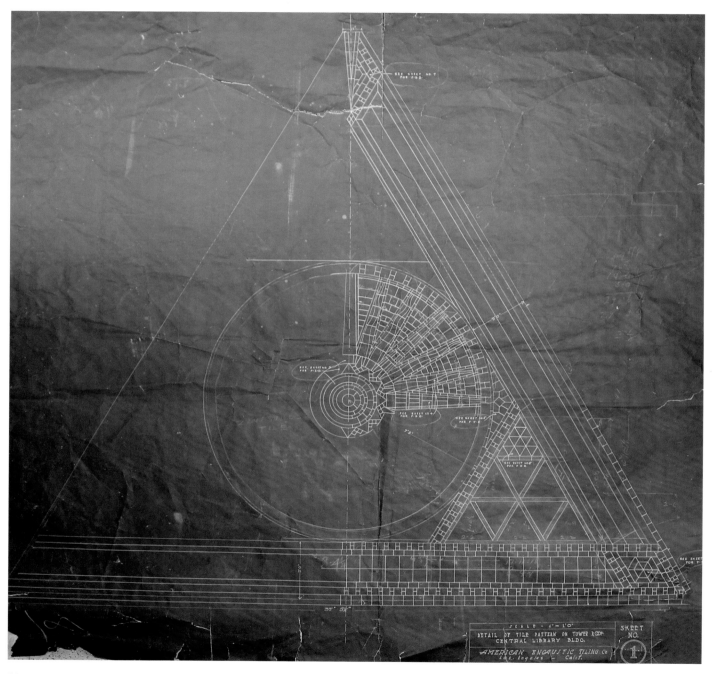

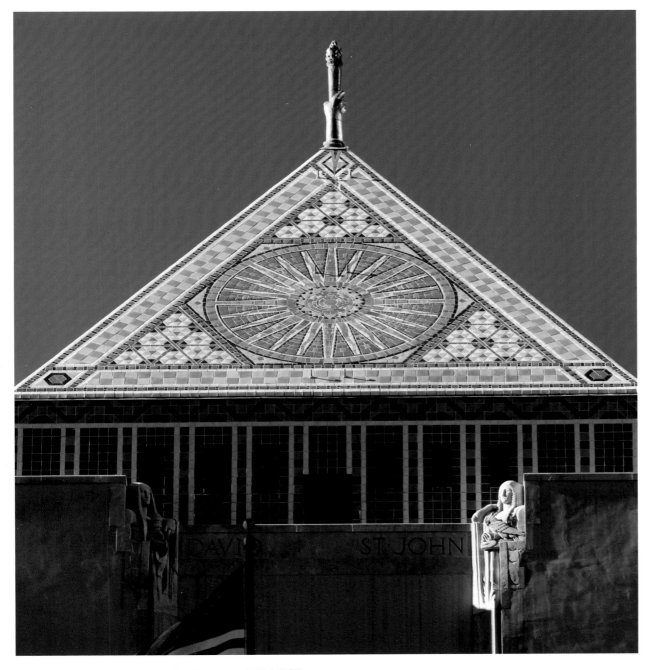

◀ *The American Encaustic Tiling Co. manufactured the tiles for the Library's pyramid roof. The finial is a replica of the original.*

◀◀ *The blueprint for the design of the tower's pyramid spelled out exact pattern and colors.*

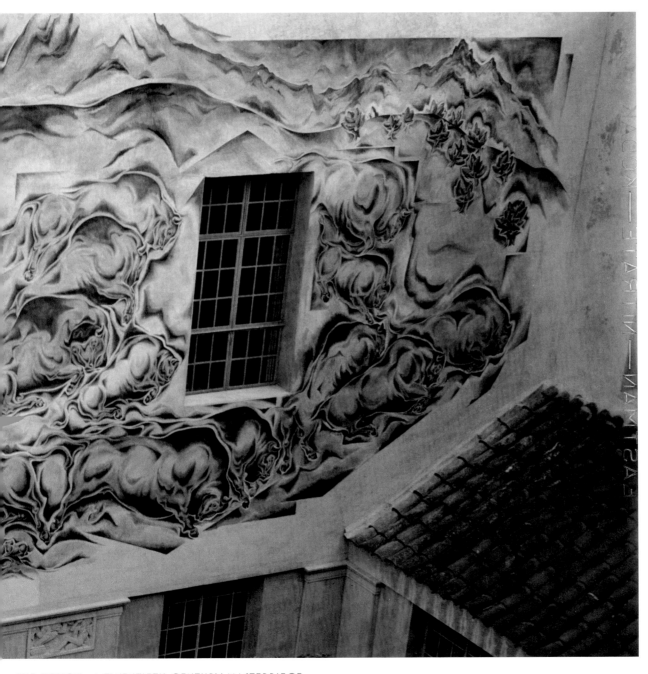

◀ *The* Bison Hunt *fresco by Charles Kassler II.*

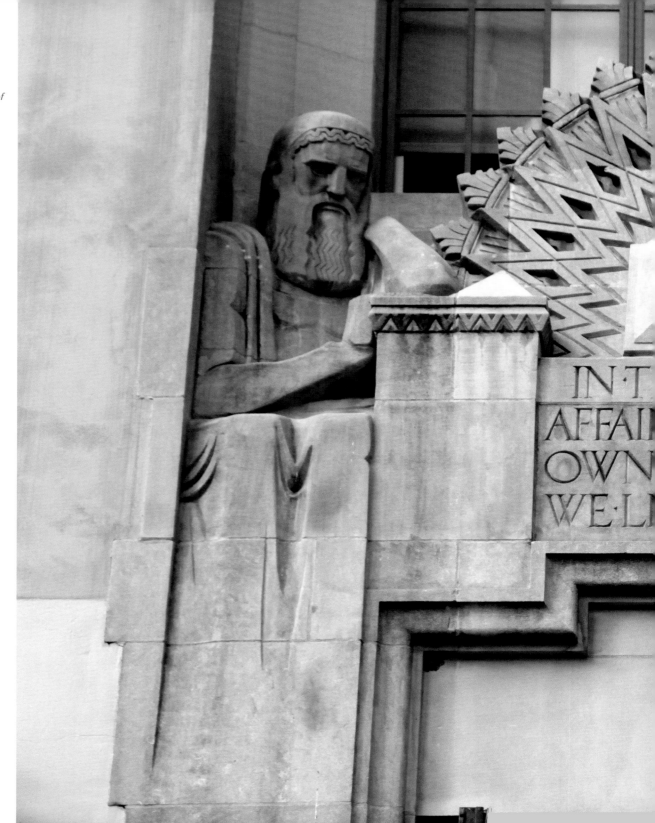

▶ *The south façade of the Central Library.*

INˑT
AFFAI
OWN
WEˑLI

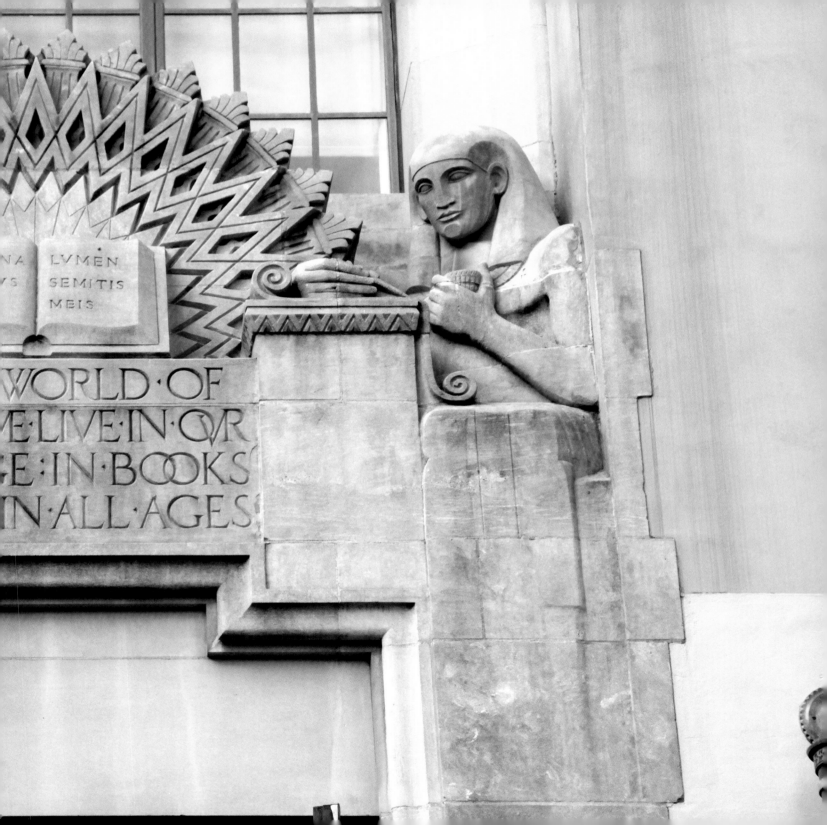

6 THE ICONOGRAPHER—HARTLEY BURR ALEXANDER

This natural image, of the light of learning, is the theme of the sculptural decorations and the inscriptions which adorn the library building.

HARTLEY BURR ALEXANDER[1]

Hartley Burr Alexander was not an architect, and yet his imprint can be seen all over the Los Angeles Central Library. A native of the Nebraska prairie, he was a poet, dramatist, philosopher, teacher, and prolific author whose passion for language, literature, history, and mythology influenced the design of such important buildings as the Nebraska State Capitol, New York City's Rockefeller Center, Department of Justice Building in Washington, D.C., and the Oregon State Capitol. California was also a beneficiary of Alexander's formidable intellect. Alexander conceived the sculpture scheme, inscriptions, and symbolism that Lee Lawrie carved for the Los Angeles Central Library, ultimately helping to create one of the state's most significant architectural landmarks.

Bertram Goodhue often spoke of his vision of producing a building with "the designing triumvirate"—the architect, painter, and sculptor. Working with Alexander, however, forced him to reconsider his notion, as the architect revealed to Lawrie in 1924. "Apparently in Dr. Alexander I have got one more of the "quadrivirate" needed to make a good building making two in all, for the painter hasn't yet appeared, and if things go any further, I am proposing to drop out in favour of a better man."[2] In his initial offer to work on the Los Angeles Central Library, Goodhue wrote to Alexander, ". . .I have come to rely on you as a confrere almost as much as Lawrie."[3]

A strong believer that philosophy had more in common with art than science, Alexander was so widely revered that he would be named an honorary member of the American Institute of Architects.

Born in Lincoln, Nebraska, on April 9, 1873, he was the fourth surviving child of Methodist minister George Sherman Alexander and his wife Abigail Smith Alexander who arrived in Nebraska in 1868 from Cape Cod, Massachusetts. Shortly after his birth, Alexander's mother wrote to his aunt in Boston, "Hartley is not behind any child of his age. He is as wild as a colt; looks and acts just like his father; he talks and sings from morn till night."[4] These were bittersweet words because their time together would be cut short. When he was three, his mother died, and his earliest memories from that time included his "hysterical fear of her dead face" and his "refusal to kiss her cold lips."[5]

Alexander's early childhood years were spent in foster homes until his family was reunited in Homer, Illinois, when his father married teacher Susan Godding, whose love of the arts would have a profound influence on Hartley. The family returned to Nebraska when George purchased the Syracuse Journal and became the newspaper's editor in addition to maintaining his ministerial duties. Being around the newspaper business, the young boy learned the art of typesetting before enrolling at the University of Nebraska.

Alexander turned down a job offer as a reporter for the *Los Angeles Times* to further his education. His graduate studies took him to the University of Pennsylvania but were interrupted when he contracted typhoid fever. Despite running out of funding, he managed to complete his doctorate at Columbia University in 1901. His obsession with books and language led to a position as an editor for the *New International*

Encyclopaedia in New York City. He later moved to Springfield, Massachusetts joining the staff of *Webster's Dictionary,* where his responsibilities included providing definitions for terms relating to anthropology, mythology, and philosophy.

In 1908, Alexander returned to his roots, accepting a teaching position as a professor of philosophy at the University of Nebraska. The same year, he married Nelly Griggs, whom he had met as a freshman while waiting tables in a restaurant. The following year, they welcomed a son, Hubert, and three years later a daughter, Beatrice. "From her resemblance to me, her mother called her the 'Little Hartley,'" he remembered.[6] Tragically, Beatrice died of typhoid in 1913, and Alexander admitted for years afterwards that his young daughter haunted his dreams. Of his appointment in 1927 as a philosophy professor at Scripps College in Claremont, California, Alexander wrote, "I have sometimes wondered if my willingness to become a teacher in a girls' college, at about the time when she would have been entering college, may not have been in part due to her."[7]

When the United States entered World War I in 1917, Alexander applied for a commission, but lacking military experience, he was overlooked. "I suppose they found it hard to imagine a philosopher as of any utility!" he reflected.[8] He worked tirelessly to raise funds for French war orphans, and in recognition of his fundraising and his wartime essays, "Liberty and Democracy,"[9] Alexander was awarded the French Legion of Honor.

Alexander's passion for history and literature led to an introduction to Bertram Goodhue. When the search for an architect to design the Nebraska State Capitol began in 1919,

◀ *Hartley Burr Alexander.*

▶ *Alexander took Goodhue's vision for "a rayed book" above the Hope Street entrance with historical figures on either side and imagined a Greek-inspired Reflection, or Thinker, and an Egyptian Expression, or Writer.*

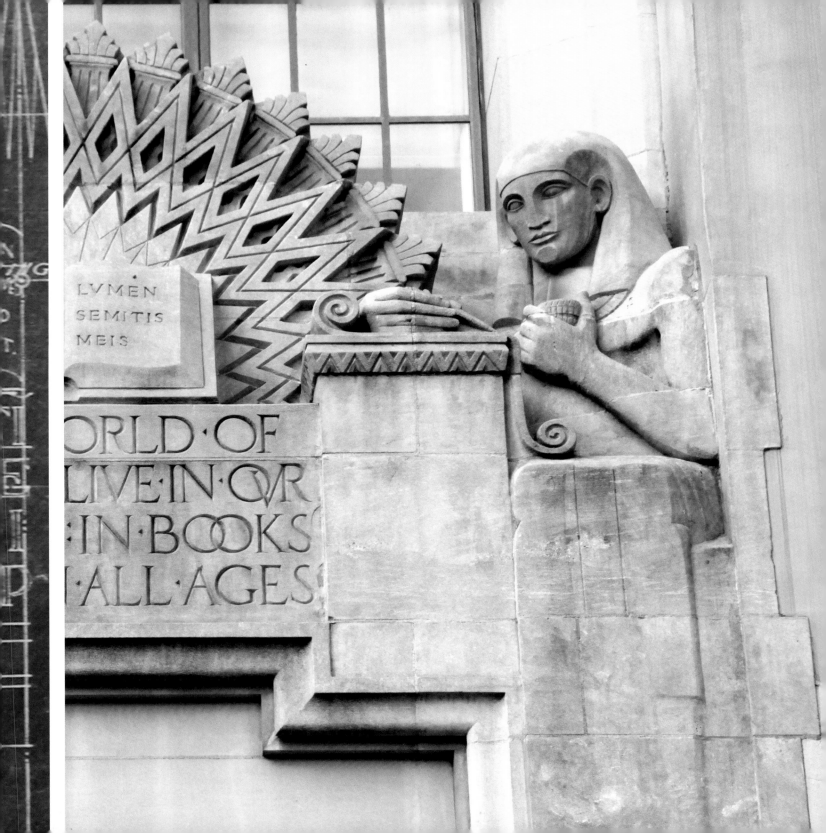

LVMEN
SEMITIS
MEIS

ORLD·OF
LIVE·IN·OVR
·IN·BOOKS
·ALL·AGES

the commission overseeing the project announced they were seeking designs that incorporated the arts. When Goodhue was selected, he wrote to Omaha architect Thomas R. Kimball, who was on the selection commission, asking advice on advancing the inscriptions and symbolism in the design of the building. Kimball suggested contacting Alexander, who had published an article in the *Nebraska State Journal* entitled, "Nebraska as a Subject for the Arts," and was well-known for "organizing pageants of Nebraska history." As Goodhue noted, their innovative collaboration would give rise to "the creation of a new profession" for his academic colleague.[10]

Alexander developed Goodhue's idea of "Knowledge, Mercy and Force" into a theme of "Wisdom, Justice, Power and Mercy, Constant Guardians of the Law"[11] for the capitol's sculptural decoration. Upon Goodhue's untimely death in 1924, the scheme was "only tentatively developed," so Alexander worked closely with Lee Lawrie and Hildreth Meieres, who created dramatic mosaics, to ensure Goodhue's vision was respectfully served. As Alexander noted, the Nebraska State Capitol would prove to be the first great public building in the United States other than a church to have "a thematic program, inside and out, that is genuinely comparable to a unified book, as a running commentary on the meaning of the edifice."[12]

Alexander's scheme for the Los Angeles Central Library, built around the idea of light and learning, adopted a similar approach. "Light and learning are associated together by an impulse so natural that it pervades the great literatures of the world," he explained. Goodhue had challenged him to "give the people something that will make them scratch their heads—not scratch their heads and give it up, but find out what it's all about."[13] Upon reviewing an early draft of his plan, Goodhue had raved to Alexander, "Your scheme for the sculpture and inscriptions is even finer, it seems to me, than

the one for the Lincoln capitol. . .Did I tell you that Mr. Lawrie is even more enthusiastic over your sculpture 'scenario' than I, if such a state of mind on anybody's part is possible?"[14]

Goodhue had instructed Alexander to begin by addressing the six great figures and inscription, which he planned for the Hope Street elevation. "Whether this inscription should relate to the figures or not, is your affair," he wrote in March of 1924.[15] Alexander envisioned Herodotus to represent History; the poet Virgil, Letters; Socrates, Philosophy; Justinian, Statecraft; Leonardo da Vinci, Arts; and Copernicus, Science. "The six images for two groups, three right and three left, and at the same time three pairs," he explained, "for beginning at the center, Philosophy and Statecraft, next Letters and the Arts, and lastly History and Science have correlative positions in defining the frame of life, its ideal expressions and its setting in time and space."[16] Each historical figure was accompanied by a simple inscription; as a group, they were intended to convey "the whole form of our human and humane traditions."[17]

Alexander then turned Goodhue's vision for "a rayed book" in a "semi-circular pediment"[18] into the centerpiece of his scheme above the terrace entrance facing Hope Street. The book was inscribed in Latin of the Vulgate from Psalm 119, verse 105, *Lucerna pedibus meis. . .lumen semitis meis*, meaning ". . . A lamp unto my feet, and a light unto my path." When Goodhue outlined his plan for two historical figures[19] on either side of the book, Alexander imagined a Greek-inspired Reflection or Thinker on the left, a nod to ancient Greek advances in philosophy and science, and an Egyptian Expression or Writer on the right, a tribute to the most ancient writing known to man. The scroll held by the Thinker reads, "Thought is the Grandeur of Man," adapted from the French mathematician and intellectual, Blaise Pascal. The Writer

▶ *Alexander and Lee Lawrie collaborated on the* Well of Scribes.

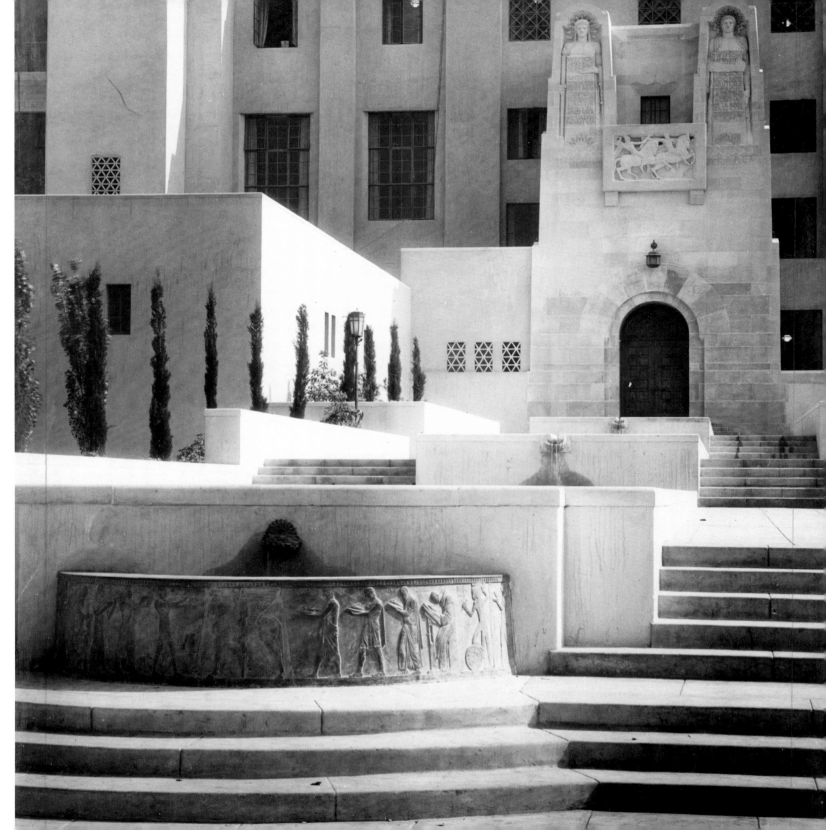

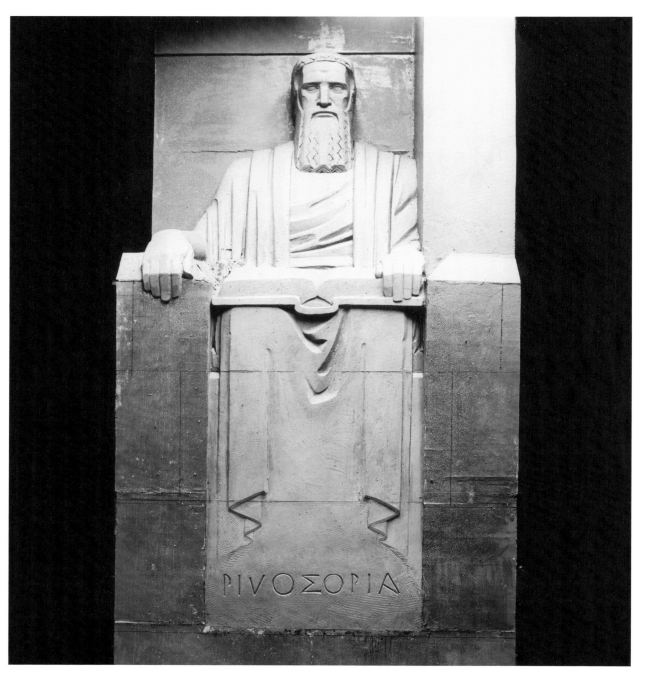

▶ *Sculptor Lee Lawrie created the models for the* Philosopher, *and* ▶▶ Phosphor *and* Hesper, *in his Harlem Studio before shipping them to Los Angeles.*

92

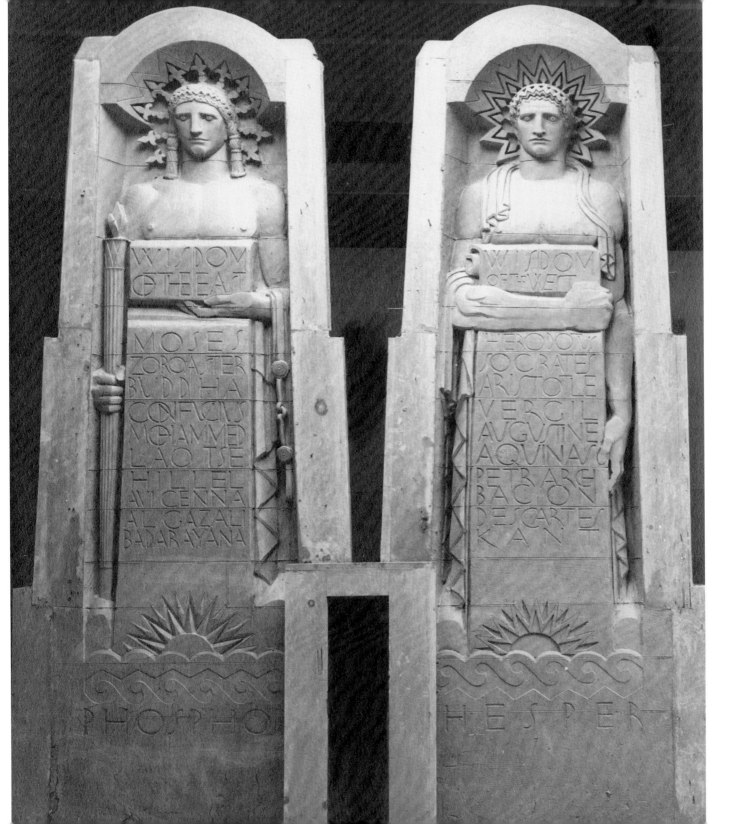

WISDOM OF THE EAST

MOSES
ZOROASTER
BUDDHA
CONFUCIUS
MOHAMMED
LAO TSE
HILLEL
AVICENNA
ALGAZALI
BADARAYANA

PHOSPHO

WISDOM OF THE WEST

HERODOTUS
SOCRATES
ARISTOTLE
VERGIL
AUGUSTINE
AQUINAS
PETRARCH
BACON
DESCARTES
KANT

HESPER

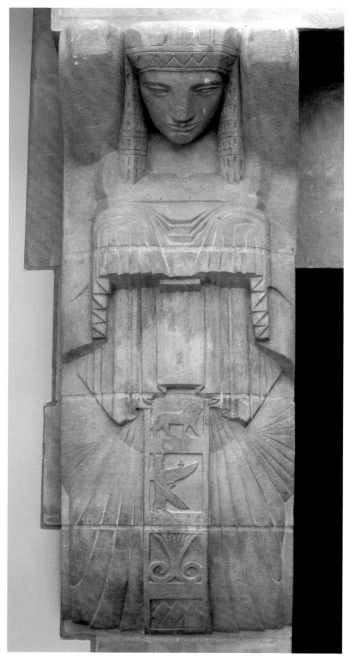

carries a scroll translated from Longinus' *De Sublimitate IX*: "Sublimity is the echo of a great mind."

Beneath the book, Alexander chose the inscription, "In the world of affairs we live in our own age; in books we live in all ages." He was inspired by French philosopher Étienne Pivert de Senancour, who wrote "In solitude we live in all ages."[20]

Shortly after Goodhue's death, Alexander received an inquiry from Librarian Everett Perry about the Nebraska project in relation to the ongoing Library work, "May I ask whether the English language was used throughout, or whether in some cases the Latin was used? In the case of our own building, which will be in the Spanish style of architecture, not a classical style, I feel that the English language is much to be preferred. Mr. Goodhue has designed for us a Library quite different from the cold and dignified buildings that have been constructed in some eastern cities. On such buildings, Latin inscriptions might be considered to be the appropriate thing, but on our building, which is informal in its style of architecture, I feel that the English language is more fitting."[21]

Before year's end, Carleton Winslow informed Alexander that the Library Board had decided the inscriptions should be in English "except for a certain few which you believe would be more appropriate in Latin."[22]

Summoning the breadth of his knowledge, Alexander harnessed the power of written words and ideas throughout history to set forth a nascent Los Angeles Central Library with its mission for the ages.

Beneath the main façade above the tiled fountain, the words, "Wisdom is the ripest fruit of much reflection," were adapted from a passage from Longinus's *De Sublimitate VI*. Above the street level entrance, "Books invite all; they constrain none" was carved into the limestone to greet visitors.[23] Above the tunnel entrance, Lawrie created a tribute to the

◀ *Spirit of the East .* ▶ *Spirit of the West.*

power of the printing press, featuring Gutenberg, Aldus, Elzevir, Caxton, William Morris, and Bertram Goodhue, divided by a wooden screw press. Lawrie reported to Alexander, "The full-length figures would be quite easy to do, and the one on the right hand, as you suggest, could be Goodhue seated at a mediaeval desk designing his type fonts."[24]

Above the Fifth Street entrance, Goodhue designed two seated relief sculptures which Alexander envisioned to "symbolize the great literary powers of the mind, Reason and Imagination, or the Philosopher and the Poet."[25] The inscription high above the entrance reads, "Books alone are liberal and free; they give to all who ask; they emancipate all who serve them faithfully." It was translated into English from *The Philobiblon*, a collection of essays by mediaeval bibliophile Richard de Bury.

For the terrace entrance on Grand Avenue that led to the Art and Music Rooms, Alexander chose, "Love of the beautiful illumines the world," words inspired by a passage in Plato's *Phaedrus*. Biblical themes were designed for the two relief panels flanking the doorway. On the right, symbolizing music, from Job 38.7: "The morning stars sang together and all the sons of God shouted for joy." On the left, symbolizing art, from Psalm 19:1, "The Heavens declare the glory of God and the firmament sheweth his handiwork."

Goodhue shared his idea with Alexander for the Children's entrance on the east elevation, "You will note that here I rather let myself go, though whether with your or Mr. Lawrie's approval, I don't know. Over the entablature, is a globe, or rather half a globe, with a small child, presumably studying geography—or considering an adventure—and looking over at the other side is a Chinaman, though whether a benevolently inclined person or an ogre, I don't know."[26]

Alexander developed Goodhue's idea for a globe into *The World of Air, Land and Water* and adding Proteus and Galatea,

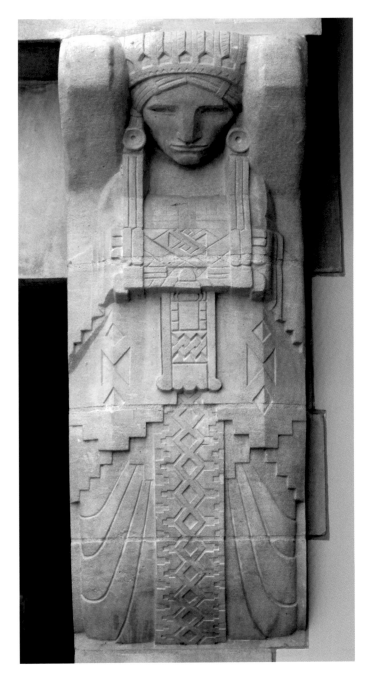

▶ *The doors that now serve as an entrance to the Mark Taper Auditorium once led to the Art and Music Rooms. Biblical themes were designed for the two relief panels flanking the doorway.*

▶▶ *On the left, symbolizing art, from Psalms 19:1: "The Heavens declare the glory of God and the firmament sheweth his handiwork." On the right, symbolizing music, from Job 38.7: "The Morning Stars sang together and all the Sons of God shouted for Joy."*

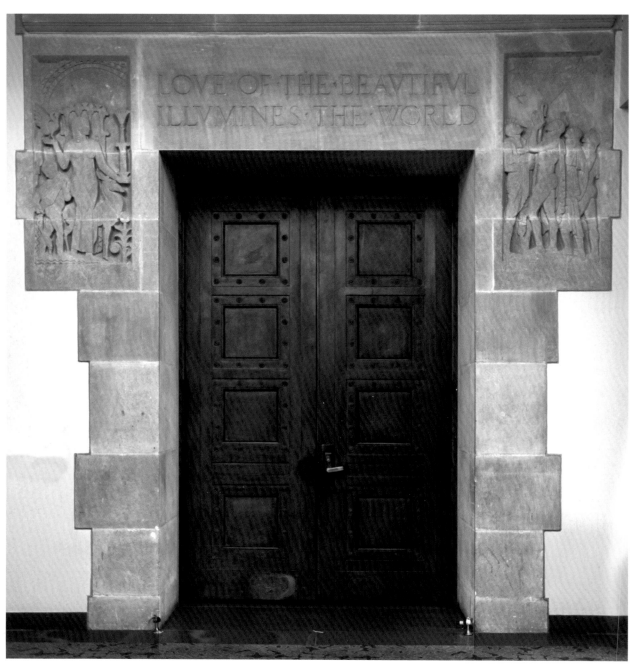

96

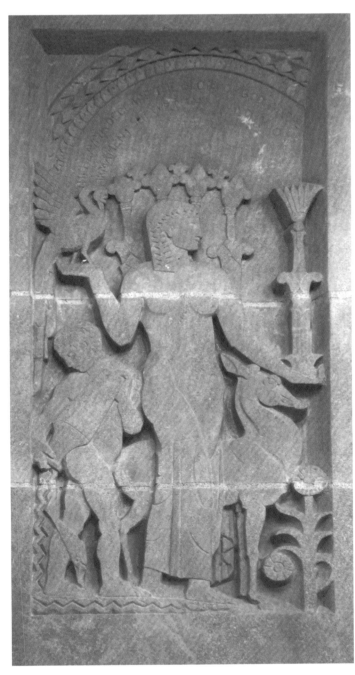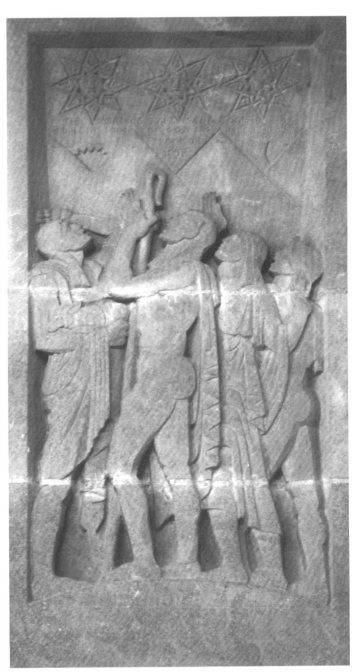

THE ICONOGRAPHER—HARTLEY BURR ALEXANDER

▶ *Owl detail from the Hope Street tunnel entrance.*

▶▶ *Lee Lawrie's model for the owl balconies.*

THE ICONOGRAPHER—HARTLEY BURR ALEXANDER

the God and Goddess of the Sea, riding the waves. Above the globe he imagined a bear beneath Polaris (the North Star) with a whale on one side and an octopus on the other. He added a Chinese frigate and an Atlantic clipper to represent the two great oceans. The sun rested in the horizon with a crescent moon above the waves.[27] In an early scheme, Alexander imagined Titania and Puck as carytides but later replaced them with the *Spirit of the East* and *the Spirit of the West*, with the words, "The world is my book," below the globe. Above the door, Alexander used the inscription, "Books are doors into fairyland: guides unto adventure; comrades in learning."

For the Children's Court, Goodhue explained to Alexander there would be two piers on each side of the court with "6 of them forming part of the wall and 2 free and clear with a cloister behind." The architect suggested, "In place of proper capitals to these piers I have shown sculptured panels with the idea that each might be filled with subjects from well-recognized children's stories, or possibly epic heroes."[28] Alexander developed the idea into a sequence based on popular children's books from "babyhood" to the "romantic age"[29] with scenes from *Tales from My Mother Goose, Alice's Adventures in Wonderland, Arabian Nights, The Merry Adventures of Robin Hood,* and from legends of King Arthur.

Alexander worked with Lawrie to create the panel carvings for the Siena marble fountain, which was installed in 1931. The fountain featured a lotus-shaped shaft rising from a square basin that depicted Blanche of Castille teaching her son, Louis IX, to read; Sainte-Chapelle built by Louis IX; King Alfred of England and his mother Osburh reading; an English castle; and the shields of Alfred and Osburh.[30]

According to Alexander himself, it was the Flower Street entrance which offered the "fullest symbolism"[31] of the image of light, a central theme for the Library. He responded to Goodhue's request for an inscription in the parapet of the central feature with a quote from Lucretius, "Et quasi cursors vitai lampada tradunt," from the passage:

> Races of men increase and races fade,
> And in brief space tribes fare their mortal way,
> Like runners passing on the lamp of life.[32]

The central panel, as Alexander explained in his thematic synopsis of the sculpture and inscriptions for Goodhue, is an "allusion to the equestrian race (as described in the introduction to Plato's *Republic*) in which the lighted torch is passed from hand to hand in a relay race."[33]

Alexander interpreted Goodhue's design of two figures in high relief with halos as Phosphor, the Star of the East, and Hesper, the Star of the West. Goodhue's draftsman calculated the scrolls the figures held should have inscriptions of "approximately eighty letters each."[34] For the scroll of Wisdom of the East, Alexander highlighted the founders of the five great eastern religions—Moses, Zoroaster, Buddha, Confucius and Mohammed. Next, he listed those famed for their wisdom; "Lao Tse for China, Hillel for the Jews, Avicenna for the Persian and Algazali for the Arabian Mohammedans, and Badarayana for the Indian metaphysicians."[35]

For the scroll of Wisdom of the West, he chose Greeks Herodotus, Socrates, and Aristotle, philosophers Virgil, St. Augustine, and St. Thomas Aquinas. The Italian poet Francesco Petrarca, is anglicized as Petrarch, followed by the "founders of the modern age," Frances Bacon, René Descartes and Immanuel Kant.

Off the Industries room, for the east Owl Window supported by owl-shaped brackets, Alexander selected, "*In Opera Gaudium,*" or "In work is Joy," and for the west owl-bracketed window off the Fiction room, "*In Libris Libertas,*" or "In books is liberty." Goodhue wrote, "At one time we had a dome, since abandoned, at each corner of which was a sort of lucifer, i.e. using the word in its exact sense as bearing a torch rather

than the manifestations of the fiend. Whether it would be well to have these figures hold lights or not is a question. It sounds rather 'tricky,' but I think how it would please Los Angeles!"[36]

The eight figures crowning the tower represent the Seers of Light, which Alexander envisioned in pairs. David, the Psalmist, who represents "Prophetic Vision," has the symbol of the tower, and John, the Disciple, "Apocalyptic Vision," has the eagle. Plato was chosen for "Philosophical Vision" and bears the dodecahedron representing the universe. Dante, selected for "Allegorical Vision," carries the keys to three worlds. Homer, representing "Epical Vision," has the lyre. Milton representing "Cosmic Vision" carries a small figure with the flaming sword. Shakespeare was chosen for "Humane Vision" and holds the tragic mask. Goethe selected for "Spiritual Vision" is depicted with the gates to paradise.[37] "These are the great Torch-bearers of Mankind," Alexander later wrote. "Their images are a fitting crown for a library which is a temple and custodian of their light."[38]

Alexander and Lawrie collaborated to conceive the subject matter for a bronze well at the beginning of a succession of pools leading to the Flower Street entrance. "I think I can get a good pattern with ten figures in low relief, around the front face of the well," Lawrie wrote. "I had wondered if we could use subjects as some of the minor deities—perhaps Boreas, Zephryus, Notus, and Eurus and a few Naiades, or may be the Nine Muses and Apollo."[39] Alexander responded with a concept for what would become the *Well of Scribes*, a celebration of the scribes of all nations recording the history of their homelands with Pegasus at the center.[40] On the right were the European scribes, the Greek, the Roman, the Hebrew, the Monastic Clerk followed by two American figures, the Aztec and a Native American. On the left, the Egyptian, the Chaldæan, the Phoenician, the Chinese, the Arab, and the

▶ *Lee Lawrie's Siena marble fountain.*

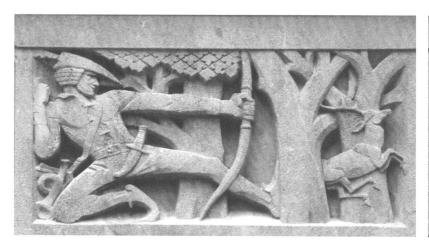
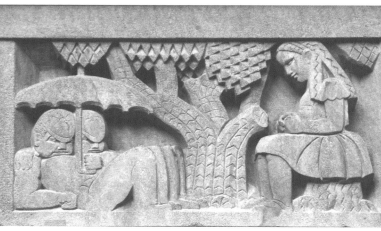
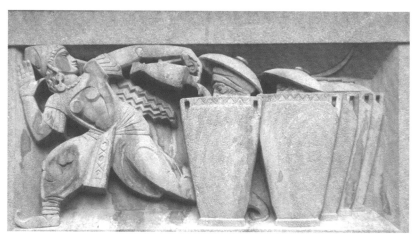

▲ *Alexander and Lee Lawrie collaborated to create the panels for the Children's Court that included scenes from classic children's works.*

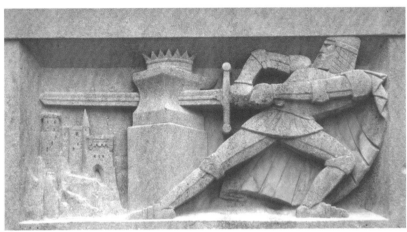
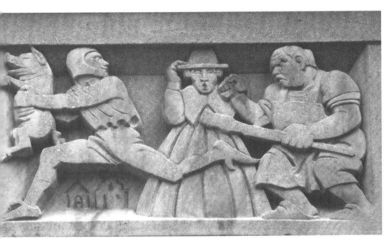
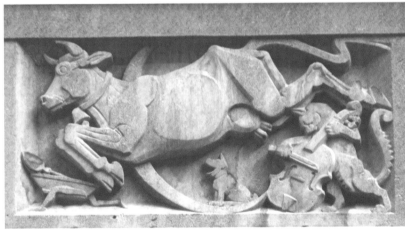

THE ICONOGRAPHER—HARTLEY BURR ALEXANDER

primitive man. Water arrived in the basin by way of a shell symbolizing the western sun sinking beneath the waves.[41] "If there had been more time for careful study we might have made a sort of Behistun Rock or Rosetta stone of this," Lawrie lamented.[42]

For the interior, Goodhue continued to look to Alexander for inspiration: ". . . entering from the north you go up a double flight of stairs, which turn into a wide single flight before you reach the main floor. On the landing, only a few steps below the main floor, is a big niche where I have suggested a sort of localized Pallas. Figure to yourself, however, the kind of Pallas she would be dripping with oranges and grapes, and things, and as unlike her Athenian prototype as could well be imagined. . . As terminations to the stair parapet, there are two bases on which I have proposed two sphinxes (or sphinges, whichever you like) precisely similar, with a little Angeleno wink in their otherwise Egyptian eyes."[43]

Alexander worked closely with Lawrie to develop what became the *Statue of Civilization*, symbolizing the progress of mankind, and the two sphinxes, symbolizing the mysteries of knowledge yet unattained.

Crafted in Italian marble and bronze, the *Statue of Civilization* carries in her left hand a torch tipped by a winged Pegasus, a symbol of enlightenment, that rests upon a turtle denoting dominion over earth and water. Her crown includes a miniature of the library, the bear and star of California and two angels representing the City of Los Angeles.

When completed, the body weighed 3400 pounds and the head 500 pounds. The panels of her copper draperies, also 500 pounds, carried the story of human civilization:

 Blank for the unknown ages of man

 Pyramids of Egypt

 Ship for Phoenicia

 Winged Bull for Babylonia and Tablets for Judea

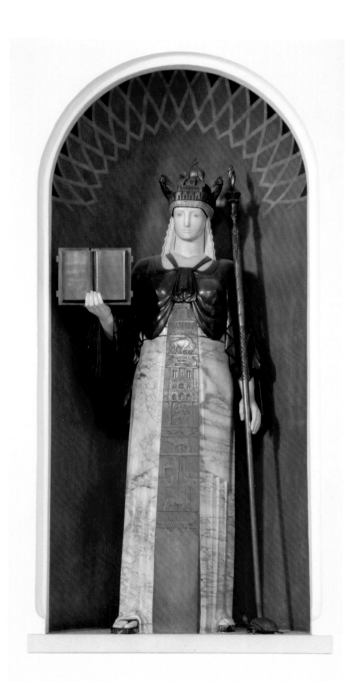

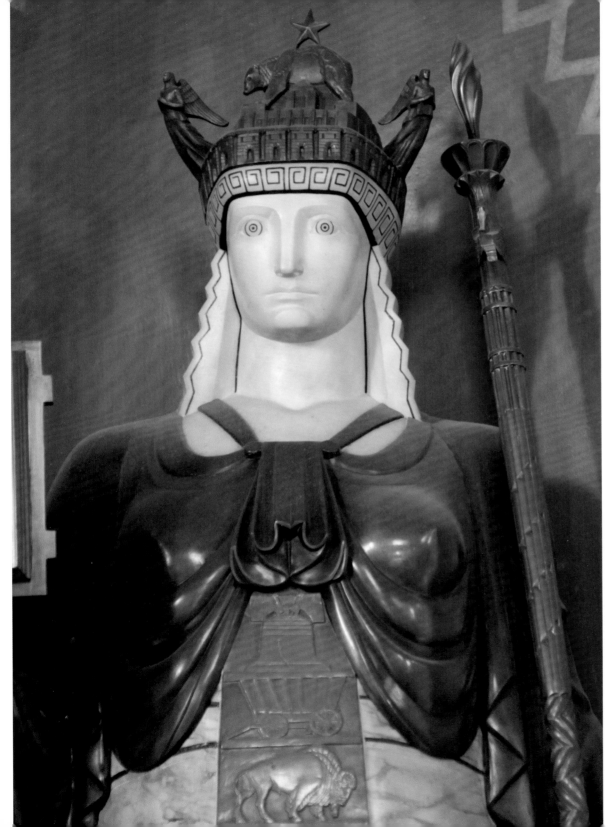

◀ *The* Statue of Civilization *symbolizing the progress of mankind. Her crown features a miniature of the Central Library.*

105

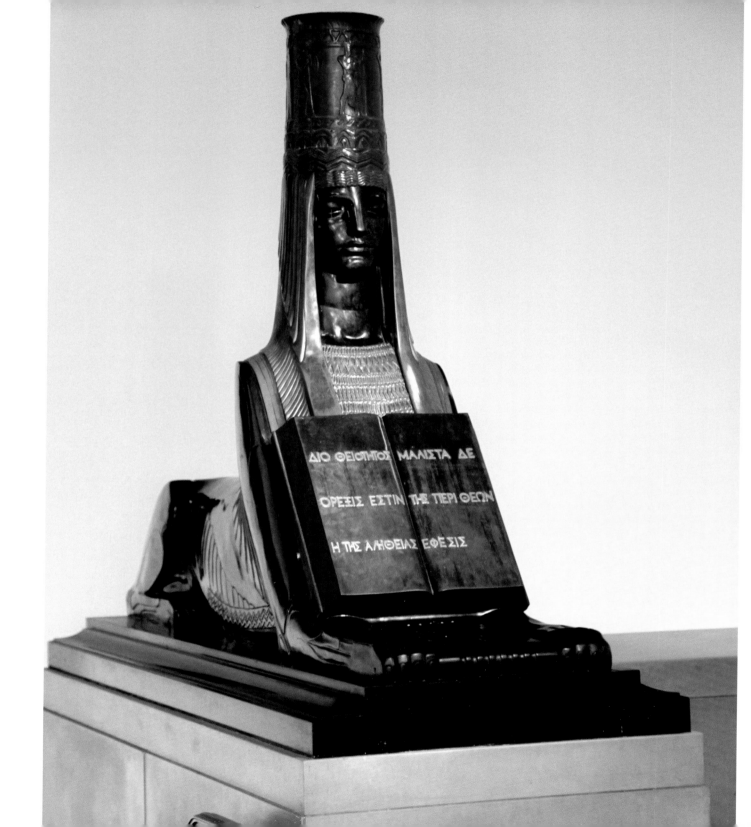

Lion Gate of Palace of Ninos and Parthenon for
 Minoan and Grecian civilizations
Wolf with Romulus and Remus for Rome
 Dragon for China
Siva for India
Notre Dame for Mediaeval Christian Europe
Plumed Serpent Head for Maya
Buffalo, Covered Wagon and Liberty Bell for
 United States of America.

In her hand she holds an open book inscribed with quotations in five languages.

"In the beginning was the word." (Greek)
"Knowledge extends horizons." (Latin)
"Nobility carries obligations." (French)
"Wisdom is the truth." (German)
"Beauty is truth—truth beauty." (English)

Both Alexander and Lawrie's work on the statue was frequently second-guessed by Librarian Perry. ". . . Perry questioned the I in A P X H I in the Greek line of *Civilization's* book," Lawrie wrote to Alexander in September of 1929. "I asked a friend of mine who is a Latin scholar and who knows a little about Greek, who consulted someone else and told me that the I is used in the classic Greek, and omitted in Hellenistic Greek in which the New Testament is written. I wrote this to Perry and he replied that he wanted the Greek that St. John wrote it in, and that when the author is quoted, he should be quoted absolutely."[44]

Sculpted from unveined black Belgian marble with a bronze headdress, the sphinxes each carry an open book, inscribed in Greek, from "On the Worship of Isis and Osiris" in Plutarch's *Moralia*. The left reads "I am all that was and is

and is to be and no man hath lifted up my veil" and the right "Therefore the desire and Truth, especially of that which concerns the gods, is itself a yearning after Divinity."

Alexander explained, "These are beautiful and significant words, and none could more securely intimate the great ends for which libraries are established, and learning cultivated by mankind."[45]

After viewing the completed *Sphinx*, Alexander declared to Lawrie, "Your *Sphinx* is wonderful—a new thrill for me. There is simply nothing to say about things like this—one must simply take off one's hat to it. And in black marble and brass . . . I wish Goodhue could have seen it. . . ."[46]

In his final correspondence with Alexander, Goodhue had insisted, "When I am in Los Angeles I am going to take up the subject with the Library Board of direct payment to you for, by all the gods, what you have done has got to be, and is going to be recognized."[47] In a letter to Carleton Winslow after Goodhue's death, Alexander wrote, "If the Board sees fit to pay the honorarium, I shall feel that it has been fully earned. In another case, I shall still have the satisfaction of having aided Mr. Goodhue to the realization of one of his great designs."[48] In the end, it took more than two years of negotiation before Alexander received his five-hundred-dollar fee.

In February of 1926, Winslow praised Alexander for his work, "The inscriptions as carved are beautifully done and most decorative. They are more than this—I feel they make the building a living and thinking thing. I hope that one of these days you will find your way to Los Angeles and see this building among other things that are being done here. The city is rather raw but promises so much."[49]

◀ *The two* Sphinxes *that guard the* Statue of Civilization *were sculpted from unveined black marble and feature a bronze headdress.*

▶ *Above the tunnel entrance, Lawrie created a tribute to the power of the printing press, featuring Gutenberg, Aldus, Elzevir, Caxton, William Morris, and Bertram Goodhue, divided by a wooden screw press.*

108

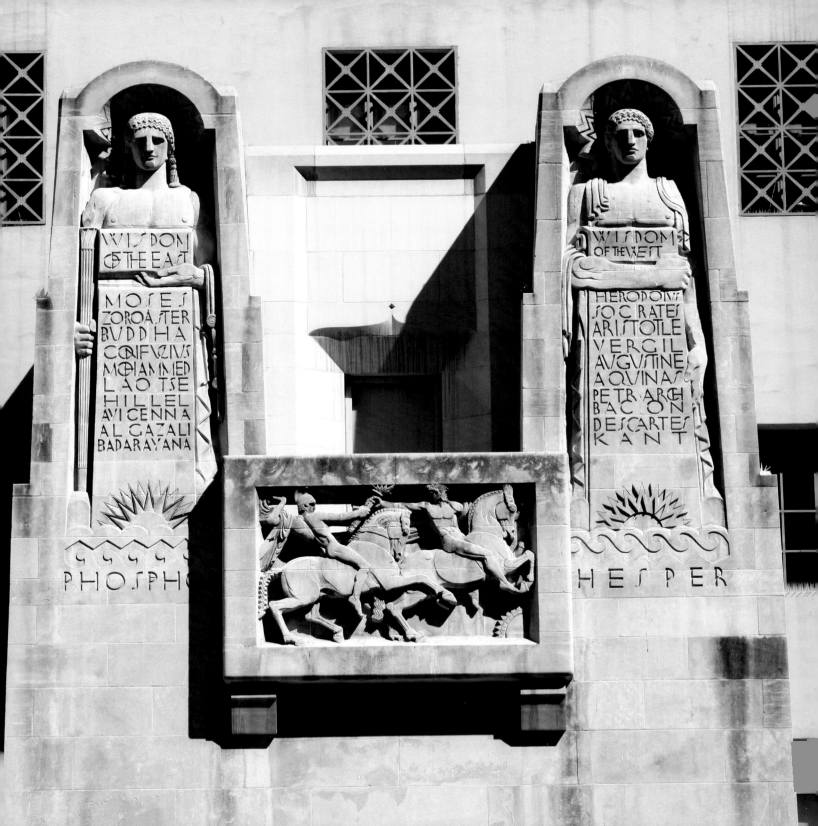

▶ *Goodhue's early plan for the north entrance, center, included two generic figures of historical significance flanking the Seal of the City of Los Angeles. Alexander was tasked with giving them meaning and designated the the* Philosopher *(left) and the* Poet *(right).*

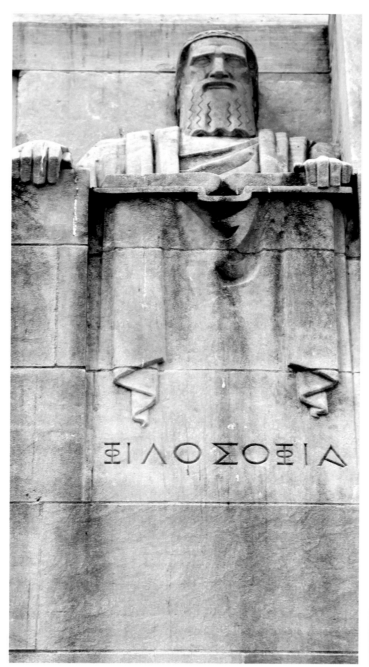

ΦΙΛΟΣΟΦΙΑ

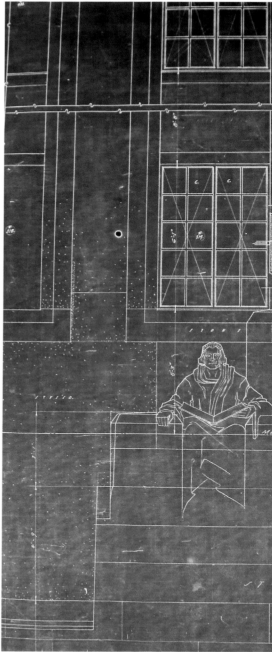

116

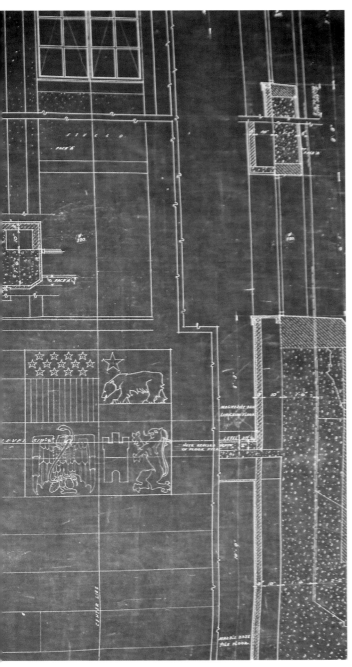

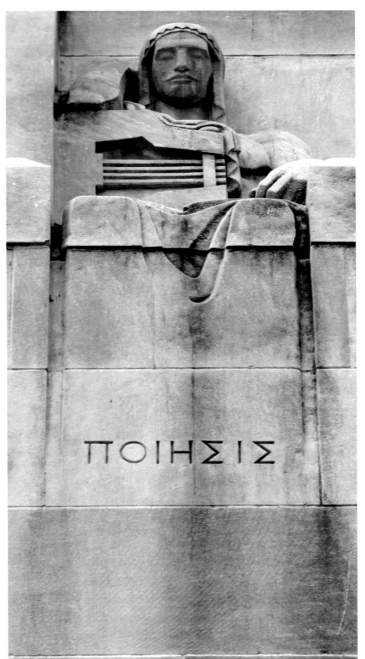

ΠΟΙΗΣΙΣ

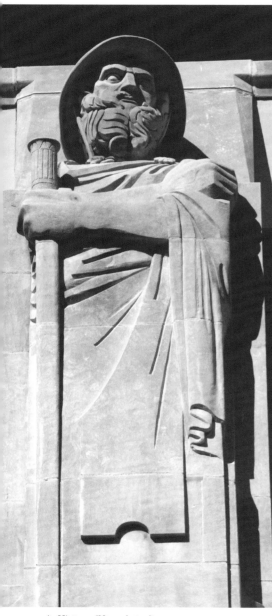

▲ *History* (Herodotus)

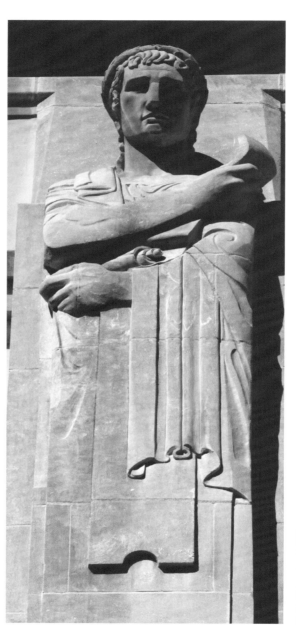

▲ *Letters* (Virgil)

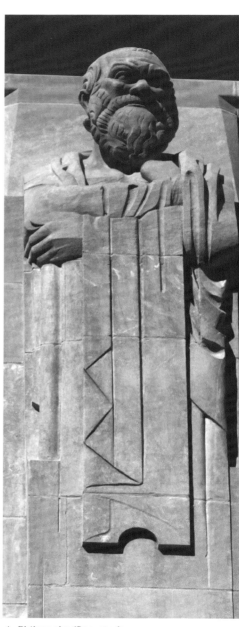

▲ *Philosophy* (Socrates)

118

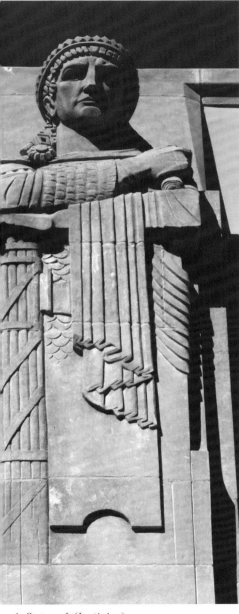
▲ *Statecraft* (Justinian)

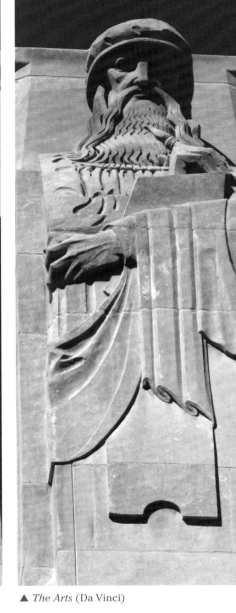
▲ *The Arts* (Da Vinci)

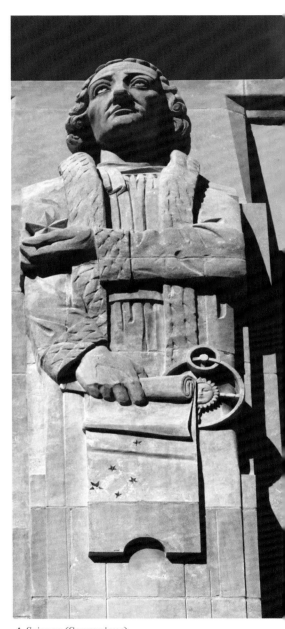
▲ *Science* (Copernicus)

the Southern California Chapter of the American Institute of Architects, "The building, as you may know, is finished and occupied; finished that is, all except some of the exterior carving and modeling. They come in orderly, though rather slow, intervals and when the Library Board seems impatient about it, I always insist that Mr. Lawrie be given all the time he needs for getting out his work."[28]

Lawrie concluded his work on the exterior on June 1, 1927. Moving forward, he would focus his attention on the interior, the *Statue of Civilization* and two sphinxes.

In September, the sculptor traveled to Los Angeles to inspect first hand the quality of Ardolino's work on the building's exterior. He spent many hours studying every angle, using binoculars to examine the finer details. "I have looked over the sculpture of the Los Angeles Central Library building and find that there are so many instances where the carving is unskillfully and carelessly done that I cannot give all the work my approval," he wrote to Winslow and the Goodhue Associates. "I do find the carving since May is better and a closer copy of my models. However, all of it is crude in the surface finish."[29]

Lawrie described in detail the "clumsy" carving of the eight figures on the tower and bemoaned the lack of symmetry in the figures of Justinian and Copernicus above the Hope Street entrance. He suggested the figures of Phosphor and Hesper above the West Entrance needed "complete recarving" and estimated the cost to Ardolino to complete his demands at $1500. Ardolino's contract was clear that if he failed to complete any figure to the satisfaction of the architects, the entire stone would be removed and new stone inserted at his expense.[30] By mid-December, Ardolino had completed the revisions, and Winslow wrote to the board, advising them Lawrie had given the work his final approval.

▶ *The original pyramid finial is displayed on the second floor.*

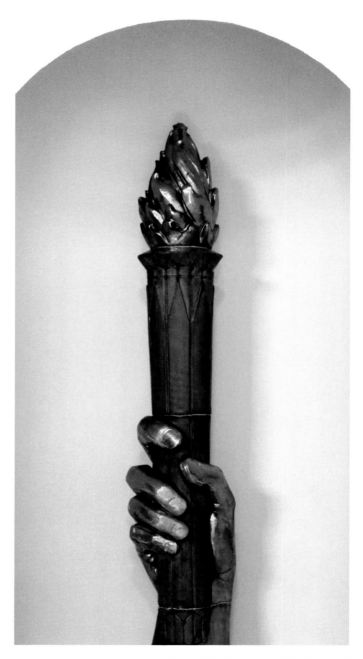

Critics marveled at how his remarkably simple line and plane kept perfect harmony with Goodhue's "plain finely proportioned walls." Yet Lawrie refused to take credit for the sculpture.[31] "It is difficult to part it from the architectural scheme. One might describe the building without the sculpture, but the sculpture cannot be conceived without the building."[32]

California Arts & Architecture raved, "Even a first view of the work of Lee Lawrie will cause the beholder to extend a vote of thanks to the Board of Library Commissioners and the Librarian who selected as architect of this municipal building one who not only had mastered the potentialities of simplicity and dignity inherent in modern concrete construction but who correlated his art with that of sculptor and painter."[33]

Lawrie's *Statue of Civilization* was delivered in nineteen pieces and assembled on site. When one of the two sphinxes that guards the statue was damaged during its journey from New York, Lawrie had to create an entirely new version. The loss delayed the completion of the commission and acceptance of his contract for several months. Creating the replacement statue was a frustrating process for Lawrie, whose work on the inscriptions was frequently second-guessed by both Winslow and Perry.

On June 19, 1930, Perry wrote to Lawrie:

> May I say that all of us are very enthusiastic, and think the *Statue* and the *Sphinxes* should be ranked among your finest work? It was, of course, a bit of bad fortune that one of the *Sphinxes* was broken, but Mr. Ardolino has indicated his willingness to replace it.
>
> I wish that I could write you that we are equally enthusiastic about the children's fountain, which doesn't seem to at all fit into the children's court and harmonize in color and other ways with its surroundings.[34]

While working away on the Library, Lawrie simultaneously

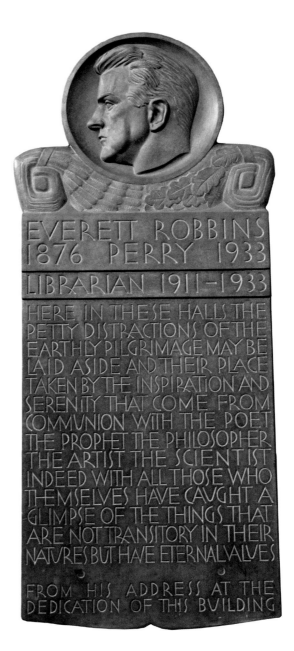

▲ *Lawrie created a marble tablet as a tribute to Librarian Everett Perry.*

toiled with tireless passion on another select project, the tomb of his beloved colleague, Goodhue, at the Church of the Intercession at 155th Street and Broadway in New York City. It was the first church Goodhue had designed on his own after resigning from the firm of Cram, Goodhue and Ferguson.

After Goodhue's death, Lawrie's plaster caster, Carl Greenhagen made casts of the architect's head and left hand, his drawing hand. The sculptor used them as a reference for the tomb that features a recumbent figure with Pegasus at his feet, a winged horse and a symbol of genius. Above an arch over the tomb, Lawrie carved the Latin inscription, "*Nihil Tetigit Quod Non Ornavit*"—"He touched nothing which he did not adorn." The architect's ashes were to be cemented into one of the stones of the memorial.

"Yesterday I finished the model for Goodhue's tomb," Lawrie wrote to Alexander on January 23, 1928. "So far as the design and thought go, I confess it is my very best. It is the only piece of work I have ever had that I could do with exactly

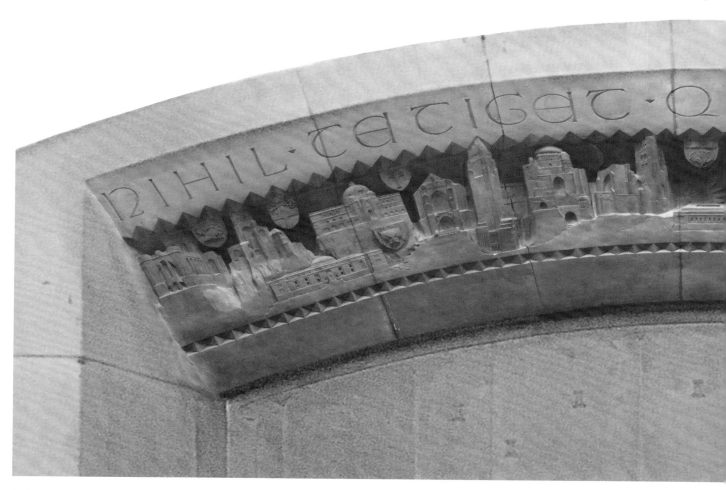

as I believed, but of course I constantly consulted what I felt would be Goodhue's idea."[35]

Nearly three years later, Lawrie's lengthy work on the library was completed in 1930. However, Lawrie would be asked to take on one final unexpected task. In 1933, several years following Goodhue's death, Librarian Everett R. Perry, with whom Lawrie had closely worked, succumbed to a year-long battle with heart disease. Lawrie was commissioned to create a profile relief in marble honoring Perry in the rotunda.

It includes a quotation from Perry's address at the historic dedication of the Los Angeles Central Library:

Here in these halls the petty distractions of the earthly pilgrimage may be laid aside and their place taken by the inspiration and serenity that come from communion with the poet, the prophet, the philosopher, the artist, the scientist; indeed with all those who themselves have caught a glimpse of the things that are not transitory in their natures but have eternal values.

◀ *Lee Lawrie imagined the arch above Goodhue's tomb to represent an architectural heaven featuring the architect's best-known work, including the Los Angeles Central Library.*

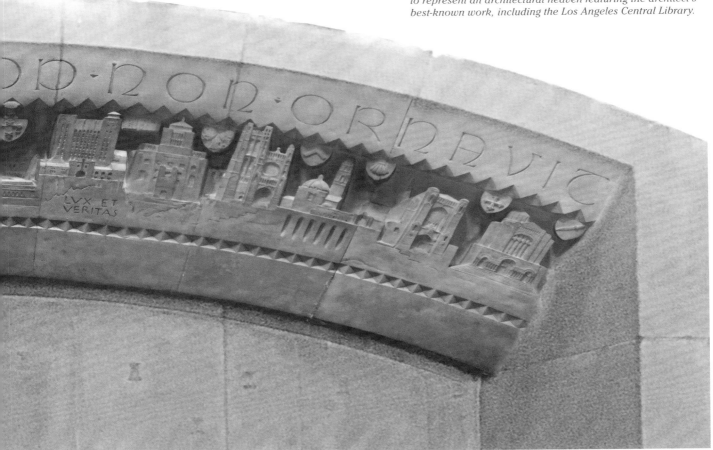

8 THE PAINTER—JULIAN ELLSWORTH GARNSEY

The painted decoration of the library is unique in that it is executed directly upon concrete ceilings. It is a solution of an entirely new problem in monumental architecture.

JULIAN ELLSWORTH GARNSEY[1]

The third member of Bertram Goodhue's designing triumvirate was the painter. Julian Ellsworth Garnsey was given the responsibility of decorating the Los Angeles Central Library's rotunda, its grand beamed ceilings, and the walls of the children's room in keeping with the architect's vision.

As with Goodhue, Garnsey's work on the Library reflected no single style. His tightly woven geometrical patterns were inspired by Byzantine, Renaissance, and Romanesque traditions. "The style of ornament will not be historically consistent, for the reason that the building itself cannot be placed in any historical style," he explained. "It has elements of many styles fused together in a harmonious new creation."[2] A distinguished painter born into a life of artistic pursuits, Garnsey had gained an impeccable reputation but would later be compelled to defend himself against rumors he had defrauded the Library by using inferior materials.

Garnsey officially joined the project in 1925 when by unanimous vote the Board of Library Commissioners agreed to award him a $46,750 contract with the full support of the Municipal Art Commission. He bested the competition from five other bidders as the board felt his sketches embraced Goodhue's "idea of harmony in architecture and decorative features." Carleton M. Winslow wrote to board members, "I feel that Mr. Garnsey is one of all the bidders who has taken carefully into account the question of light which is such an important one in your building. His interpretation of the sketches prepared by your architect is intelligent and sympathetic."[3]

▲▲▲

Garnsey was born in New York City on September 25, 1887, the son of muralist Elmer Garnsey and his wife Laurada (Davis). When he was fourteen, he worked with his father at the Minnesota State Capital by holding stencils for painters who years later would then work for him.[4] He studied architecture at Harvard University and graduated Phi Beta Kappa in 1909. Like his father, he studied at the Art Students League in New York City and would later serve as the organization's president.

He perfected his talents in Paris under Jean-Paul Laurens and Richard Miller before returning to America to assist his father on numerous commissions, including the decoration of the New York Customhouse, Minnesota State Capitol, and the Wisconsin State Capitol. However, his painting would have to take a back seat to grave world events developing overseas. During World War I, Garnsey served as a captain in the First Division of the American Expeditionary Force and was honored with the French *Croix de Guerre*.

After being discharged, Garnsey resumed his art career and settled in Los Angeles, where he decorated the Standard Oil Building, the Second Church of Christ, Scientist, the Fairfax High School Auditorium, the home of film star Mary Pickford, and more than twenty-five bank buildings. In 1921, he served as art director on two Hollywood movies, *The Idle Rich* and *A Trip to Paris*.

But his interest in decorating grand libraries was something that had been passed down from his father. The senior Garnsey spent years working on the Library of Congress, Boston Public Library, Columbia University Library, Middlebury

College, and Byerson Library of the Chicago Art Institute. Father and son worked together on the Richardson Memorial and the St. Louis Public Library. Julian Garnsey would go on to decorate the ceilings of Royce Hall and Powell Library at the University of California, Los Angeles, and the University of Southern California's Mudd Memorial Hall. His accomplishments would eventually land him in a major role in charge of the color design of the highly anticipated 1939–40 New York World's Fair. When asked about his vision for the Los Angeles Public Library, Garnsey explained:

> My theory of color decoration is briefly this: I believe that decoration must carry forward the conception of the architect already expressed in the design of the building. The goal of all engaged in creating a building is unity. The architect is the guiding mind, therefore the decorative painter's work must seem to be the architect's mind working through the painters. . .We have here a massive, simple structure, practically a concrete monolith, of honest, straight-forward design. The construction is entirely visible—the beams are seen doing their work. Since my decoration must be no less simple and straightforward, it is restricted to geometrical ornament, the forms of which are older than history, the combinations of which are infinite. The object of the ceiling decorations is to emphasize the construction, and to mark centers of interest by more elaborate design and color."[5]

Garnsey's designs were applied directly to the concrete ceilings by way of intricate stenciling. In the rotunda, he created his most elaborate visual, often carrying a megaphone to convey instructions to his employees working on scaffolding

◀ *Julian Ellsworth Garnsey.*

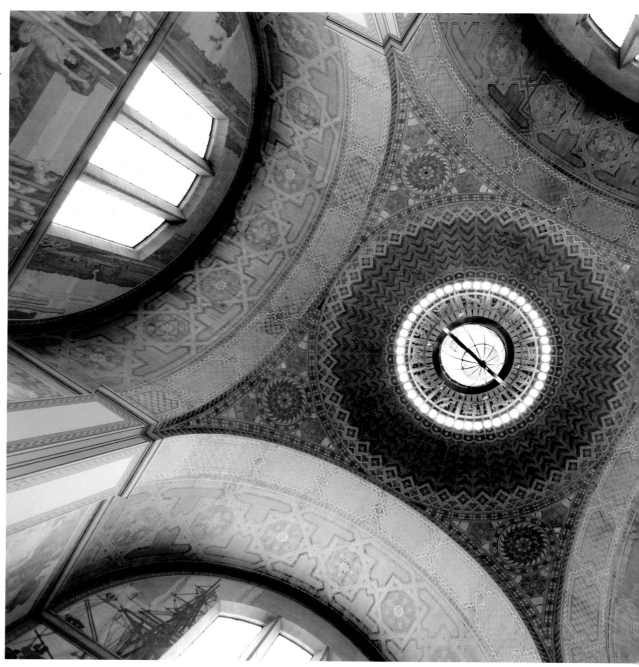

▶ *"A great honor has been paid me to assist in beautifying this civic building dedicated to the people of Los Angeles," Julian Garnsey said of being hired to decorate the ceiling of the rotunda.*

▶▶ *Garnsey's rendering.*

126

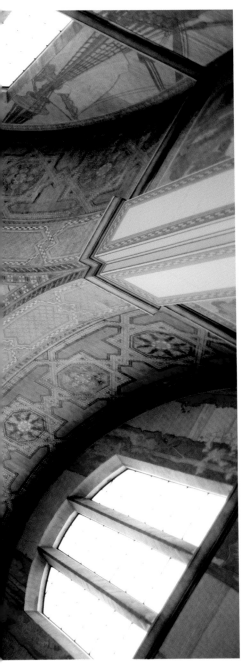

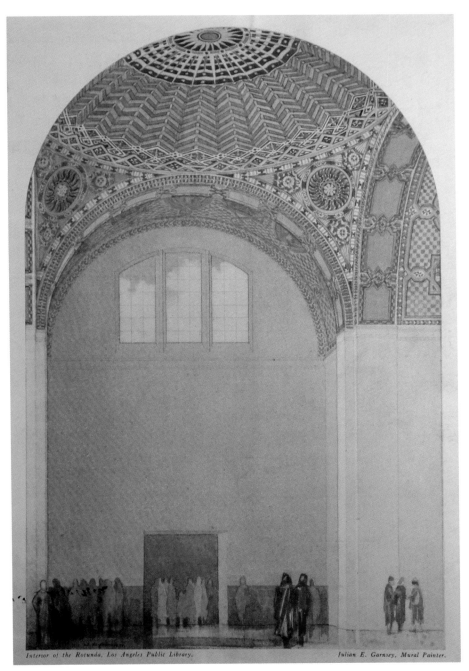

Interior of the Rotunda, Los Angeles Public Library.

Julian E. Garnsey, Mural Painter.

THE PAINTER—JULIAN ELLSWORTH GARNSEY

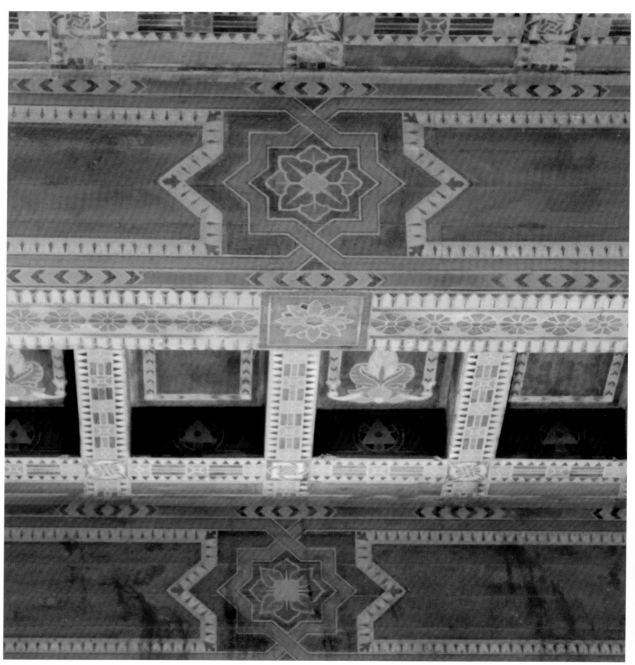

▶ *Detail, ceiling above north stair hall.*

▶▶ *Detail, ceiling of Children's Literature Department.*

128

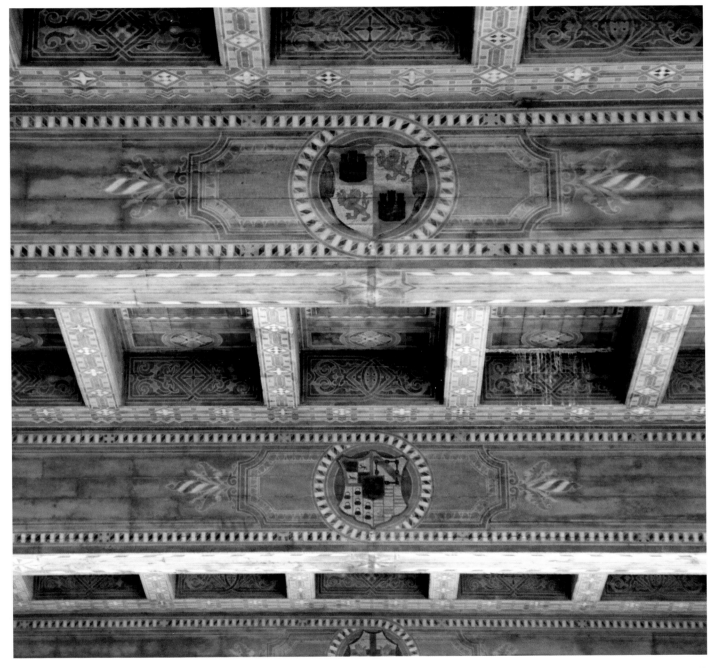

THE PAINTER—JULIAN ELLSWORTH GARNSEY

high above. "Its form is that of a Greek cross, roofed by a vault of pendentives which has twenty-four leaves or facets," he explained.[6]

Garnsey created a twenty-four pointed star from which brilliant silver and gold rays radiate connected by alternating yellow and blue bands, the blue embellished with gold stars. The design echoes the sunburst on the pyramid above. Below the rays, he painted what he described as "a field of gray-green and gray-violet recalling tiles laid in herringbone pattern" that extended in an "intricate interlaced border in color and gold" which "bind the vault together at the level of the supporting arches. The undersides of these arches and their adjoining barrel-vaults will be covered with interlacing bands and running patterns which will further accentuate their fine architectural effect."[7]

Garnsey painted the walls of the rotunda with Symentrex, a liquid concrete finish to smooth the surface. His decorative skills were also applied to the ceiling above the north stair hall, the Reference Room, and the four rooms surrounding the rotunda including Science, Fiction, General Literature, Sociology, and in the Children's Room. In addition, he decorated three vestibules and the Art, Music, and Teachers rooms in the east wing. "With few exceptions, only geometrical forms have been used in the ornament," he explained.[8]

In the Reference Room, Garnsey included in his design the shield of Antonio de Mendoza, the first governor of New Spain; the coat of arms Christopher Columbus adopted after his discoveries in 1502; the shield of Antonio Maria de Bucareli y Ursúa, viceroy of New Spain (1771–1779); the coat of arms of Hernán Cortés who claimed Mexico for Spain; the shield of Castile and Aragon; the shield of the Count of Monterey, and the shield of the Franciscan Order. The board rejected his

◀ *Garnsey applied his designs using intricate stenciling.*

idea to use the names of literary characters in his scheme for the decoration of the Sociology, Fiction, Science and Industry, and General Literature rooms and also his suggestion for an inscription around the dome of the rotunda.

For each room, Garnsey chose a dominant color scheme. "The North Stair Hall is in porphyry red and ultra-marine blue, the Reference Room in red, green and old gold, General Literature in Venetian red and old gold, Sociology in Delft blue and so on," he described.[9]

In the Children's Room, Garnsey decided to take a different approach than that of the more formal rooms. From his studio in the downtown Bryson Building, he wrote to architect Winslow:

> After thinking out the problem, and after consulting Miss Jones and Miss Livesey of the Children's Department, I have come to the conclusion that we should show, as far as we can, the various ideas that are Charity, etc. These ideas are brought together nowhere so well, we think, as in the story of *Ivanhoe*. The children who will use the room are mostly of an age to read that story, or to be led to read and appreciate it. And, finally, so far as I know, it has never been used before. (You will remember Abbey's *Holy Grail* series in the Boston Public Library). . .The rather difficult shapes of the rooms prevent my taking subjects from too widely removed sources, and demand some kind of thread running through the various subjects to tie them together. I feel that I have arrived at a wonderfully lucky solution, and want to be sure that you and the Board are of one mind before I go ahead.[10]

Garnsey's vision for Sir Walter Scott's story of *Ivanhoe* evolved into a series of figures executed in tones which harmonized with the elaborate ceiling decoration, which was painted to resemble old wood.

▶ *The murals in the Children's Room, now the International Languages Department, were executed by A.W. Parsons.*

132

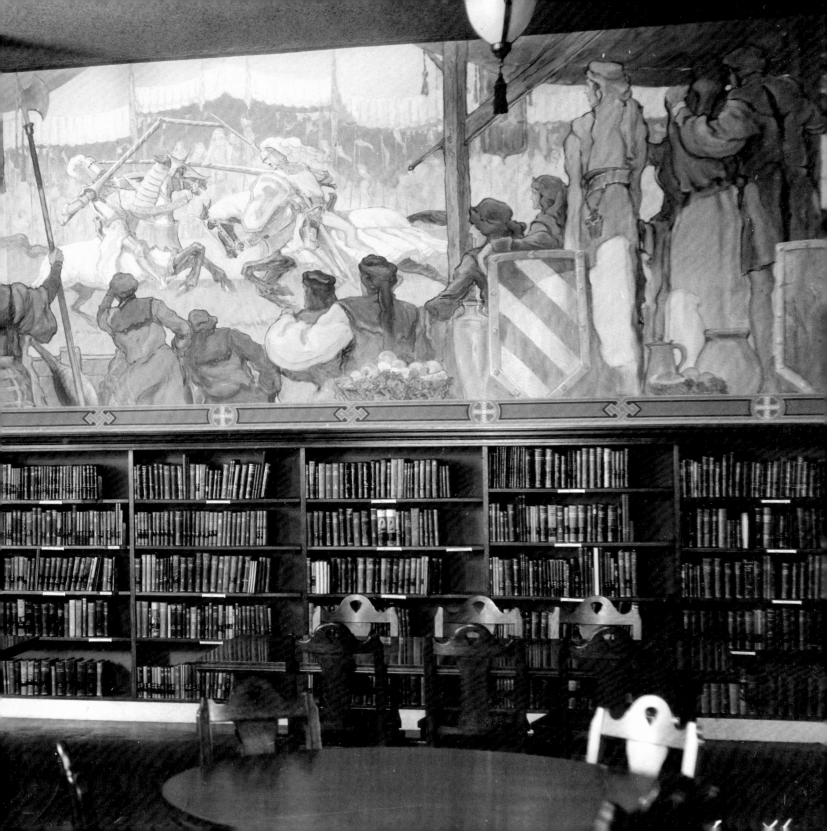

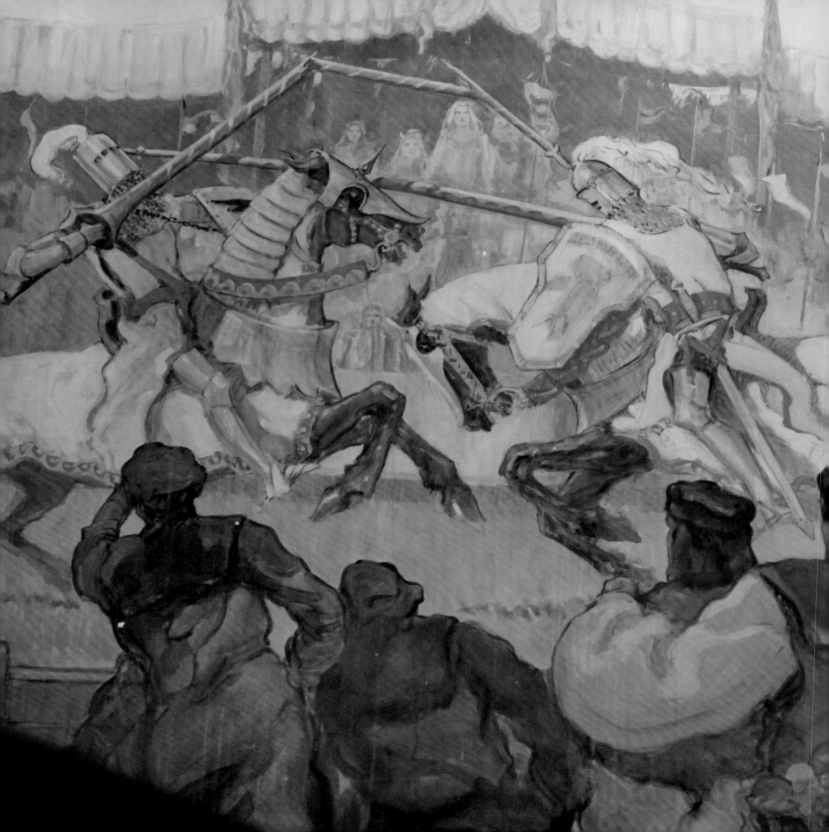

The *Ivanhoe* paintings featured detailed images of various scenes from the story, including:

Ivanhoe, in Disguise

The Tournament

The Archery Contest

The Capture of Rowena

Richard the Lionhearted in Friar Tuck's cell

Storming the Castle

The Rescue of Ivanhoe

Dividing the Spoil

The Trial of Rebecca for Witchcraft

The Wedding of Ivanhoe and Rowena

The large-scale work was executed by painter A.W. Parsons who was employed by Garnsey. When Parsons demanded recognition for his work, Garnsey graciously granted his request and submitted a signed agreement to the board acknowledging Parsons' contribution.[11] Critic Arthur Millier, writing in the *Los Angeles Times*, was particularly impressed. "They lend considerable richness to the room, which is—a paradise of romance for the young," he raved.[12]

The Children's Room was well received, and Garnsey's efforts in other rooms met with the board's approval, however his work in the Sociology department received less favorable reviews. In March of 1926, the Municipal Art Commission adopted a resolution that described the ceiling colors as being "indistinct;" the result they claimed "lacks something to be desired." Garnsey had, in the commission's opinion, "toned down the glazing too much."[13] According to the board minutes in June, architect Hardie Phillip from Goodhue Associates "expressed dissatisfaction with Mr. Garnsey's work on the ceilings of the vestibules and with the type of decoration in the Children's Room."[14]

◀ *The Tournament, detail.*

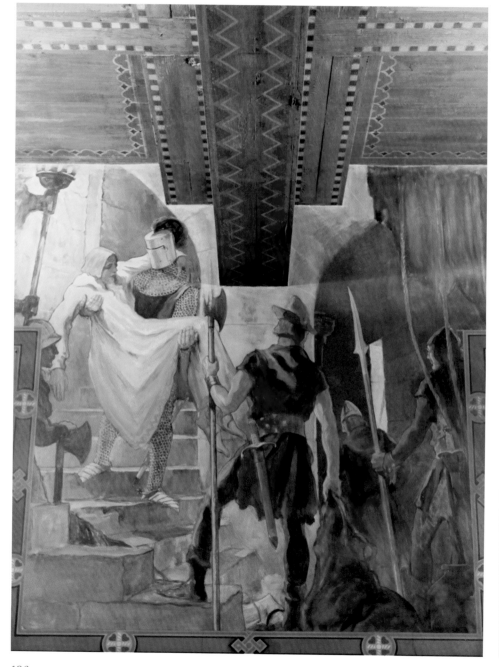

◀ The Archery Contest.

◀◀ Rescue of Ivanhoe.

THE PAINTER—JULIAN ELLSWORTH GARNSEY

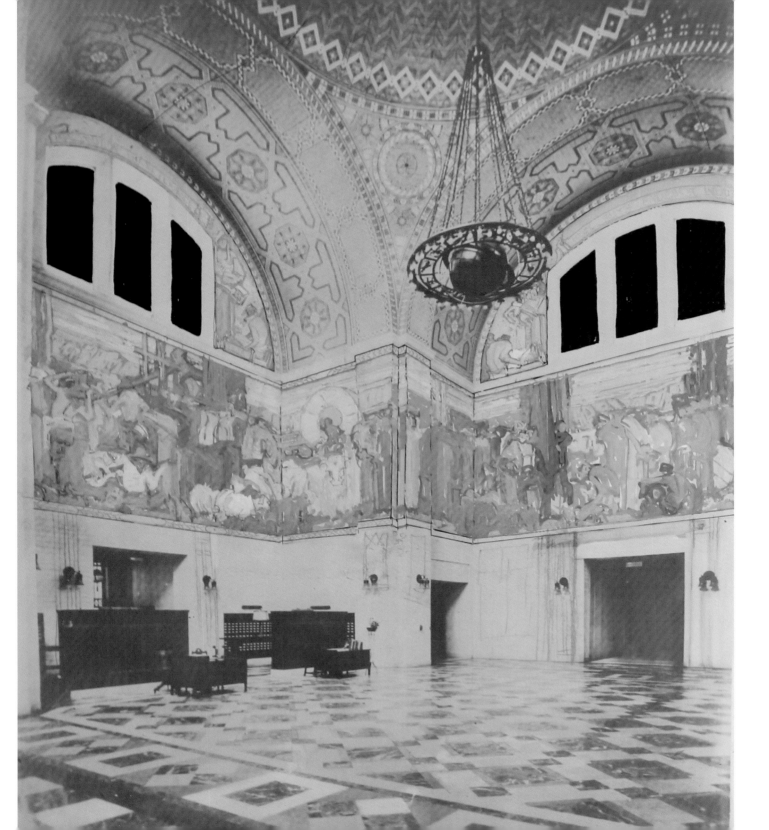

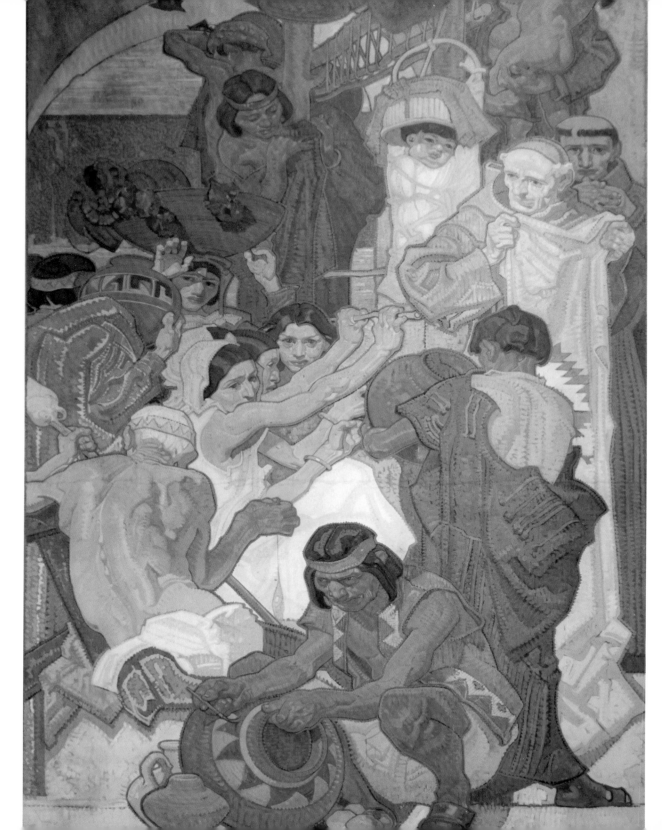

▶ *Art featuring pottery, rug-making and basketry.*

▶▶
Cornwell created the rotunda murals in London and completed them in Los Angeles.

144

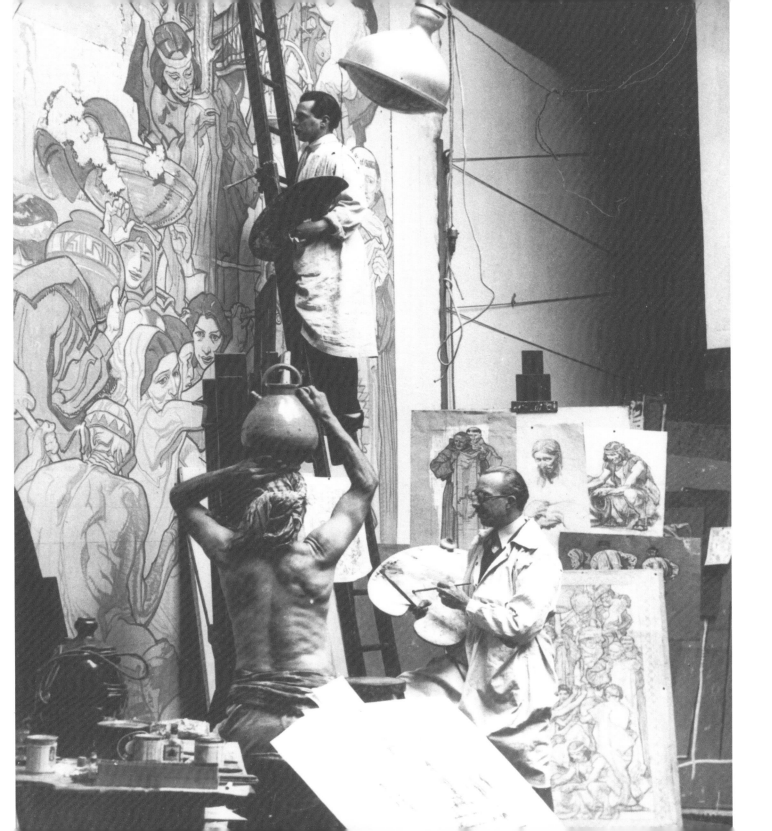

My position is a peculiar one, in that my tendencies as a decorative painter have of necessity all these years had to be held back, and hence in doing my 'job' well, have nothing to show in the kind of work I can probably do best.

Last year I broke away from the demands of my time, and executed for and from designs by Frank Brangwyn, four large panels to complete his great scheme in the Hall of Skinner's Co., London.

He was most apparently pleased as I am to return shortly now to be associated with him in doing what is probably the most important commission of modern times, the House of Lords.

I cannot help being keen as I am to have a chance at the Los Angeles Public Library. Mrs. Perry showed me photos of the building, and I have given it no little thought. The peculiar and untraditional problems the interior offers, a fine robustness that will hold its own with the daring mosaic ceiling and will express the great spirit of California and the splendid modernity of the architecture of the building, of vital importance.[8]

Had Bertram Goodhue still been alive, it is possible he would have persuaded the board to hire Eugene Savage to create the murals. The architect had previously included a proposal from Savage for the Reference Room along with his own design plans he had submitted to the board. In fact, a month before he died, Goodhue wrote to his collaborator Hartley Burr Alexander, "I don't know whether you know Savage's work or not, but it is the finest I think I have seen so far, produced by an American."[9] Goodhue later withdrew the scheme, but the board was aware of his admiration for Savage and encouraged him to submit a new proposal after the architect's death. He obliged but made it clear he could not begin work for at least three years, as he was busy work-ing on a series of allegorical murals for the Elks' Memorial Hall in Chicago.

The Special Committee on Mural Decorations for the Central Library Building agreed to draw up a short list of candidates after seeking advice from sculptor Lee Lawrie, John Nilsen Laurik (who was director of the San Francisco Museum of Art) and C. Powell Minnigerode (the secretary and director of the Corcoran Gallery of Art in Washington). On November 24, Librarian Perry sent a telegram to Lawrie asking for his opinion of Dean Cornwell. "Dean Cornwell's illustrations I have long admired as having a quality that is rare in story pictures and a poetic sense in the rendering of a fact. There is no doubt he is a most able artist. I should rather have him as a wall painter than Brangwyn, and yet I have not seen a wall by either," Lawrie replied.[10]

The committee was determined a successful scheme would incorporate and blend with Julian Garnsey's existing arch and ceiling decorations. An advertisement was placed in the *Daily Journal* and artists were given three months to submit designs before the competition closed on May 25. Nine entries were considered from artists Ray Boynton, Dean Cornwell, Maynard Dixon, Albert Herter, Norman Kennedy, Willy Pogany, Taber Sears, Augustus Vincent Tack, and A.W. Parsons.[11]

All of the artists embraced grand themes befitting of such a monumental project. Tack's scheme, inspired by Burr's iconography, depicted great figures in literary history. Albert Herter's idea for a scheme of decoration built around the idea of the story of the book was also shared by Kennedy. Boynton, Dixon, Pogany, Cornwell, and Parson all submitted schemes inspired by California history, while Sears chose four literary classics as the inspiration for his illustrations. After reviewing all nine entries, the committee narrowed its choice to two artists: Dean Cornwell or Taber Sears.

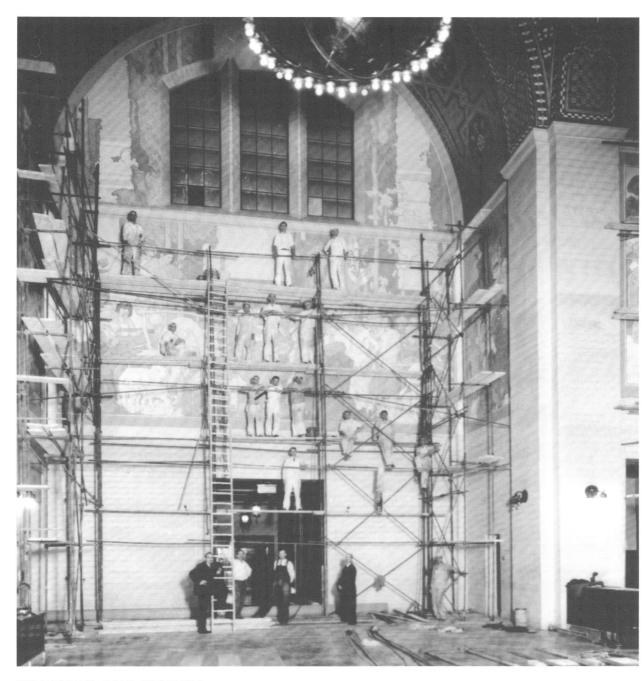

THE MURALIST—DEAN CORNWELL

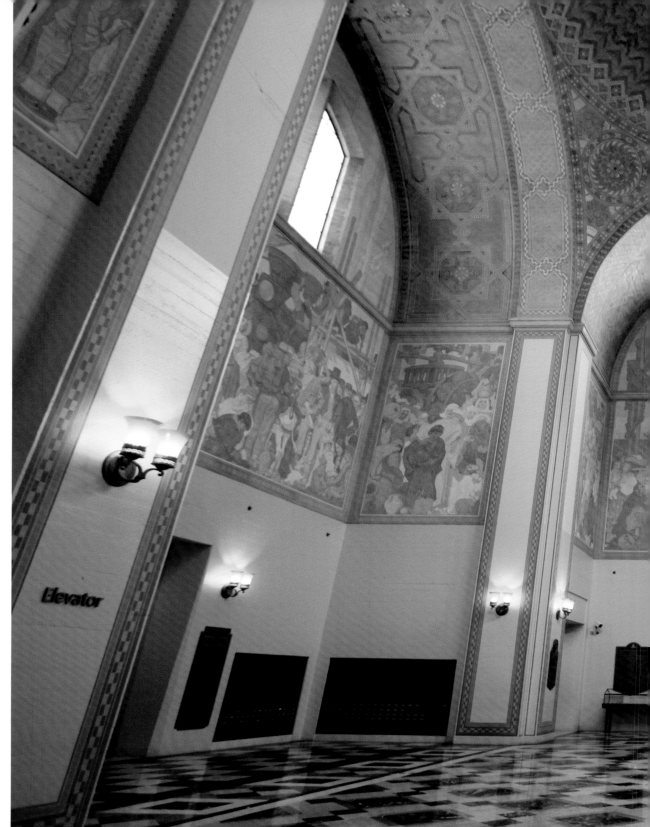

► *Cornwell restrained his use of color in the murals for the Central Library rotunda to harmonize with the mosaic-like ceiling painted by Julian Garnsey.*

148

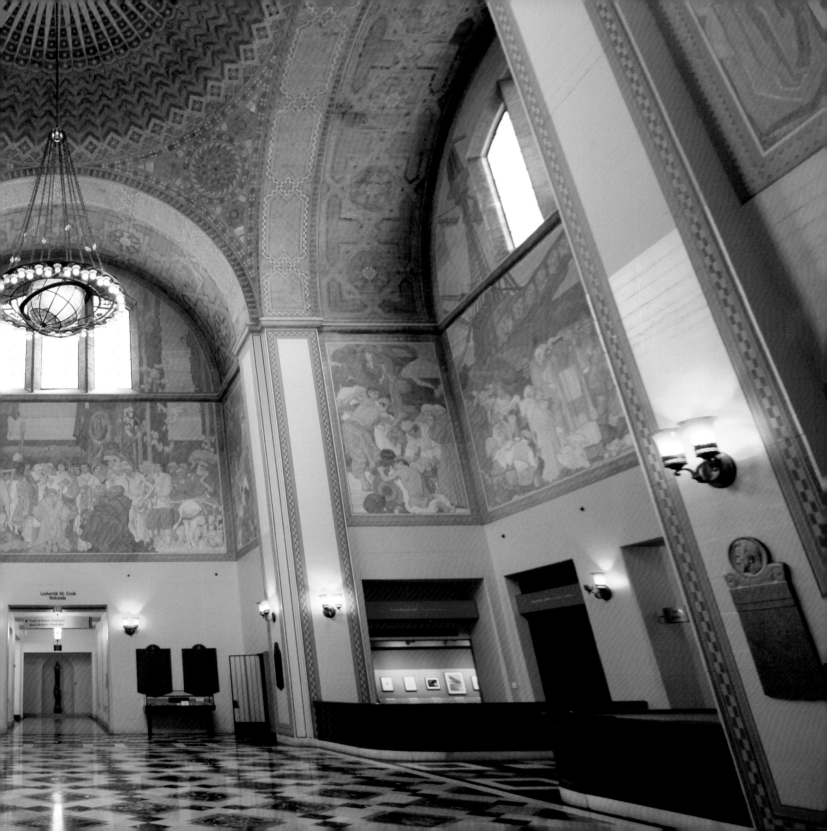

Sears ultimately lost due to "his misunderstanding of the existing color scheme" and the fact that his treatment represented "a series of paintings in decorative frames placed around the wall surfaces," an effect the committee believed could easily be achieved by purchasing "fine old paintings." Sears's bid of $95,000 was also considered expensive.[12] The board later informed Cornwell his preliminary sketches were, "incomparably superior to those of the other distinguished artists whose proposals were submitted for our consideration."[13]

On May 31, 1927, with the blessing of the Art Commission, the committee formally agreed to award Dean Cornwell a $50,000 contract to decorate the rotunda. The committee also awarded $10,500 to Albert Herter to decorate the first floor lobby and the tunnel leading up from Hope Street.[14] Committee President Monnette relayed the good news to Cornwell via telegram:

> Contract for decoration of Rotunda this day awarded to you, it being our understanding that your scheme of decorations contemplates canvassing entire walls including portions beneath murals extending to floor and treatment of such canvas in harmonious color. If this understanding is correct please confirm immediately by wire. If so, we will submit detail to City Attorney for formal contract.

Cornwell responded:

> Apropos extending canvas to floor, this to me would defeat chances for beauty of ensemble. However, could be done, but much prefer seeing certain areas retain concrete character, which was Goodhue's intention, simply treated with flat service paint of harmonious color. Same applies two entrance corridors. Refer to scenario for exact canvas sizes and wire approval or otherwise.

"In your Los Angeles Library I find the spirit of light and

▲ *Cornwell's model.*
▶ *Detail,* Americanization of California.

airiness emphasized throughout," Cornwell told the *Los Angeles Examiner*. "It expresses to me the free spirit of the West in more forceful manner than anything I have seen."[15]

Despite Cornwell's good news, at least one critic, Arthur Millier, did not support the board's selection. Millier wrote in the *Los Angeles Times*, "My personal reaction to the award is one of disappointment. After careful examination on three occasions, of the sketches by nine competitors, I was satisfied that the Cornwell scheme was particularly unsuitable and out of keeping with the spirit of the building."[16]

Determined to prove his critics wrong, Cornwell made hundreds of life studies. Unable to find a space big enough to work on the project in New York City, Cornwell accepted

Americanization of
California, *the arrival
of clipper ships,
covered wagons and
the locomotive.* ▶▶

▲ Earth, *the discovery of gold.*

Brangwyn's invitation to work in London with the help of his teacher's critiques. In a South Kensington studio previously used by American painter John Sargent to create murals for the Boston Public Library, Cornwell began working with seven-square-foot versions of his designs that were later photographed and projected onto large canvases allowing him to expand the images, at first with charcoal and then oil. An arduous process, it took eight men to get the large canvases in position for painting.[17]

"When I was given the commission I spent several months in Italy studying large-scale murals of the Renaissance, particularly those of Giotto and Gozzoli, and I came to see the larger the area to be decorated the less strong color could be used," he told the *Los Angeles Times.* "So in keeping with California light and the vast wall space of the Library I have evolved a color scheme on a very light scale which I believe will harmonize well with the ceiling decorations."[18]

Cornwell made several trips to New York to seek out models and undertook detailed research of historical dress and artifacts, costumes and historical artifacts. When he needed to make sketches of Spanish clerics, he visited a nearby church and persuaded members of the clergy to pose for him. His murals were intended to depict four great eras in California history, the establishment of art and industries and the conquering of the elements.

The four large panels measured 18' 6" by 36' 6" and the eight smaller panels 18'6" by 12 feet. Custom-made in Belgium, the fine canvases cost Cornwell five thousand dollars. On the north wall, Cornwell envisioned the *Discovery Era* with images of explorers such as Hernán Cortés, Francis Drake, and Vasco Núñez de Balboa. On the east wall, he planned the Mission Building Era, the establishment of the missions in conjunction with and the development of agriculture. The south wall represented the Americanization Era, with the arrival of clipper

▲▶ Fire, *represented by kiln-baked pottery, and Cornwell's sketch, right, of the young boy with fired-clay urn on his shoulder.*

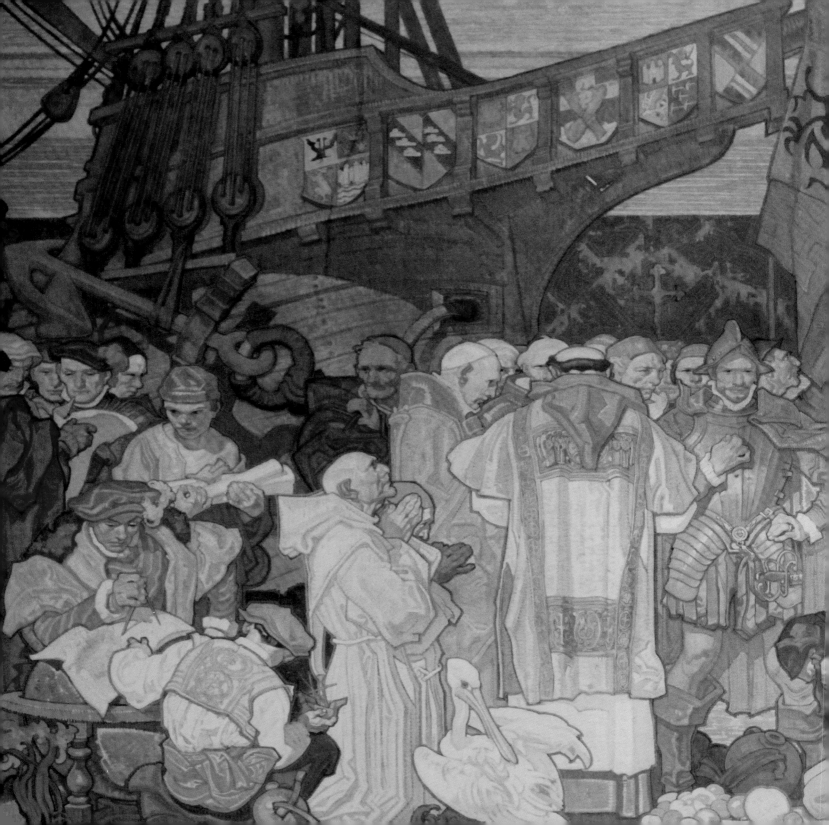

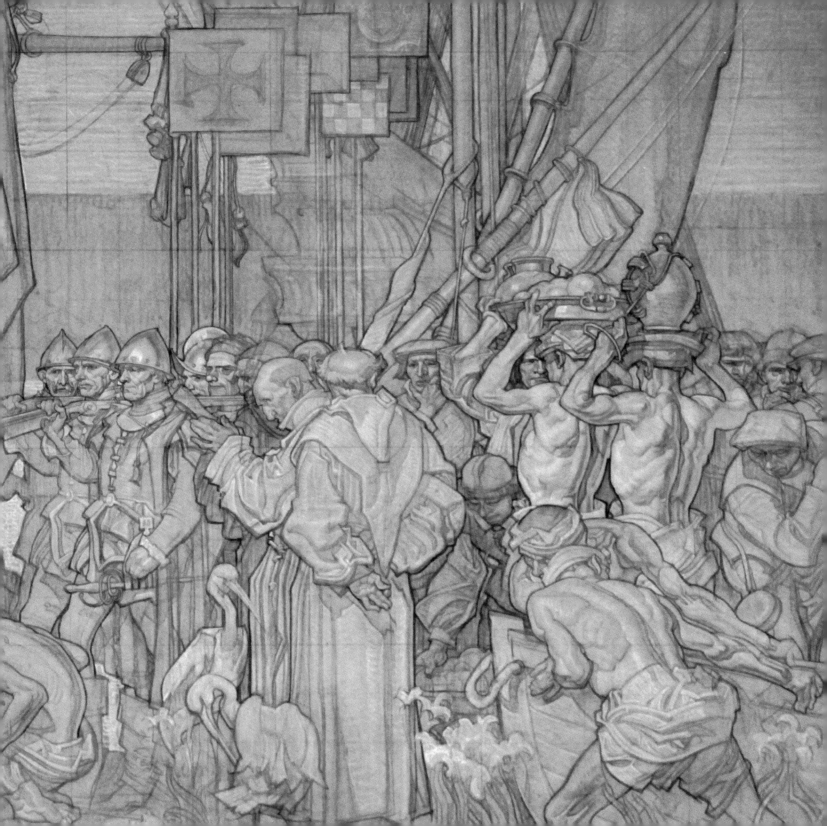

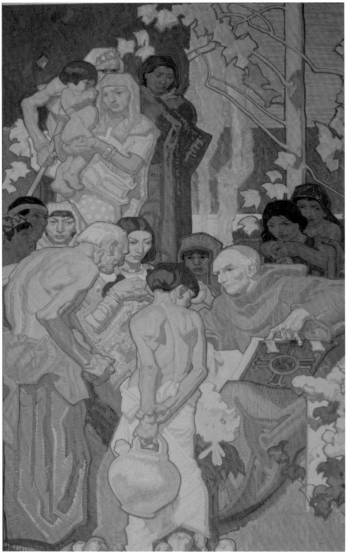

▲ Education, *padres teaching. Sketch, left.*

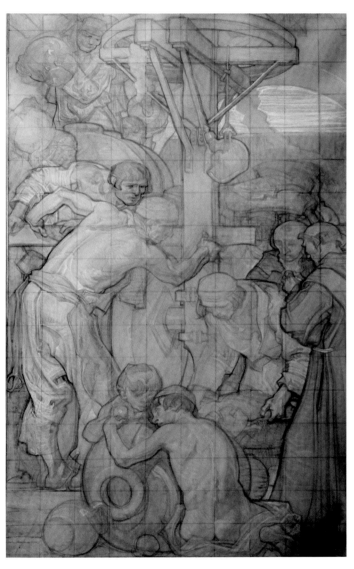
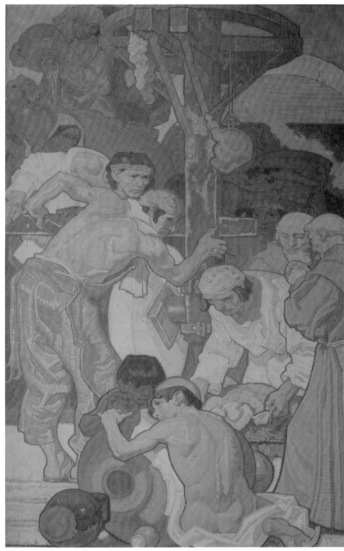

▲ Industry, *fruit presses. Sketch, left,
and Cornwell's completed mural panel.*

Mission Building Era, *the development
of land and expansion of the missions.* ▶▶

THE MURALIST—DEAN CORNWELL

159

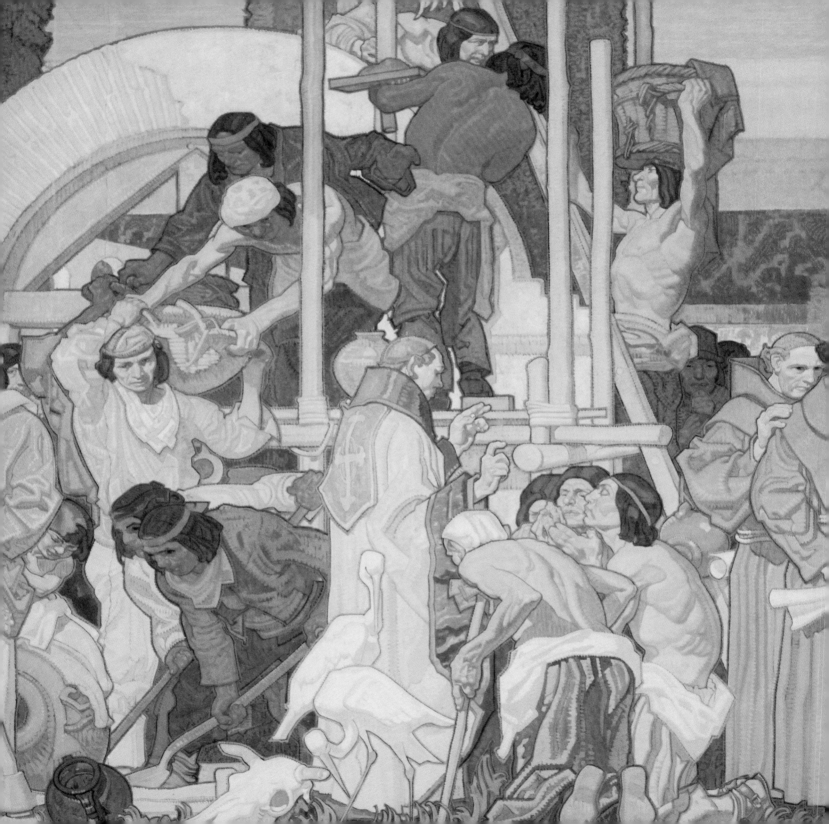

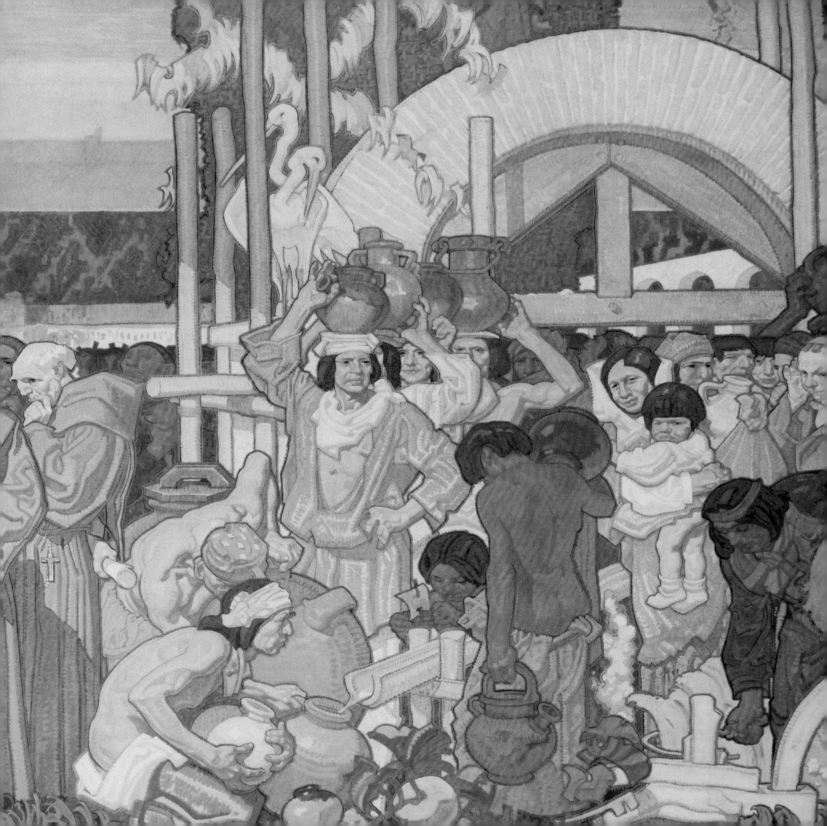

▲ Water, *an early water wheel.*

▲ Commerce, *a wagon trader.*

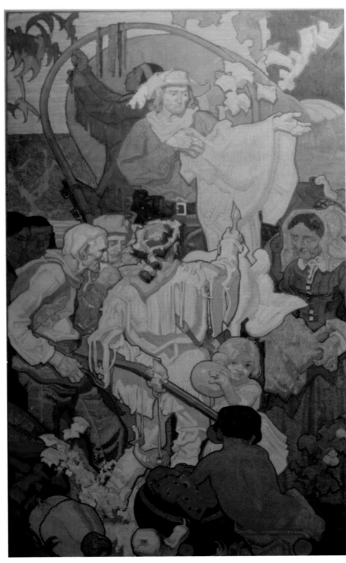

Founding of Los Angeles,
A proclamation is read by Don Felipe de Neve dedicating
El Pueblo de Nuestra Senora la Reyna de Los Angeles. ▶▶

THE MURALIST—DEAN CORNWELL

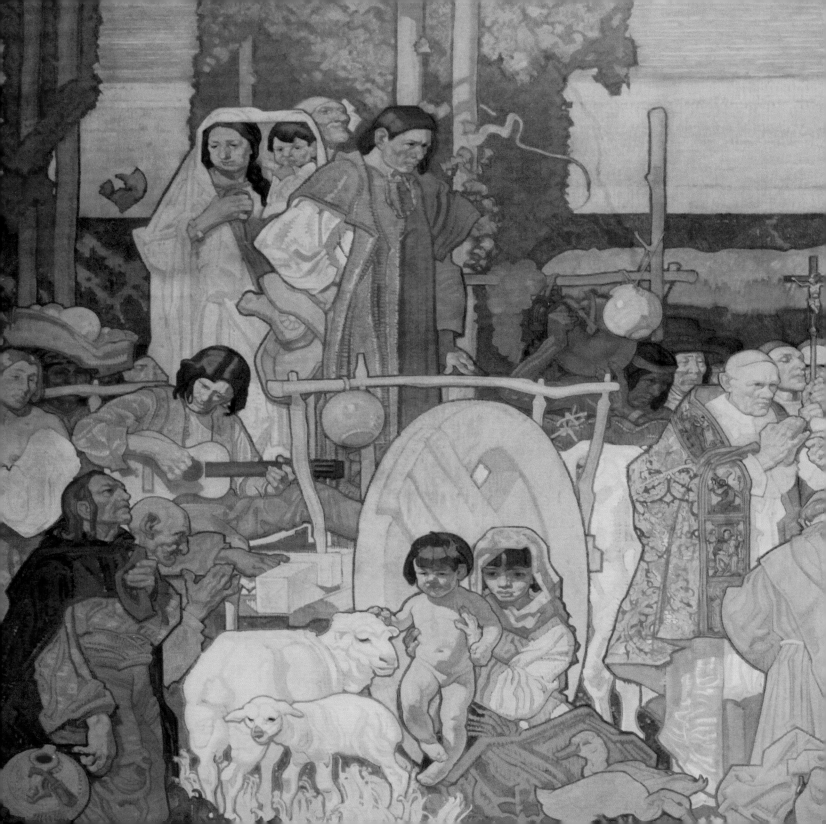

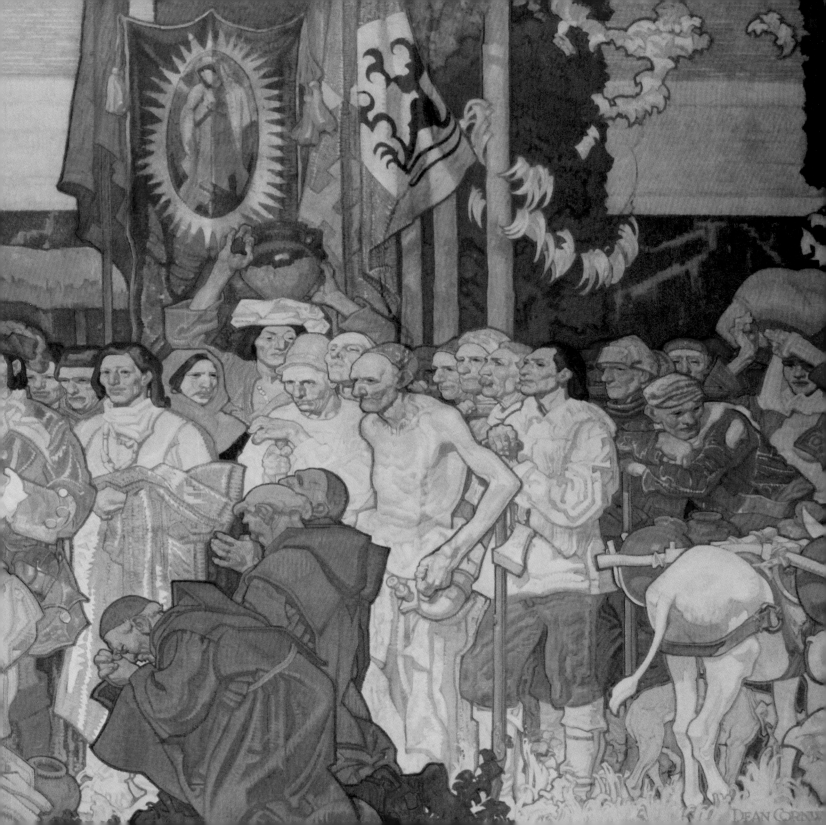

ships, covered wagons and locomotives. And finally, the west wall would depict the *Americanization Era, Founding of Los Angeles*, showing Don Felipe de Neve reading the proclamation dedicating the city to Spain.

The eight smaller panels were designed to symbolize local *Art* through basketry, pottery, and weaving; *Industry* with fruit presses; *Commerce* as covered wagon traders; *Education* with padres as teachers; *Earth* with men digging for gold; *Air* as productivity, and *Water* with a water wheel. *Fire* was represented with kiln-baked pottery. Cornwell decided not to include contemporary imagery, "The last century of 'movie' queens and hot-cha I leave to other more heroic hands," he explained.[19]

In July of 1929, Cornwell wrote to Perry,

> For the past two months while I have been making finished studies from life for the hundreds of figures that form our scheme, all the while revising, re-designing, and re-considering the theme and color scheme, constantly talking it over with Brangwyn over the weekends, my assistant has been covering again, every foot of the nine thousand-odd square feet I am to paint with the purest white lead obtainable, this being on the advice of all the leading chemists and artists' colormen. It is necessary for this to dry several months before starting painting. . .I'm sure no one could beforehand have visualized the colossal engineering that this job is proving to be, aside from the all important "art" side.[20]

Cornwell's rigorous schedule and devotion to the task began to take a toll on his health. "I've just gotten out of bed for two weeks with a bad attack of liver and generation exhaustion," he wrote to Perry. "Please let me recall to the Board that Sargent worked thirty years on his Boston Library and Abbey twelve years. . .However, this is only to show that I am trying to do a bigger and greater job with equal sincerity in much

less time. . ."[21] In the summer of 1929, Library Commissioner E.N. Martin paid a visit to Cornwell at his London studio and found that the artist "looked very tired," and he "thought best not to press him unduly."[22]

By 1930, Cornwell was granted an eighteen-month extension to complete his work, and the following year he returned to the United States. Once In Los Angeles, he rented studio space on Sunset Boulevard that previously had been used to produce large-scale scenery for Hollywood movies. "I could never have done it without that studio," he explained. "Providence ordained that it be built. It had no floor, and I just sat in a given place and had the canvas moved by a series of pulleys."[23]

Concerned by the amount of time Cornwell was taking to finish the project, in early 1932, Librarian Perry wrote to architect Carleton Winslow, imploring him to push the artist past the finish line. Winslow responded, "I have not however, followed the policy of urging Mr. Cornwell on but have let him take his own time believing that artists do their best work when their minds are free. From now on, however I will try, as diplomatically as possible, to keep the date for finishing the work before Mr. Cornwell, hoping that there will be no further disappointment."[24]

By August, eight of the twelve paintings had been mounted on the concrete walls using a composition of white lead and varnish. "They come fully up to expectations we had formed about them," the Board of Library Commissioners recorded in their annual report. "The complete effect of their beauty cannot be realized until the ceiling is toned down to a proper color subordination, and until the other four paintings are installed, which should take place in October."[25]

Dean Cornwell's mural paintings in the Los Angeles Public Library were completed in February 1933. The $50,000 contract he received had barely covered his expenses. "The money I received covered the cost the materials and transportation,"

166

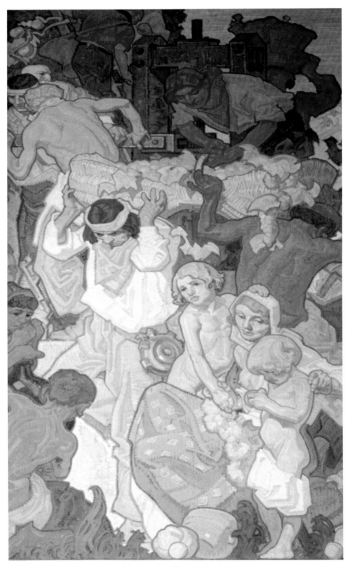

▲ Air, *productivity and sunshine.*

he explained, "and part of my expenses, but the labor had to be written off to personal satisfaction and a love of art."[26]

The board was delighted with Cornwell's work and praised his "consummate skill and fidelity and devotion to the highest ideals in art."[27] The reviews of his efforts were widely positive, despite the critical reaction of Thomas Craven who wrote in *American Mercury* of the "enlargements of coated-paper magazine illustrations with which Dean Cornwell is swiftly and inexorably ruining the interior of one of the few tolerable buildings in Los Angeles."[28] Arthur Millier, who originally did not support Cornwell's commission, was more complimentary, writing in the *New York Times* that the artist "has put all his knowledge of design and power of execution into making this pageant a beautiful one. The result is a series of murals such as few American public buildings can boast."[29]

For Cornwell, his ambition to leave a lasting legacy had been achieved. He later reflected, "I nearly lost my shirt doing it, but the satisfaction of those grand figures and the realization that thousands and thousands of people will see and enjoy them made up for it all."[30]

10

THE MURALIST—ALBERT HERTER

Los Angeles of all American cities, is perhaps most democratic. . .It is not surprising then to find the greatest public paintings which Los Angeles as yet possesses, placed in a tunnel entrance to her public Library where the lowliest street-sweeper seeking a book for his weekend reading may see the history of California and learn somewhat of the State he has chosen to live in as he parks his car and races up the tunnel to the check room.

ARTS & ARCHITECTURE[1]

Albert Herter knew first hand the high standards demanded of artists recruited to collaborate on buildings designed by Bertram Goodhue. A precocious talent, he had joined forces with the architect to create a series of murals for the National Academy of Sciences building in Washington D.C. Celebrated as California's "greatest artist"[2] by *Arts & Architecture*, Herter was a perfectionist who perpetually wrestled with when to put down his tools and wrap up work on a project. It was something the Board of Commissioners for the Los Angeles Public Library would come to know after the board hired him in May of 1927 to decorate the first floor lobby and create murals chronicling the state's history for the Hope Street tunnel. Despite his dedication to the job, he would be criticized for his lack of historical accuracy and subsequently face the upheaval of having to dismantle his completed work and resize it for a new location within the building.

Herter's friezes, mounted above the bookshelves in what is now the Children's Department and formerly the History Room, depict a romantic image of early California history from the Spanish era to the Gold Rush of 1849. In its entirety, the eight colorful scenes include *Landing of Juan Rodriquez Cabrillo, 1542*, depicting the Portuguese sailor who landed in Alta California in 1542 and claimed the land for Spain; *Building of a Mission*, a scene typical of the Spanish occupation of California; *Jose Gaspar de Portolá*, one of California's first governors who discovered San Francisco Bay from the land side;

Juan Bautista de Anza, leader of the 1775 expedition that established an overland route from Sonora to Monterey; *Fiesta at a Mission*, a typical scene from the *rancho* period; *American Flag Raised at Monterey*, Commodore John D. Sloat raising the flag July 8, 1849 at Monterey Bay; *Discovery of Gold, 1849*; and *Arrival of Relief Ship at San Diego 1770*, the ship *San Antonio* sailing into San Diego Bay, bringing relief to the Portolá-Serra expedition.

Albert Herter spent a career painting portraits of presidents and civic leaders, illustrating books and magazines and winning awards for his art in America and Europe. His gracious, colorful murals decorated the state capitols in Madison, Wisconsin, and Hartford, Connecticut, and California landmarks such as the St. Francis Hotel in San Francisco and the Warner Bros. Theater in Hollywood.

▲ ▲ ▲

Born in New York in 1871 to decorative artist Christian Herter and his wife Mary, Albert Herter received his earliest artistic instruction from his father, who had studied art in Stuttgart and in Paris at the École des Beaux-Arts. The senior Herter had arrived in New York from Germany in 1859. After working for the renowned Tiffany and Co., he joined forces with his brother Gustave to form Herter Bros., an interior design firm, which would grow to become one of the most

◄ Albert Herter

respected in the country. Decorating private homes, banks, churches, and office buildings, their clients included the likes of J.P. Morgan and railroad titans William H. Vanderbilt and Collis Porter Huntington. Although the firm worked in various historical styles, it became synonymous with the Anglo-Japanese style.

By age fourteen, Albert Herter was already exhibiting and selling his paintings. He would go on to study at the Art Students League in New York under James Carroll Beckwith, before moving to Paris to study at the Académie Julian under Jean-Paul Laurens and Fernand Cormon. In 1890, he won an honorable mention at the world famous Paris Salon exhibition and was elected to the Society of American Artists. He met his first wife in France, fellow artist Adele McGinnis, whose father was governor of New York. Adele, who had studied in Paris with Gustave-Claude-Etienne Courtois, often painted in pastels and was noted for her portraits. They married in 1893 and had three children, Everit Albert, Christian Archibald, and Lydia Adela. In 1898, the Herters returned to America, settling in East Hampton on Long Island.

In 1908, Albert and Adele founded Herter Looms, employing French weavers to produce Gothic style tapestries in a New York workshop. The following year, when Herter's widowed mother moved from New York to Santa Barbara, Albert and Adele decorated her enormous California El Mirasol mansion. When his mother died in 1913, Albert inherited her $1,000,000 estate and converted her home into a luxury hotel, expanding the property by adding garden cottages.

The Herters grew attached to Santa Barbara and were involved in numerous social endeavors, including a theater group in which Albert was a troupe member. Their seemingly

▲ The Landing of Cabrillo at Catalina Island.

170

charmed lives, however, were shattered by the death of their eldest son Everit, who was killed on June 13, 1918 during the World War I Battle of Belleau Wood in northern France. "Everything is splendid, and you don't have to worry, for this is the most splendid adventure I have ever embarked on," he wrote to his parents shortly before his death. Sergeant Herter did not live to meet his newborn son who was named in his honor.[3]

In memory of Everit, who had worked in New York as an architect before enlisting, Albert Herter presented a 40-by-16-foot mural depicting French soldiers leaving for war as a gift to the French people. In 1926, it was unveiled at the Gare de L'est train station in Paris by American Ambassador Marshall Joffre. At the ceremony, Herter was awarded the rosette of the Legion d'Honneur for his contribution. Everit's brother, Christian, who was rejected for military service for being underweight, was serving as secretary to Ambassador Gerard in Berlin when the United States entered the war. He would follow a path in politics and go on to serve as governor of Massachusetts and U.S. Secretary of State under Dwight D. Eisenhower.

Back home in Santa Barbara, Herter wrote to the Los Angeles Library Board asking to be considered to paint the murals in the Los Angeles Public Library rotunda. In a letter dated January 6, 1927, he proposed a general theme for the decorations of "the history of the cultural influence of the written word."[4] The board overlooked Herter's suggestion, which he would later adapt for the Santa Barbara Public Library and requested ultimately that he focus on the history of California for the Hope Street tunnel.

"Of course the board has taken into consideration the fact that Mr. Cornwell and myself will both be covering more or less the same field of subject matter in proposing California history for both the Rotunda in Mr. Cornwell's case and the Tunnel in mine," Herter wrote to the Library Board, "but if by any chance they should prefer to have me to do something different, I should be very glad to use any other subject matter they might suggest or so modify my scheme as not to repeat in any way what Mr. Cornwell may do."[5]

Herter created his murals for the Library in his Santa Barbara studio from where its sweeping view of the dramatic Pacific Coast served as inspiration to the artist. He recruited members of old aristocratic Spanish families and an ancient order of monks to pose for him, although his attention to detail caused him to fall behind on the project. "The unforeseen reference work and documentary research necessary to the subject matter in connection with California history and a temporarily disabling accident to my knee last summer have delayed my work," he wrote to Everett R. Perry in December of 1927, requesting a three-month extension to his approaching December 22 deadline.[6]

On March 21, 1928, the day before the tunnel entrance was due to open, Herter wrote to Perry requesting he be allowed to work on his murals on Sundays and other times when the Library was closed.

> It is traditional that no artist knows when he has done all that he must to his canvas and should always have someone pull him away from it at the perfect moment before he spoils it, but I know without being told that of my ninety figures in these decorations all have not been carried to the same degree of technical finish and that there are many spots I should like the privilege of studying in greater detail and not under the pressure of a date.[7]

He continued, "Through my own lack of judgment I failed to ask for sufficient time to properly execute to my own satisfaction so many figures, (270 days for ninety figures is an average of three days on each figure, not to mention landscape,

▶ *Detail,* Raising the Flag at Monterey.

THE MURALIST—ALBERT HERTER

▶ *Detail,*
The Building
of a Mission.

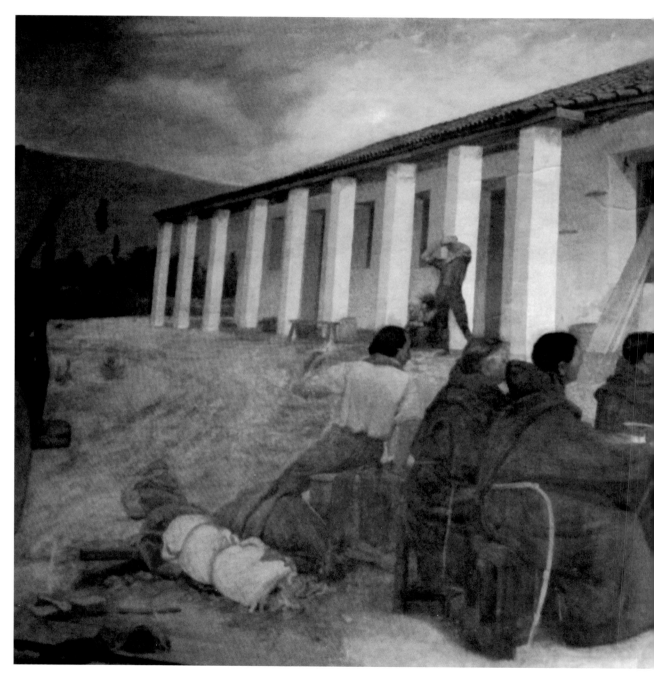

174

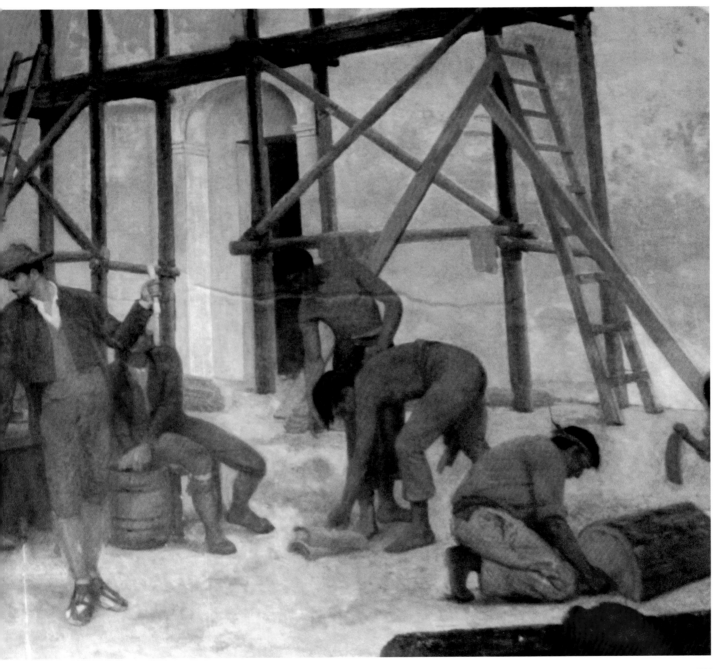

THE MURALIST—ALBERT HERTER

▶ *Detail,*
Fiesta at a Mission.

176

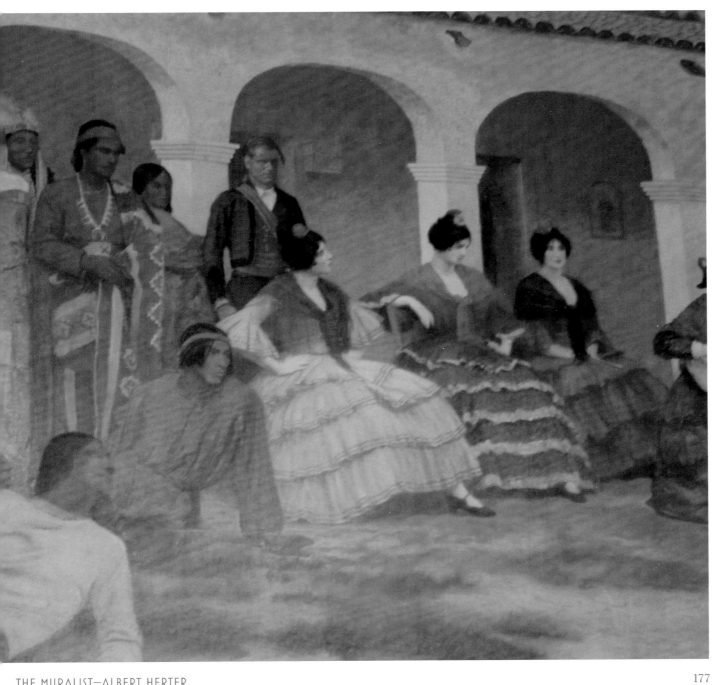

THE MURALIST—ALBERT HERTER

▶ *Detail,*
Fiesta at a Mission.

▲ *Herter's subject Jose Gaspar de Portolá led the Portolá-Serra expedition.*

boats, architecture, etc.) and I want to make good both for the credit of the Library and for my own professional integrity, if it can be done without trouble to anyone but myself."[8]

Herter was also concerned about the historical accuracy of his work and revealed to the board he had "brought Indians to the Fiesta, who should not properly be there."[9] When a critic later pointed out that the Indians did not appear local, being clothed in native dress representative of the Great Plains, he retorted they were "merely visiting".[10] Another critic complained, "a keg in one of the pictures was of the same construction as a nail keg in use at the present day, and that this particular type of keg was not in existence at the period of time depicted in the murals."[11]

Nevertheless, Herter's overall work gracing the Hope Street tunnel and the intricate Venetian red, gold and turquoise Grecian, Cretan, and Moroccan patterns he painted on the domed ceiling of the lobby did receive rave reviews. "Mr. Herter has acquitted himself like the thorough craftsman he is," Arthur Millier wrote in the *Los Angeles Times*. "After one has disposed of the doubt whether this passage is a proper place for mural pictures he cannot fail to enjoy the works themselves. The simple harmonious palette, the noble beauty of the types selected by the painter, the care with which they have been painted, and the simplicity of the composition leave little to be desired."[12] M. Urmy Seares, writing in *Arts & Architecture* observed, "Interesting masses of flat but tender color, refinement of line and skill in delineation unequalled on two continents are a few of the qualities we have for our inspiration and refreshment in these wall paintings given so generously to the whole municipal district by Mr. Herter."[13]

In two years time, water seepage and poor tunnel lighting led to Herter being commissioned again, this time to oversee the relocation of his work to what was then the History Room. He wrote to Perry, "Needless to say I should be very happy

▲ Herter painted Juan Bautista de Anza, who discovered San Francisco Bay in 1776.

to see the work already done viewed under more happy conditions, as for the sake of my own reputation I should like to appear at my best!"[14]

Herter was forced to actually cut up some of his work to fit the new space. "We have together calculated the new disposition of the canvasses in the History Room and have been rather staggered by the complications," he wrote to Perry. "On the two long canvasses the rise, as you will easily see, is greater than on the shorter panels and will necessitate a standard height of about thirteen feet, which means adding more canvas to the short panels than seemed necessary at first. . . I am sorry to have to prepare you to realize that it cannot be very cheap."[15]

The board agreed to pay Herter $5,450[16] to move his work from the tunnel. With the help of his assistant, David Imboden, he removed his six original murals to find that four were suffering from mildew and another the beginnings of peeling paint.[17] In order to create a continuous frieze, Herter added two new works, *Jose Gaspar de Portolá* and *Juan Bautista de Anza* to the historical sequence. Of his original paintings, *The Relief Ship at San Diego* was most affected by the move since Herter had no choice but to cut his image into multiple sections in order to fit arou nd the windows on the south side of the room. "A figure added here, a few rocks or a tree there and not a seam visible," the *Los Angeles Times* reported.[18]

11 AN UNCERTAIN FUTURE—WHAT TO DO WITH THE LIBRARY

When the fire took place, the community poured out in droves to help us and to rebuild the Library. It became absolutely evident this was a crucial part of Los Angeles.

BETTY GAY TEOMAN, CENTRAL LIBRARY DIRECTOR[1]

Like the history of the city in which it was conceived, the saga of the Los Angeles Central Library is a powerful tale of politics, ambition, and reinvention. Between 1920 and 1930, the city's population more than doubled from 576,673 to 1,238,048, and by 1933, the Library had the highest circulation of books in the nation. As Los Angeles grew exponentially, however, so too did the demands placed on Bertram Goodhue's structure, which by the 1960s was thoroughly overwhelmed.

As the number of branch libraries expanded, city leaders questioned what role a Central Library could play in an increasingly decentralized city. Critics queried whether, given the high price of downtown real estate, it would make more sense to sell the property and build a new library elsewhere, and in the coming decades, numerous proposals would be considered. The debate over its future would ignite an unprecedented preservation movement in the city, as residents, who had grown tired of watching architectural treasures demolished, came together to make a stand.

As early as 1962, a detailed study of remaining space confirmed the Central Library was nearing exhaustion. Renamed in 1964 in honor of Rufus B. von KleinSmid, former University of Southern California president and longtime member of the Library Board of Commissioners (a memorial plaque by sculptor Merrell Gage is found on the northeast pillar of the rotunda), the building was unpopular with librarians who complained about poor ventilation, an outdated electrical system, non-working elevators and telephones, a lack of adequate parking, and improper care or shelving for rare books.

Every year, more than 200,000 new books were added to the collection that had long before surpassed the capacity once imagined by Bertram G. Goodhue and Everett R. Perry.

During the Library's fortieth anniversary year, the so-called Green Report (named for its green cover), compiled by the city librarian and independent consultants, recommended demolishing the existing structure and replacing it with a

▼ *The Central Library after the demolition of the West Lawn.*

new facility double the size. The March of 1967 designation of the building and its grounds as a historic cultural landmark by the Los Angeles Cultural Heritage Board did little to deter the building's critics. "It is unthinkable that we should leave future generations library buildings that have inadequate and deteriorating book collections,"[2] Albert A. Le Vine, president of the Board of Library Commissioners, declared at a press conference announcing plans to raze the structure. The following month, the building's frailties were further exposed by a storm that left more than seven hundred volumes damaged by water leaks.

The Library Board convinced the City Council to place a $26.2 million bond measure on the May 1967 citywide ballot for the construction of a new building, as well as branch enhancements. Voters rejected the initiative, which implied the destruction of the existing structure. "A civilized people does not indiscriminately destroy the work of its ancestors,"[3] Councilman Marvin Braude argued in a statement opposing the measure.

By 1968, a lack of adequate space led to some books being moved into a warehouse about a mile from the Library, and the volumes would only be available with a day's notice. The same year, the Southern California Chapter of the American Institute of Architects (AIA), a leading proponent of saving the building, produced a report offering a series of alternatives to razing the structure, yet no city agency offered an official response.

When employees, angered by the lack of parking near the building, protested and "stayed home" for a day in February 1969, the Library Board responded by pushing for the demolition of the West Lawn, the trees, pools, fountains, and walkways to make way for 188 new parking spaces. A lawsuit filed by Robert E. Alexander, a prominent local architect, temporarily delayed the destruction, but ultimately, it wasn't enough to prevent one of the few green spaces downtown from being paved over.

In 1970, the same year the Los Angeles Chamber of Commerce committee delivered a report calling for the Library's replacement, Wyman Jones was hired as city librarian after a nationwide search. He immediately made finding a new home for the Library his top priority. After just three days on the job, he complained to the *Los Angeles Times*, "the city needs a new Central Library. . . the facilities just are not there."[4]

The Central Library was placed on the National Register of Historic places in 1971. When the fire department inspected the building two years later, it issued citations for twenty-six separate fire and safety violations amid fears the stack areas could serve as giant flues. When Councilman Gilbert Lindsay, in whose district the Library stood, was confronted by a woman pleading with him to save the building, he responded, "What? Save that heap of junk?"[5] He would later describe the building as a "fire hazard" and a "disgrace" to the city.[6]

Los Angeles Chief Administrative Officer C. Erwin Piper invited consulting firms to submit proposals for a Central Library feasibility study in 1974. After narrowing down thirteen proposals to three, Piper, the most powerful non-elected official in City Hall, ignored the advice of his colleagues and awarded Charles Luckman Associates a $58,000 contract to investigate potential sites for a new Library.

Luckman, who designed the building that replaced New York City's Penn Station, had been widely criticized for his work on the Convention Center and the L.A. Zoo. Piper's determination to award him the contract alienated members of both the Library Board and the City Council, who expected a more open selection process.

What was meant to be a four-month project turned into an expensive multi-year effort for the architect, who had been tasked with finding a site that could accommodate a three to five-story building with 575,000 gross square feet (410,000 net square feet) and a thousand on-site parking spaces. He later claimed to have "overspent" $390,000 of his firm's money while examining twenty-eight different sites and researching the project.

Luckman narrowed the site possibilities to three, including the current location and a Bunker Hill site between First and Olive Streets, Grand Avenue and Second Place. However, he recommended locating the building on a block east of Pershing Square on a lot bounded by Broadway, Hill, Sixth, and Fifth Streets. "You cannot remodel the present building or add to it," he said at a special session at City Hall. "That would cost $20 to $25 million and we don't think it is worth it. It would be a waste of taxpayers' money. It's a lousy Library. . ."[7]

A master salesman, Luckman had trouble selling the idea of the site to preservationists who took exception to any plan that would demolish the existing Library, while the City Council and local business owners were opposed to the destruction of a shopping district along Broadway at the rear of the site. Some in City Hall believed a new building should be constructed on a site east of Main Street in the heart of Skid Row, while others pushed for a building near the Los Angeles Convention Center.

When opposition to demolishing the historic Library reached a fever pitch, to diffuse the controversy Luckman reversed his position and offered to produce a free feasibility study on restoring and renovating the Goodhue building.

The architect's recommendations included demolishing the children's wing, the addition of single-story modernist wings on the East and West Lawns, and a subterranean parking structure with six hundred spaces. "The existing exterior of the present building [would remain] unchanged and the low level additions will incorporate materials and colors to make the total complex look as if it had been constructed at the same time," Luckman explained.[8] Supporters of saving the Goodhue building were particularly outraged by the architect's proposal for an escalator to transport patrons to the heart of the rotunda.

In mid-1977, the City Council approved the renovation-expansion plan in concept estimated to cost $38.3 million. The Community Redevelopment Agency (CRA) had reservations about the cost analysis but agreed to issue bonds for construction funds. In December, the City Council certified

the environmental study.

A landmark lawsuit filed by the AIA, however, questioned the adequacy of the project's environmental studies and threatened to derail the plan. "We recognize that as a Library it [the structure] is now very much inadequate," James Pulliam, the president of the Southern California chapter, told City Council. "We do believe, however, that the renovation should be carried out responsibly."[9] It was the first time in its history the AIA chapter had resorted to legal action.

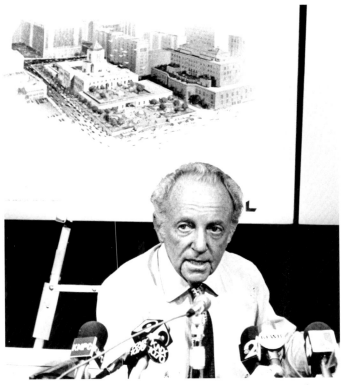

▲ *Charles Luckman made the case for his design at a press conference.*

Another obstacle in the way of the proposed project was Proposition 13, California's 1978 statewide tax-cutting initiative that ended the use of redevelopment funds. When council members first addressed the issue of what to do with the

Library, they were promised $43 million from the CRA. Now, they would have to look for new ways to fund the currently estimated $58 million project.

In an effort to refocus the debate, the Southern California AIA chapter produced a report, Guidelines for Preservation, Restoration, and Alterations to the Central Library. "With the expectation that the Library would be rebuilt, there had generally been an attitude of neglect, and there was suspicion towards any effort to regard the building worthy of preservation," explained Margaret Bach, who edited the document.

Upon reviewing the report, Samuel M. Burnett, an associate partner at Charles Luckman Associates, sent his boss a handwritten note, suggesting it had been produced by "a variety of idealistic dreamers,"[10] but it became clear proponents of saving the Library were beginning to find their voice. Two years later, Bach, who had helped form a group known as the Committee for Library Alternatives in 1976, would go on to become the founding president of the Los Angeles Conservancy, an organization that would grow to become the largest local preservation group on the West Coast and play a central role in saving the Library.

"In the late 1960s, we lost Irving Gill's Dodge House and the [Morgan, Walls and Clements-designed] Richfield Building, a gorgeous Art Deco, black-and-gold building," Bach noted. "This was a turning point for historic preservation in the city. It was very clear there was no organized voice for preservation in Los Angeles."[11]

Many members of the council and the media were suspicious of Luckman's disdain for the existing structure and of Piper's aggressive attempts to hire the architect before Piper himself retired on August 17. "Most Los Angeles city workers expect a gold watch when they retire, but City Administrative Officer C. Erwin Piper wanted a $35 million Library," the *Herald-Examiner* observed.[12]

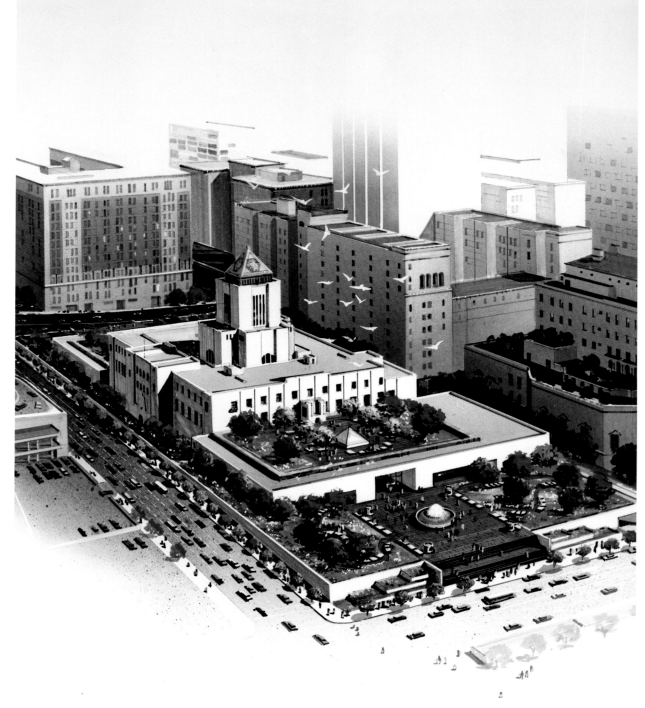

▶ *Luckman's plan to expand the Central Library included two new modernist wings.*

▶▶ *His plan to bring patrons to the rotunda via escalators.*

186

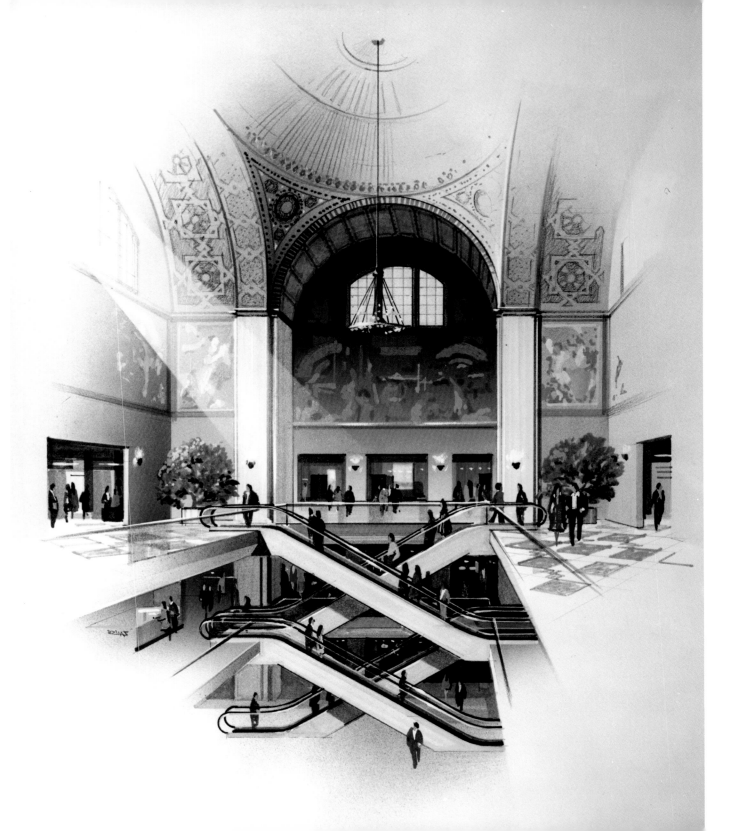

The Board of Public Works held the right to select an architect for the project under the terms of the city charter, however, the City Council controlled the purse strings. When Luckman was selected by a Board of Public Works screening panel as the architect for the renovation and expansion of the Library in the summer of 1979, Councilman Zev Yaroslavsky questioned why the other five firms interested were given only one day to prepare for interviews.[13] "The choice had been made long ago," Yaroslavsky complained in a letter to Mayor Bradley. "Decisions are being made with unseemly haste and the hint of backroom politics."[14]

Many on the City Council believed the selection process had been rigged in Luckman's favor and voted 9-2 to delay any action on the project until September. At a press conference at the Los Angeles Press Club, Luckman said he was "tired of being a scapegoat" and announced he was ready to share his four years of research with other architects interested in bidding on the project.[15] "I'm not a politician," he explained. "I do not need anything from anybody, and I have nothing to gain. I simply want to get this project moving before it is too late."[16]

Privately, Luckman grew increasingly concerned the tide had turned against him and blamed the local AIA chapter for ruining his chances. "If they don't take off their blinders, there will, in my personal judgment, be no Council approval,"[17] he wrote to Library consultant Joseph Becker.

Luckman's worst fears came true when the City Council, by a single vote after an emotional session, opted to kill every initiative related to the Library. "I feel sorry for the city,"the architect said after hearing the news. "Do you want a Library or don't you?"he demanded of council members. "The Library you have is not going to last. (I have a feeling) some of you don't even want a Library in the central city. . ."[18] The vote left the City with no clear plan as to what to do with the Library.

The next effort to solve the problem came in 1981 when the Library Board issued a request for proposals from developers that included 400,000 net square feet and six hundred parking spaces to be located on the present site or nearby. "Wyman (Jones) was open to anything to get a Library," former City Administrative Officer Keith Comrie explained."[19] Earlier proposals had included converting the existing building into a cultural center or city museum, combining the Library with an office and retail complex or building a new Library alongside the Music Center on Grand Avenue. The latest request galvanized preservationists who realized, once again, the Library was at risk of being demolished.

John Welborne, an attorney and native Angeleno with a passion for local history, was among those who decided to do what they could to save the building. "For years the people in the downtown community had heard nothing but the librarians' point of view that the building was dangerous and couldn't be restored and had to be torn down," Welborne explained. "Nobody had explored the preservation alternative."[20]

Welborne formed what became known as the Citizen's Task Force for Central Library Development, which included members of the Conservancy and the CRA. Together, they courted influential business interests and in particular the Central City Association, representing many powerful downtown corporations. In a political gesture, Welborne also invited Librarian Jones and Betty Gay, assistant to the director of the Central Library, to join the steering committee.

Architect Barton Phelps, chairman of the Cultural Heritage Committee of the Los Angeles Chapter of the AIA and a member of the task force, was given the responsibility of making the case to save the Library at a special lunchtime presentation for the Central City Association. Phelps, who spoke after Wyman Jones argued for a new building, told the audience, "The city's business and professional leaders have

not yet lent their expertise. It is essential that we all work together now."[21]

The task force convinced Mayor Bradley to delay the Library Board's request for proposals and accept an offer by management consultants Arthur D. Little, who volunteered to evaluate Library operations and subsequently recommended the renovation and expansion of the existing building. Robert F. Maguire III, a managing partner in the development firm Maguire Thomas Partners, and Robert O. Anderson, former chairman of ARCO, "were looking out the window at the Library site"[22] when they decided to do something. They assembled a team of experts and spent $300,000 on a study to examine ways of saving and expanding the Library.

"The City was talking about issuing a Request For Proposal to develop the site and basically build two fifty-story buildings on the site which we thought was a lousy idea, and so Bob and I put together a fund to see if there were alternatives to demolishing the Library," Maguire recalled.

Although Mayor Bradley made it clear the City of Los Angeles did "not have the funds" to make changes to the Library,[23] there were valuable assets that could be used to entice a developer. City building codes allowed for nearly a million additional square feet of development on the Library's five-acre plot. The remaining space, considered density or development rights, could be sold or traded to developers seeking to erect taller buildings than city codes would normally allow. The Library's historic status also meant that a private buyer who acquired the building, remodeled it, and leased it back to the city, could receive considerable tax credits.

The CRA began working closely with Maguire Thomas Partners to develop a project that became known as Library Square and would include the construction of three new skyscrapers. The transfer of zoning credits and the sale of

◀ *Robert F. Maguire III.*

tax-allocation bonds would play an essential role in funding the rehabilitation and expansion of the Library.

The first tower, a seventy-three-story cylindrical skyscraper designed by architect Henry Cobb, would become the tallest building on the West Coast and stand directly opposite the Library's Fifth Street entrance. The New York firm of John Burgee made studies for the second tower in partnership with architect Philip Johnson, although the building, located along Fifth Street between Grand Avenue and Olive Street, would ultimately be designed by Richard Keating of Skidmore, Owings & Merrill. Both properties were developed by Maguire Thomas Partners while a third tower on South Hope Street was built by Lincoln Property. "It was the largest public-private partnership in the United States with over a billion dollars in construction costs, both the private office buildings and public structures," Maguire recalled.

Maguire Thomas Partners would commit to the construction of an underground parking garage in front of the Library's Fifth Street entrance, along with restoring the former green park space and adding a restaurant. The firm also funded a stairway and cascading water garden called the Bunker Hill Steps, designed by landscape architect Lawrence Halprin, that linked Hope and Fifth Streets. Edward Helfeld, head of the CRA, brokered the deal that Robert Maguire later described as "ungodly complicated."[24] "Without Maguire, who was a very entrepreneurial and gutsy developer, we couldn't have done it," Helfeld reflected. "We had to have a developer that was willing to take a gamble on that much office space."[25]

The CRA and Library Board worked together to identify firms they believed had the necessary experience to renovate and expand the Library. After reviewing potential candidates, they began working with Hardy Holzman Pfeiffer Associates (HHPA) in June 1983 to develop a concept for the expansion.

The firm, made up of Hugh Hardy, Malcolm Holzman, and Norman Pfeiffer, was known for adaptive re-use and expansion of historic buildings and had worked on the Cooper-Hewitt National Design Museum in New York and the Sculpture Hall and East Wing of the St. Louis Art Museum. Pfeiffer, who led the project, was based in New York but had grown familiar with Los Angeles while working on the expansion of the Los Angeles County Museum of Art (LACMA) on Wilshire Boulevard.

Like Bertram Goodhue, Seattle-born Pfeiffer had known from an early age he wanted to be an architect. "My family who moved to Seattle from Norway were in the construction business," he explained. "My grandfather built a lot of the towers in downtown Seattle and as a young kid he used to take me on the weekends to go visit the work that he was doing, and often times we'd go to visit the architect's office where he would have meetings with them. They would give me some paper and a drawing, and I'd start tracing things from what they had done. It just was a bug that bit me. I wanted to be an architect all my life."[26]

After graduating with honors from a five-year architecture program at the University of Washington, he attended graduate school at Columbia University. After completing his studies, Pfeiffer decided to make a go of it in New York and discovered Hugh Hardy's name in the telephone business directory. Walking into Hardy's office without an appointment, Pfeiffer was eventually hired after being interviewed by Holzman. Hardy made Holzman and Pfeiffer, his two most promising associates, partners in 1967.

As the Los Angeles Central Library project advanced, Pfeiffer began traveling to Los Angeles monthly for project-related meetings. The architect was asked to develop plans for a new wing that would more than double the available space and extend the structure to Grand Avenue.

Pfeiffer worked closely with Betty Gay, who was promoted

190

to Central Library director in 1984. Traveling to cities, such as Cleveland and Seattle, that had built contemporary libraries, Gay worked with a team of building consultants, who provided information to HHPA. "I was looking not just at the new wing but the entire building," Gay recalled. "We would describe issues with how the building currently worked and then ask them to solved those problems in the floor plan. We needed it to be very easy and secure for the user."

Pfeiffer and Gay were in a meeting at her office on April 29, 1986 when they heard a fire alarm at 10:52 a.m., which they first believed to be a false alarm.

"All of a sudden, we realized that there was smoke, and that there was a fire," Pfeiffer remembered. "We just left everything. I left my jacket, the keys to my hotel room, the keys to my rental car, everything was left on her desk along with all the drawings that we had that we were reviewing."

The alarm signaled the beginning of the worst library fire in the nation's history. More than 250 firefighters from forty-nine fire companies across the city battled a fire that began in the fiction stacks and burned out of control for more than four hours.

Firefighters who entered the inferno were hampered by a desire to use as a little water as possible for fear of damaging even more books and the building's configuration. As a result of overcrowding, eighty-five percent of the books were located in inaccessible closed stacks at four corners of the building. When the fire took hold, they became what Pfeiffer described as "four chimneys."

There was no sprinkler system, since the fear of fire had taken a backseat to the fear of water damage. "This is the most extremely difficult fire we ever fought," Fire Chief Donald Manning said after the flames were finally extinguished.[27]

By the time it was over, forty-four firefighters were injured and twenty-three had been transported to the hospital. An estimated 375,000 books had been destroyed and of those remaining, 750,000 suffered water or smoke damage. Early estimates put the cost of the fire at $22 million.

When the fire department had cited the building in 1979, it called for installation of smoke alarm-operated fire doors that would cut off the center of the Library from the stacks if a fire broke out. Ironically, steel doors were in the process of being fitted when disaster struck. "This magnificent building is something we have tried to save. We tried to get it up to safety standards," Mayor Bradley told reporters.[28]

It would be more than six hours before Pfeiffer was allowed back into the building to retrieve his belongings. "I pulled my coat off of the drawings and there was just a big white place where the soot hadn't gotten to on the drawings because everything else was covered in soot, including my suit coat," he remembered.

The fire sparked what the *Los Angeles Times* called "the biggest spontaneous outburst of civic energy since the Olympics."[29] More than 1,700 volunteers rushed to freeze-dry books damaged by the thousands of gallons of water firefighters sprayed inside the building. In one of the largest book-salvaging campaigns in American history, hundreds of thousands of books were stored in a refrigerated warehouse to prevent mold and mildew from forming on the pages.

The following September, a second fire destroyed an additional 25,000 books and added to the city's jitters. Investigators concluded both fires were arson. A lengthy investigation, including 350 interviews, led to the arrest of 28-year-old Harry Peak, although the district attorney's office deemed the evidence against him insufficient, and no charges were filed.

A "Save the Books" campaign, co-chaired by ARCO chairman Lodwrick M. Cook and Mayor Tom Bradley, raised more than $10 million in a series of public and corporate fundraising efforts that included a $2 million donation from the Getty

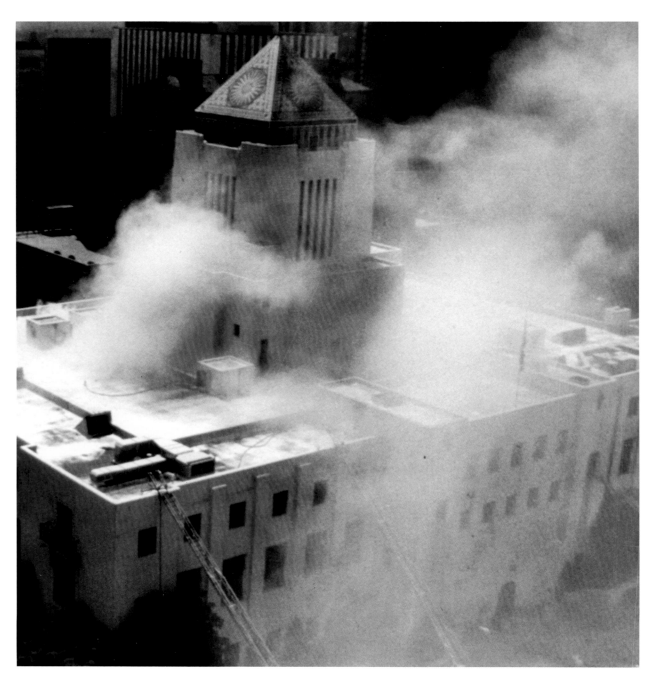

▶ *The Los Angeles Central Library fire April 29, 1986 destroyed an estimated 375,000 books.*

Trust. In recognition of their achievement, the Library rotunda would later be named in Cook's honor and the new wing, when completed, would be named to honor the mayor.

Although the fire damage would prevent the Library from reopening before the renovation and expansion work was scheduled to begin in late 1987, it did not cause any major structural damage. While the Library operated in temporary quarters in the Title Insurance Building on Spring Street, management was provided with office space across Flower Street courtesy of ARCO. In 1987, the Whittier Earthquake damaged tiles on the pyramid and the following year, a third fire broke out in the Library's basement. Fortunately, as books had been removed, the damage was confined to construction material.

In March 1991, nearly five years after the fire, the final 1,800-pound steel girder of the new east wing was hoisted into place, four stories above Grand Avenue. The beam was painted white and adorned with signatures of Library workers and well-wishers. Attached to the beam was an evergreen and an American flag tied with yellow ribbons. City Librarian Elizabeth Martinez Smith told the crowd who gathered to witness the "topping out the Library" that the tree was part of an ancient tradition meant to ward off evil spirits. "We're not taking any chances on this building!" she explained.[30]

In September, the City Council rejected a controversial proposal to sell the building to a subsidiary of tobacco corporation, Philip Morris, for $71 million and lease it back. Under the terms of the plan championed by Mayor Richard Riordan, Philip Morris Capital Corp. would have benefited from tax credits under historic preservation laws, while the Library would have saved $11.5 million. When presented to the City Council, all but one member, Councilman Hal Bernson, voted against it.

The effort to return the books to the Library began in June and required 225 workers more than six weeks to complete.

The 2.1 million volumes were absorbed in a round-the-clock effort estimated to have cost $500,000. A newly installed computerized catalogue did away with card catalogue files and linked the Central Library with its branches.

On October 3, 1993, the restored and renovated Library finally opened its doors to the public. More than two hours before the official opening, lines of spirited spectators began forming, and by the time Mayor Riordan cut the ribbon, crowds that were expected to reach between 20 to 25,000 had surpassed 50,000. The surrounding streets, blocked off since the early morning, were full of citizens who gathered on a warm Sunday afternoon to share in the excitement of the rebirth of a landmark.

"I think that a city can be judged by how seriously their citizens are about their libraries," Riordan told the crowd. "Today we have living proof that we really care about our city."[31] City Librarian Smith shared in the outpouring of enthusiasm. "It has been a long journey to this day," she proclaimed, "the Library represents a future for all of us."[32]

In 2001, Mayor Riordan's supporters overcame the protests of librarian unions and dissenting council members to rename the building the Richard J. Riordan Central Library in recognition of the mayor's efforts to improve the city's libraries.

12 A NEW BEGINNING—A DESIGN FOR THE TWENTY-FIRST CENTURY

We hung onto the very principles of planning that Goodhue had established and extended them into our new building.

NORMAN PFEIFFER[1]

The transformation of a deteriorated architectural icon into a renewed source of civic pride for the twentieth-first century required a decade-long effort that ultimately was achieved at a cost of $213.9 million. To expand the Central Library, Hardy Holzman Pfeiffer Associates (HHPA) explored twelve different concepts, ranging from "an underground addition to a freestanding high-rise," before setting its sights on a partially subterranean new wing contiguous to the east side of the Goodhue building.

"We recognized Goodhue's masterpiece as the key to the appropriate solution to adding onto his original building and that we had to adhere to his rules in order to make the whole result compatible," Norman Pfeiffer explained.

Pfeiffer's plans, inspired by Goodhue's block-like massing, would provide an additional 330,000 square feet, include eight floors, four below ground, and extend the main axis to Grand Avenue. A glass-roofed atrium, a contemporary correlative to Goodhue's rotunda, served as the symbolic heart of the new design.

To create the space, the East Lawn was sacrificed and the children's wing had to be demolished, although the room containing Julian Garnsey and A.W. Parson's *Ivanhoe* murals was spared. Lee Lawrie's Siena marble fountain and other important works in the children's courtyard were moved to a new courtyard adjacent to the north façade of the new wing.

Lawrie's carytides, the *Spirit of the East* and *Spirit of the West*, which served as a symbolic entrance to the east wing, found new purpose as the gateway to a new 235-seat auditorium that could be accessed from within the building or directly from Fifth Street. The venue was named the Mark Taper Auditorium following a million-dollar donation to the project from the Mark Taper Foundation in 1990.

It was decided early on the restored Goodhue building would remain the established gateway to the Central Library, with entrances located on Flower, Hope, and Fifth Streets. It would also house the circulation desk and information services, administration offices, support services, and children's literature. The other subject departments would be located in the new wing and reached by way of a series of dramatic cascading escalators.

In order to guide the restoration and expansion project to completion, Pfeiffer needed the approval of more than twenty city, state, and federal agencies, including the Los Angeles Cultural Affairs Commission, which maintained jurisdiction over all city-owned historic buildings. More than $25 million of the funding depended on historic tax credits, meaning the National Park Service and State Historic Preservation Office would keep a watchful eye on the project.

"Every time we touched the historic building they had to approve the planning for that and the details," former Central Library Director Betty Gay Teoman remembered. "That was a brutal process."[2]

Pfeiffer was forced to reconsider his vision for a peaked stainless steel-and-glass atrium when the Cultural Affairs Commission rejected his design, citing concerns it was too competitive with the original structure. When the City Council

voted in favor of the design approved by Mayor Bradley, it led to an expensive delay in the project. To avoid similar standoffs, the mayor announced the formation of a design advisory panel he hoped would offer an "early warning system" against such costly delays on future city projects.[3]

The dispute lasted thirteen months and came to an end in April of 1988 when the Cultural Affairs Commission, the Library Board, the CRA board, and the City Council all gave their blessings to Pfeiffer's revised design that lowered the top of the atrium by twelve feet and flattened it to a trapezoidal shape. "I don't think of it as a compromise," Pfeiffer said at the time. "I think of it as another approach."[4]

The architect's plans envisioned alternating planes of ivory stucco and green terra cotta to complement the texture of the original building's asymmetrical facades. A large glass window in the Grand Avenue wall added to the atrium's natural light. "The tall buildings across the street were south-facing, and they were so reflective that we got the borrowed light from the reflections of those buildings bouncing right into our atrium making it just like brand new morning," Pfeiffer described.

Pfeiffer, who worked closely with HHPA associate, Stephen Johnson, took inspiration from Goodhue's work not only for the building, but also for the interior furniture, carpets, and lighting. The stencils on the ceilings of the original building inspired the motifs and patterns found in the carpet. "All of the ornamentation for the Library was on the ceiling," the architect recalled. "We wanted to have it on the ground, so we've turned the whole palette upside down. . .colors from the Goodhue palette were very muted, primarily because they were painted on concrete."

The original mahogany-stained oak reading room chairs

◀ *Norman Pfeiffer.*

195

with an acorn cutout in the back inspired the new chairs stained aubergine, blue, green, and red. The architect turned to Goodhue's plans to create detailed reproductions of the original light fixtures, incorporating elements of their design into fixtures for the new wing. The specially woven fabric for the seats in the auditorium featured a bird of paradise, the official flower of the City of Los Angeles.

Hardy Holzman Pfeiffer Associates and the general contractor Tutor-Saliba worked with an array of restoration experts to renovate the original structure. For more than two years, an army of workers could be found removing layers of

▼ *Norman Pfeiffer's vision for the Library's new wing.*
Rendering by David Purciel.

paint from the stucco façade and patching and repairing on every side of the building.

"On the tower, the limestone had suffered several decades of acid rain damage which caused surface to erode,"[5] explained Charles Kibby whose firm CK Arts Inc. was responsible for restoring the historic masonry.

To replace the damaged Indiana limestone, the firm sought new supplies from the same quarry used during the original construction in the 1920s. Empire Quarry, in southern Indiana, was so named for providing the stone used in New York's Empire State Building.

Kibby and his team also worked to repair and replace more than eight thousand of the 30,000 tiles from the pyramid

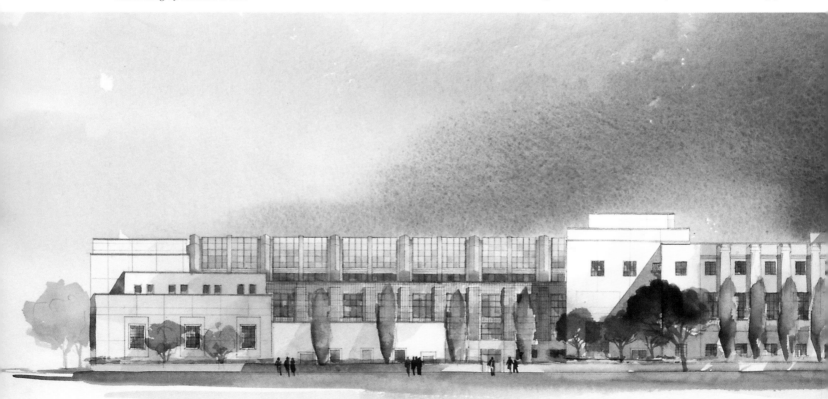

roof, repair sculptural elements, remove failed grout, and restore more than 250 limestone caps.

The most complex task the firm faced was the removal of a sixty-ton fountain, which, it was feared, might crush the newly constructed parking structure below. "We contacted some friends who worked in a quarry outside of Albuquerque," Kibby said. "We hired them to bring a diamond-wire saw, which at that time was a very new technology, and we used that to slice off the ends and the back of the fountain to remove about twenty to thirty tons of weight and make it then possible to reinstall."

Inside the rotunda and also in what had been the History Room, scaffolding was erected to allow a team of independent conservators, including the Los Angeles based A.T. Heinsbergen & Co., to begin the painstaking work of removing dust and grime from Dean Cornwell and Albert Herter's treasured murals.

As the restoration work continued, the 1950s-era elevator cabs were replaced with replicas of the 1926 originals, this time equipped with modern mechanics. Architect Brenda A. Levin worked with HHPA to create the Annenberg Gallery and also a new children's storytelling area.

A city requirement mandated that one percent of funds for construction of new public buildings be spent on new art projects. A committee made up of Pfeiffer, members of the CRA, Cultural Affairs department, and commissioners from the Library Board, as well as prominent local art experts,

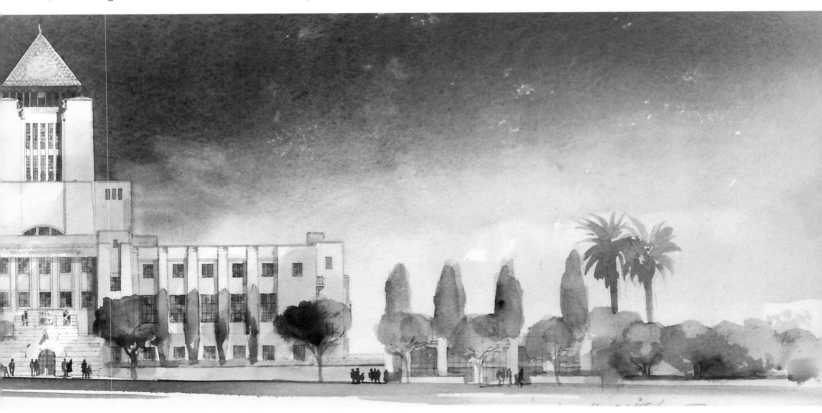

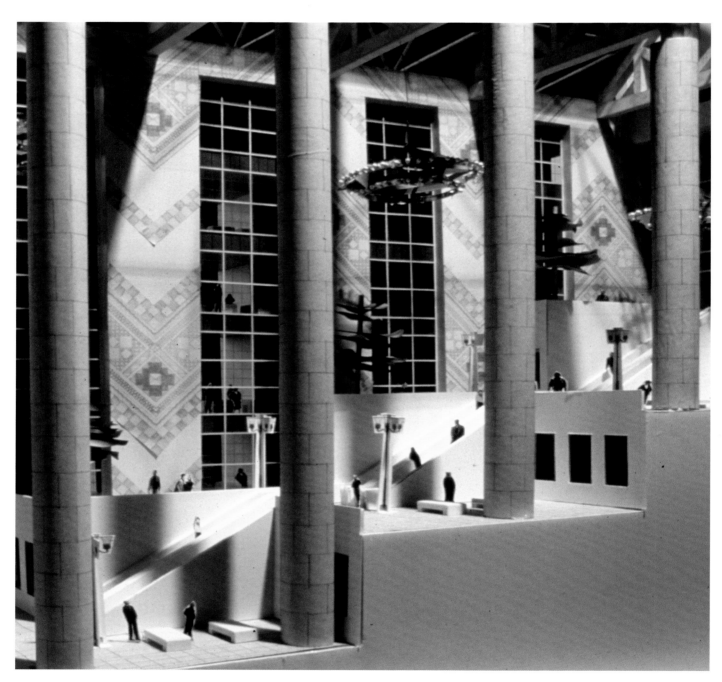

LOS ANGELES CENTRAL LIBRARY

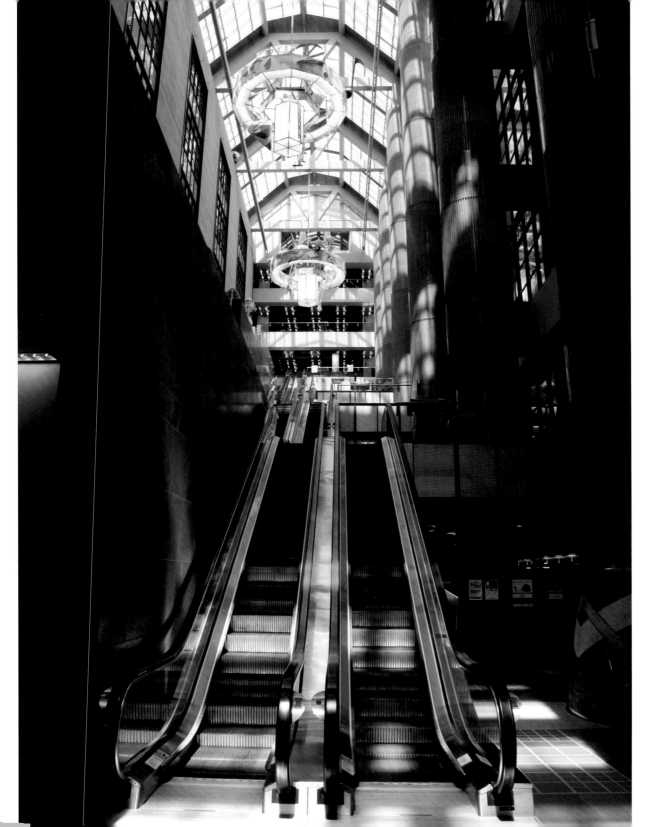

◄ *Pfeiffer's design included a series of dramatic cascading escalators.*

◄◄ *Norman Pfeiffer's design anticipated a tiled wall on the south side of the new wing. "They couldn't afford to fund it," the architect explained. "It still looks like it's ready to have something happen to it."*

199

worked together to identify appropriate spaces for artworks and select the artists.

The committee reduced a list of three hundred possible candidates to thirty-five before asking the artists to submit proposals. "We looked at artists who were good and did things intellectually with their art, who tell a story in some fashion or really have a strong viewpoint," Teoman explained.

Eleven artists were selected, but funding was only immediately available for five artists to begin work: David Bunn, Ries Niemi, Renee Petropoulos, Ann Preston, and Therman Statom.

Ralph Bacerra, who planned an elaborate tiled design for the entire south wall of the atrium; Stephen Prina, who imagined a clock that chimed to the sound of pop music; Mitchell Syrop, who envisioned using photographs and text to identify the subject departments; John Valadez, who proposed a mural based on the history of the written word for the east wall of the atrium; Buzz Spector, who planned a "book sculpture" for the new boardroom; and Susan Mogul, who expected to create a mural with school children for a wall next to the children's puppet theater, all were told to wait for funds that never materialized.

Renée Petropoulos—*The Seven Centers*

Los Angeles native Renée Petropoulos was the only artist commissioned to work inside the Goodhue building and painted the 36-by-36-foot vaulted ceiling of the street-level lobby. She spent three months in the summer of 1993 in a giant plastic bubble, erected to protect her work from construction dust, as she labored seven days a week on a scissor lift to create *The Seven Centers*. Inspired by the idea of decoration as a subject matter, her work featured brilliantly colored rings, starbursts, and checkerboards—as well as the names of several contemporary authors, including Bob Flanagan,

200

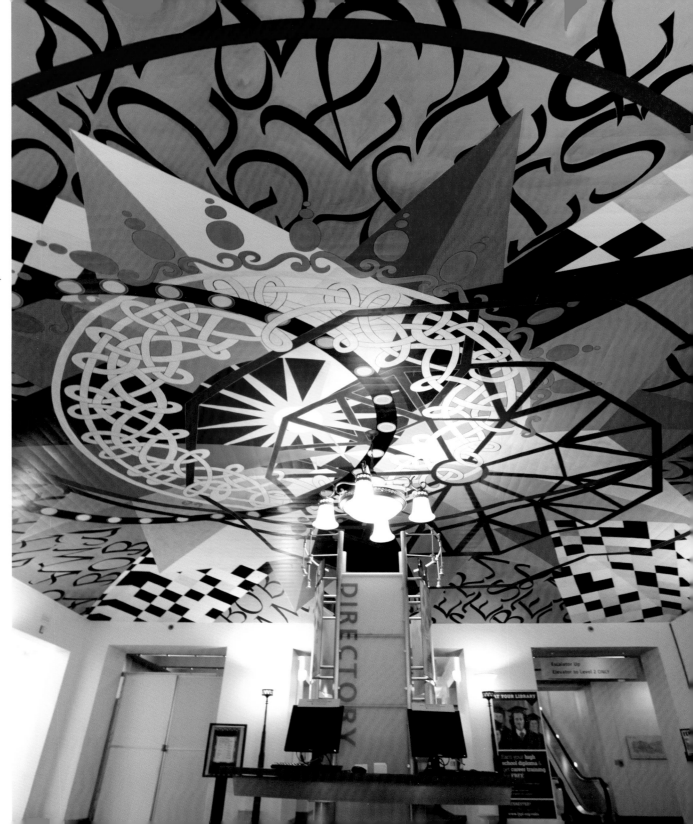

▶ *Depending on where you stand in the lobby, you get a different experience observing Renée Petropoulos' The Seven Centers. "It's the optical nature of putting concentric rings of some kind, not lined up with the center of the building as they slide across simultaneously concave and convex ceiling," she explained.*

◀ *Hardy Holzman Pfeiffer Associates looked at patterns on the ceiling of Goodhue's building for inspiration for the carpet in the new wing.*

◀▼ *The firm also designed the custom fabric for the seats in the Mark Taper Auditorium, featuring the Bird of Paradise, the city's official flower.*

Bernard Cooper, and Amy Gerstler. "I asked if I could make a proposal for the Goodhue building," she said. "I thought a lot about the building and the architecture as I approached it, and I thought a lot about its role in the City of Los Angeles as the Central Library."[6]

Petropoulos was inspired by the artwork found in the rotunda directly above and included references to Julian Garnsey's painted sunburst ceiling and Lee Lawrie's zodiac chandelier in her work. "I looked in his (Goodhue's) ceiling for these various elements and I brought them, in a sense, down to my ceiling," she reflected. Petropoulos used an old-fashioned technique known as pouncing to transfer her design to the ceiling.

"In the 1920s, there was a notion of a singular type of thought, a hierarchical kind of organization of thought, and that it was predicated on the center and that the center was of utmost importance and everything radiated out from that center," she explained. "All of my centers misalign. I felt in the early '90s, that we were not in any kind of symmetrical relationship to power organization. I wanted to emphasize de-centering and a kind of destabilization within the framework of a very centered and very historically symmetrical notation of order."

The lobby serves as the building's orientation center and has four separate entrances. Petropoulos' original proposal had included plans to decorate the hallways that lead to the center. However, restrictions placed on the restoration of a historic landmark meant her efforts were ultimately confined to the ceiling.

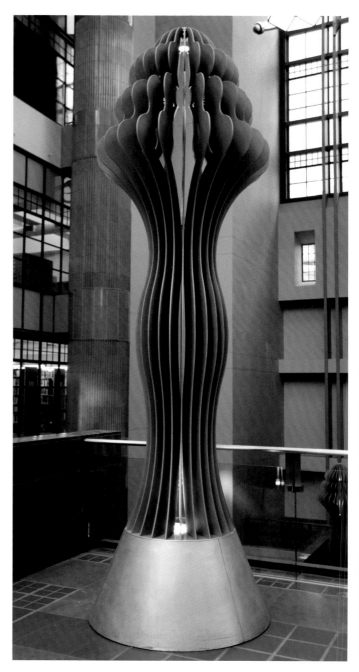

▶ *Lantern,*
by Ann Preston.

▶▶ *Chandelier by*
Therman Statom.

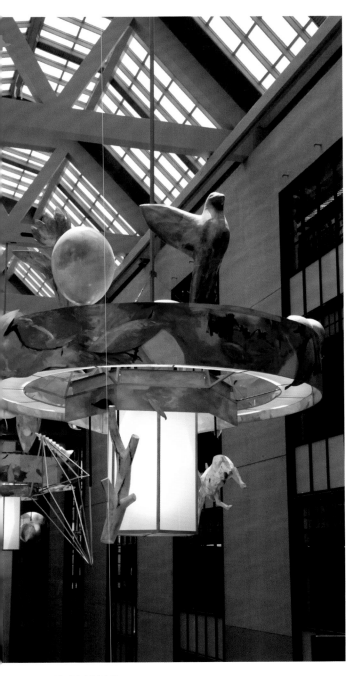

Ann Preston—*Illuminations*

Ann Preston had been exploring a number of works using the human form as a template when she began creating *Illuminations*, a series of four freestanding lanterns installed on the Library's escalator landings.

The artist assembled twenty-four duplicate strips of aluminum to form the cylindrical profile of an upside-down human head. "I did a feminization of the totem as it were," she explained. "It's intended to take the notion of the architectural column or stanchion and transpose it into curvaceous lines using the human profile."[7]

At the base of each lantern, a light shines upward to a reflector at the top of the fixture, thus spreading light to the surrounding space. Since her work would be displayed in the Library, Preston said, "it seemed entirely appropriate to light up a head."

When she began the project, Preston had anticipated her lanterns would be displayed against a never-realized tiled wall to be designed by Ralph Bacerra. "I expected a very active background, and it's one of the reasons why my pieces were so reserved," she added.

Therman Statom—*Atrium Chandeliers*

Therman Statom had never made a chandelier before being selected to design the trio of immense, playful light fixtures, hanging in the atrium. An experienced glass artist, he labored for more than three years to develop the circular structures adorned with fiberglass symbols representing the natural, technological, and metaphysical spheres of human existence.

"My initial response in the design phase was to create something that was a big toy but had enough intellectual content that it wasn't," Statom explained. "I also wanted to create a different type of textural quality to them."[8]

Statom, who worked with Peter Carlson Enterprises in

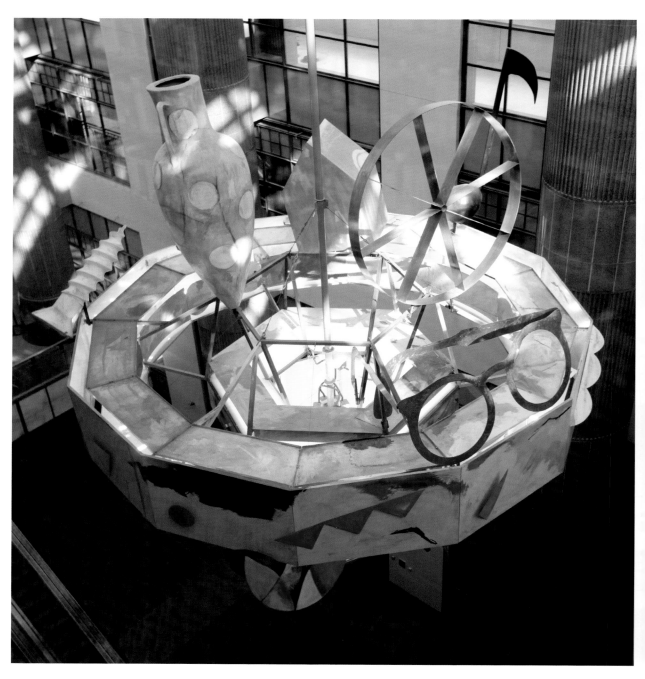

▶ *Therman Statom had never designed a chandelier until he was selected to create three of them for the atrium of the Central Library's new wing.*

LOS ANGELES CENTRAL LIBRARY

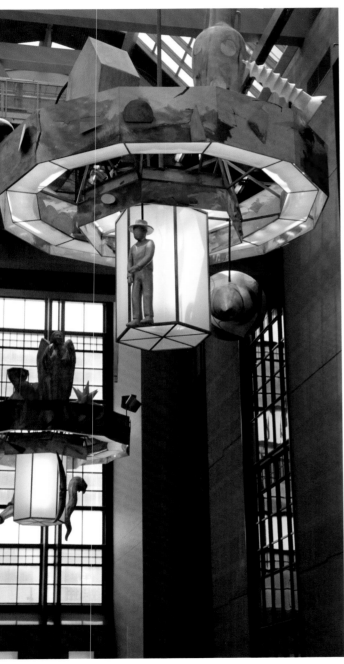

Sun Valley to create the chandeliers, was forced to scale back his plans to use glass and heavy metals to stay within the 1,100-pound weight limit. "We had to go with aluminum and even had to remove the foam from inside the fiberglass forms," he revealed.

The artist adorned the fixtures, each measuring 18.5 feet, with bold imagery, including an egg, angel, heart, turtle, carrots, birds, and a life-sized sculpture of himself. "I tend to be more implicative in my work," he noted. "I don't want to say 'this means this or that means that. . . I wanted the response to be from the gut.'"

When it came time to finally install the chandeliers, Statom said he was shocked by the initial negative reaction. "It's kind of a funny thing, because no matter how close I worked with Norman (Pfeiffer), after they were up, man, he didn't like them." Statom remembered, "It was awful. It was odd because they had drawings, but I think they never really comprehended it."

Over time, the artist noticed a shift in attitude toward his work. "As we progressed with the installation, because they were light, they looked pretty flimsy. As they got installed and lifted up, it was like watching a massive group of people who are not so sure about you, change their attitude. . . Prior to that, no one would say 'Hi' to me. It was funny watching every-one's attitude change day by day."

"On opening day someone from Pfeiffer's office came and thanked me, and it was pretty evident that what I had done made sense. It just kind of created a different textural quality to it all. It created a different kind of feel in the place."

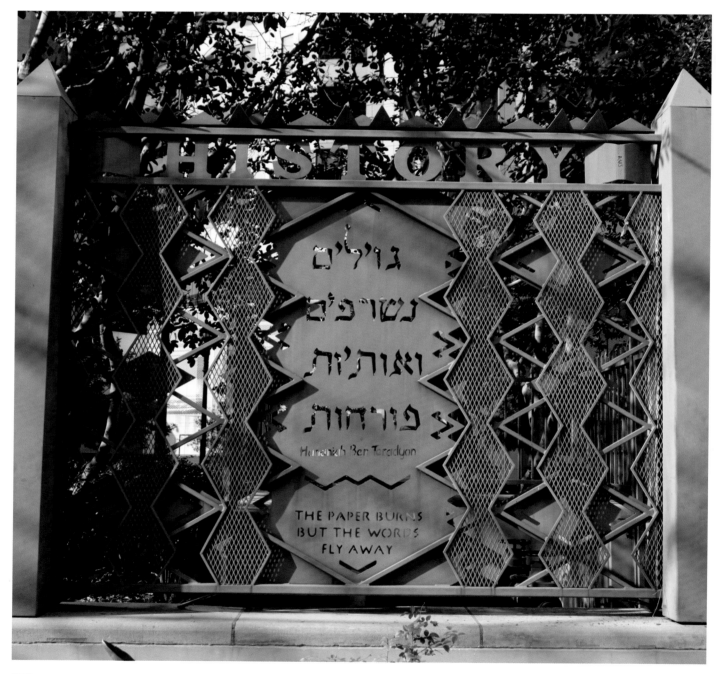

David Bunn—
A Place for Everything and Everything in Its Place

When artist David Bunn acquired the obsolete index card catalog from the Central Library in 1990, he decided to put it to good use. To create *A Place for Everything and Everything in Its Place*, he used 9,506 of the cards to line the two elevator cabs and the shafts in the new wing.

"Wherever the elevator stops, the catalog cards visible in the elevator shaft would identify the subject area for that floor," Bunn explained. "A second selection of cards from the catalog are mounted from floor to ceiling on the walls inside the cabs. All cards in the catalog beginning with 'Complete' were arranged in order in rows from A to Z. Since this selection would not fully cover the wall surfaces of both cabs, it was followed by all the cards beginning with 'Comprehensive,' which was the next section following 'Complete' in the card catalog."[9]

"Generally, an elevator serves as a metaphoric core of a building, an element of architecture that connects the whole. In a library, the elevator serves as an exploration pod, journeying to the various subject levels like something from a Jules Verne novel. The elevator physically represents the concept of exploration among the vast holdings of 'all the world's knowledge.' The elevator cab as a connector from top to bottom floors also physically travels through the Dewey Decimal Classification System."

While Bunn's concept was well-received, its execution proved problematic for safety reasons. "The elevator cab drove us nuts because there were all the building code issues," Teoman declared. "Getting it to happen in a way that the fire department considered safe was really interesting. It took a lot of time and energy, and it is much more expensive than a conventional elevator."

◀ *Detail,* The Literate Fence.

▲ *Detail, Bunn's elevator cab.*

Ries Niemi—*The Literate Fence*

Industrial artist Ries Niemi was commissioned to create a physical and symbolic link between the Goodhue building and the new wing along Fifth Street.

Working in his Inglewood studio, Niemi designed and constructed the ninety-foot long fence, five metal gates, and four window grills in the Children's Courtyard. Adorned with geometric motifs, his work featured the names of library subject categories, along with inspirational quotations in six different languages.

"I wanted to have layers of meaning," Niemi explained. "One of the layers would be a design layer, another layer would be real text, literal meaning."[10]

The artist worked closely with librarian Sylva Manoogian

in the International Languages Department, as well as native Korean-, Spanish-, Arabic-, Hebrew-, and Armenian-speaking librarians from various branches to select with the inscriptions promoting reading and knowledge.

"I came up with a concept that the quotation should be about knowledge, about reading, and information," he said. "So she (Manoogian) jumped into it with both feet, and she spoke five languages at least herself."

Niemi incorporated quotations such as "Knowledge is the prime need of the hour," from African-American educator and civil right activist Mary McLeod Bethune, and "The pen is the tongue of the soul" from Spanish author Miguel de Cervantes.

When the artist was told his fence would need to be topped with razor wire for security reasons, he came up with an innovative design solution. He added three bands of triangles, inspired by the architecture of the original building, to deter anyone from climbing over. "They satisfied risk management without making it into a prison camp," he recalled.

"I've been really always so proud and happy to have had the opportunity to do it, and I often get people, even now, complimenting me on it, and saying, 'Oh, it's one of my favorite things.' It was a great opportunity. I really enjoyed doing it."

Robert F. Maguire III Gardens

The responsibility of returning the 1.5-acre Flower Street parking lot to lush gardens on top of a four-story subterranean parking garage was handed to celebrated landscape architect Lawrence Halprin.

Considered the pre-eminent environmental designer of a generation, Halprin cemented his reputation as an urban visionary with his work on the FDR Memorial in Washington D.C., Ghirardelli Square in San Francisco, and the Nicollet Mall in Minneapolis. The designer, who said his style was influenced

▶ *Robert F. Maguire III Gardens.*

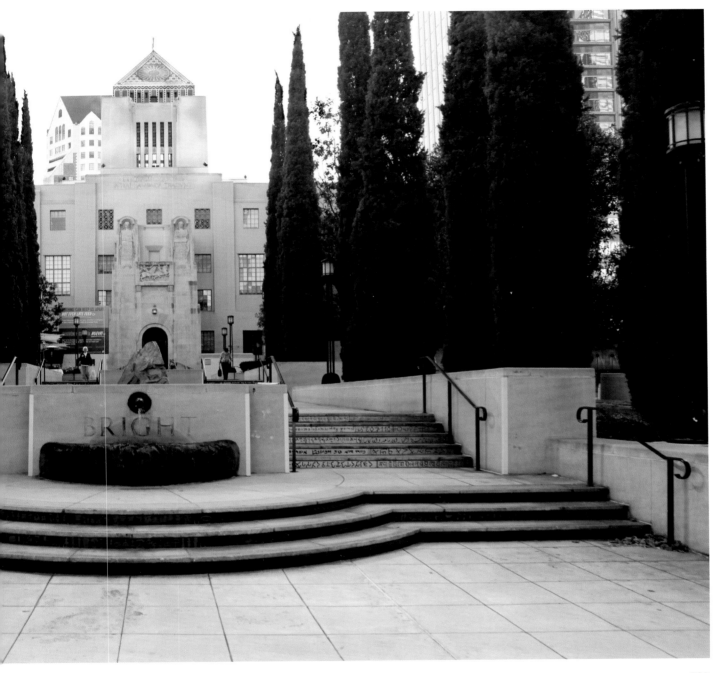

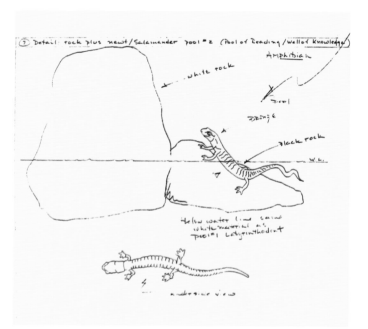

by his wife Anna Schuman, a former modern dancer, famously invented the term "motation," a combination of "movement" and "notation," to explain his vision of movement through space.

"Larry obviously was an important figure," developer Robert F. Maguire III, who hired Halprin, explained. "He had the flexibility to design this, and we worked very well together."[11]

In Los Angeles, Halprin recruited the firm of Campbell & Campbell as associate landscape architects. Principals Douglas and Regula Campbell had worked successfully with Halprin on a number of Southern California projects. However, their perspectives began to diverge when it became clear the duo favored a strong reference to Bertram Goodhue's original design. The Campbells found powerful allies in the West Lawn Coalition, a group composed of local architects and preservation experts. The alliance, assembled by John Welborne,

◀ *Jud Fine's design for a replica California Newt.*
▼ *The completed work cast in bronze.*

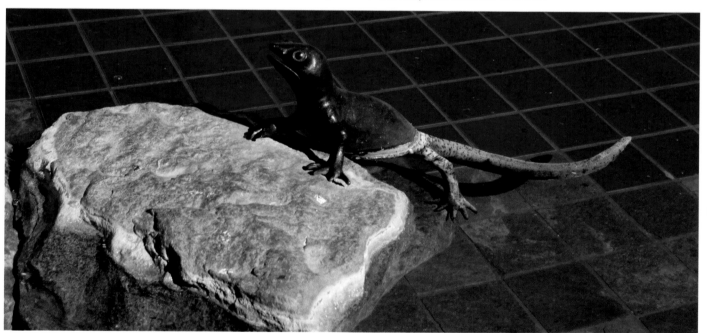

had been energized by an earlier proposal to build a semi-submerged retail space in front of the Library's west entrance.

"As time went by, Larry Halprin realized that people were paying more attention to his subcontractors than they were to him, and he tried to reassert control," Welborne recalled.[12]

"One of the clashes we had with Halprin," as Regula Campbell described, "was when we were originally laying out the West Lawn, and I said 'Of course the cross axis originates under the (Library) tower, and here is the Goodhue access extending out to the sidewalks and the city.' Halprin said, 'No, no, no,' and then he drew this big swath and said, 'This is the Halprin axis.'"[13]

As part of his design, Halprin added a north-south axis and teamed up with artist Jud Fine to design the austere Grotto fountain, inspired by the Villa d'Este in Tivoli, Italy. The feature included a series of rectangular tiers, feeding into a semi-circular reflecting pool. The text chosen by Fine to adorn the fountain was intended to provide a "snapshot" of the evolution of civil liberties in the United States.

Words on the upper well read "All born or naturalized in the United States are citizens," while the lower well carried the text from the 14th Amendment: "No state shall abridge the privileges or immunities of citizens nor shall any state deprive any person of life, liberty or property, without due process of law nor deny equal protection." The arch displayed a quote from Frederick Douglas: "Power concedes nothing without a demand. It never did. It never will."

Pressure from preservationists meant Halprin would have no choice but to cede elements of his modernist vision for the park. "There was always an ambition to animate the West Lawn with water and to recall the original axis with the stepped pools, but in Halprin's original sketches this was episodic and asymmetrical expressions," Douglas Campbell explained.

The Campbells saved many important plants from the East Lawn, including the symbolic olive trees. Although they were told Lee Lawrie's *Well of Scribes* had been saved following the original park's demolition in 1969, it was never found.

"This was first major on-structure planting in Southern California," Douglas Campbell reflected. "So we had to do research on what plants would thrive over the long run. We had to research its root structure and growing habits, and what we looked for are plants that could grow in rocky, shallow soils."

"We wanted plant material that would grow to the scale of its surrounds, of its setting. We really wanted this to look not like the top of parking structure but as a park as it used to be," Regula Campbell added.

Campbell and Campbell paid tribute to the winding path of the East Lawn by creating a curved walkway leading to the Library's west entrance and honored Goodhue's vision by replanting Italian cypress alongside the stepped pools.

In keeping with the building's inspirational theme, they added a Bodhi tree, a symbol of enlightenment, and added plants from all the continents except Antarctica.

Robert Maguire recruited the firm of Backen Arrigoni and Ross to design the single-story restaurant on the northwest corner of the property. In recognition of his efforts to revitalize space, the West Lawn was renamed Robert F. Maguire III Gardens in 1993.

Jud Fine—*Spine*
Jud Fine was elated when he was selected to devise a contemporary art plan for the Library's West Lawn. However, when he realized how much of Bertram Goodhue's original design would return to the space, he feared his creativity would be severely restricted.

"I had come up with all these ideas, and I felt like my hands

were tied," he recalled. "I couldn't change the original design, I could only work with it or around it." [14]

An important addition to Lawrence Halprin's team, Fine quickly saw the potential, nonetheless, for what he described as a "respectful collaboration" with Goodhue. The artist developed a plan he named, *Spine*, a reference to the central structure of a book overflowing with information with multiple layers of meaning.

Beginning at the Flower Street entrance to the gardens, Fine created two scallop-shaped entry points he compared to endsheets in a book. Mixtec and Inca architecture inspired the left scallop on the north side, while the right scallop displayed mathematical equations from celebrated physicists: Niels Henrik, David Bohr, Erwin Schrödinger, and Werner Heisenberg.

For the succession of grand pools leading to the Library's entrance, the artist saw an opportunity to combine story-telling with art using multiple themes.

Fine re-imagined Lee Lawrie's bronze *Well of Scribes* with a contemporary design, featuring a geographical map of significant Library fires, including the 1986 blaze at the Central Library. "We did a lot of research on all the basic destructions of books and libraries, accidental and on purpose, throughout history," he explained.

Fine chose the theme of "Evolution" to enliven the Library's pools of water.

The first pool feeding into Fine's *Well of Scribes* featured a waterspout crafted to represent an osteolepiform rhipidistian, an extinct ancient fish closely related to land-based vertebrates. Inside the pool, the artist re-created the skeleton of a labryrinthodont, an extinct amphibian partially submerged beside a large green rock. "The idea was that it would look like it was just lifted from the Natural History Museum," he said.

Fine created *Alphabet Spout*, made up of a variety of bronze letters, for the second pool, which displayed his design of a replica California newt cast in bronze, standing on a black granite rock in the water. The middle pool fed to its respective well, which was emblazoned with text symbolizing the advance of print.

For the uppermost pool, closest to the building, Fine chose a stainless steel female head as the waterspout to symbolize the "summit" of intelligence. Around her neck, a bronze collar contained symbols representing women, dreams, swimming, fertility, food, and the center of the world. Water flowed from the mouth and nose into a well, embellished with similar imagery.

Inside the third pool, the artist created a scale replica of a peregrine falcon, fixed upon a large red rock and about to take flight. Fine searched several local museums for an accurate model before finding the perfect specimen at the Santa Barbara Museum of Natural History.

The three pools were individually inscribed with Bright, Lucid and Clear, words often used to describe both water and intelligence.

For the incised steps leading to the Library, Fine turned to his former college roommate Harry Reese, an art professor at the University of California, Santa Barbara, for inspiration. Together, they researched the history of communication from ancient times to the electronic age before selecting eighty types of written expression that were sandblasted into the risers.

Fine and Reese's collaboration grew so extensively they chose to document their efforts in a volume titled *Spine*. "The problem with any kind of commission like this is somebody is going to know the truth," Fine explained. "You can't put in early Assyrian and just bluff it, because somebody is going to walk up and go, 'That's not right.' Everything had to be accurate and from original sources."

▶▲ *Jud Fine's study for a replica labyrinthodont.*
▶ *The completed work.*

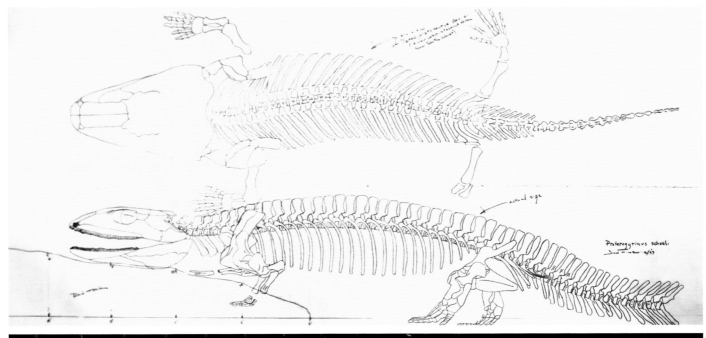

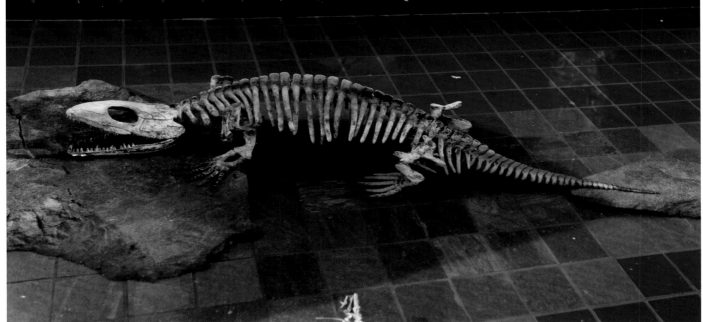

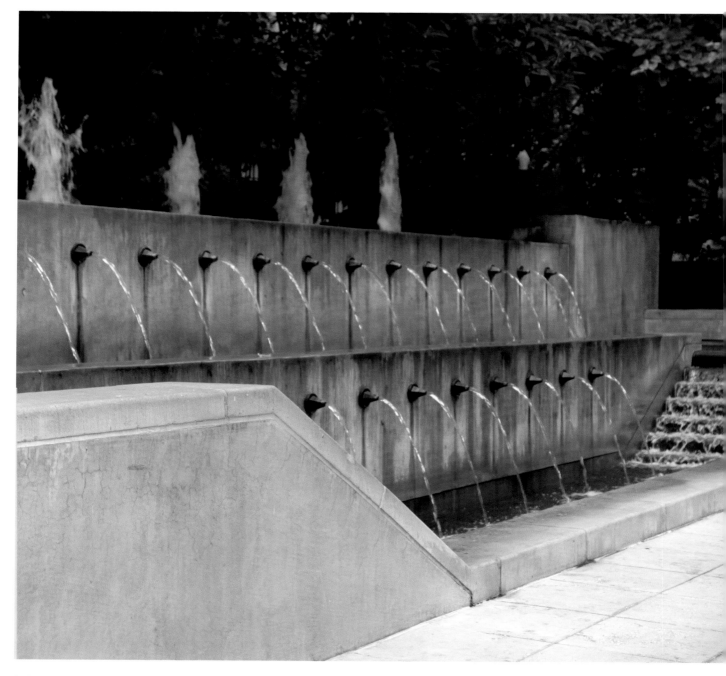

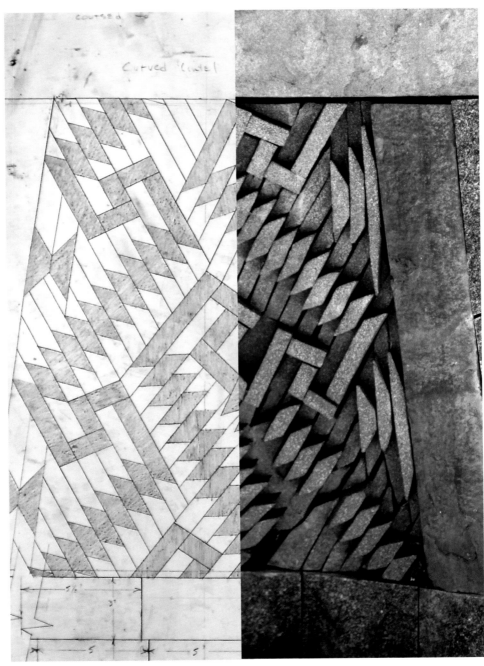

◀ *Fine looked to Mixtec and Inca architecture for his concept for this scalloped entry point. Design left, completed work, right.*

◀◀ *The Grotto Fountain was the centerpiece of Larry Halprin's design for the revitalized West Lawn.*

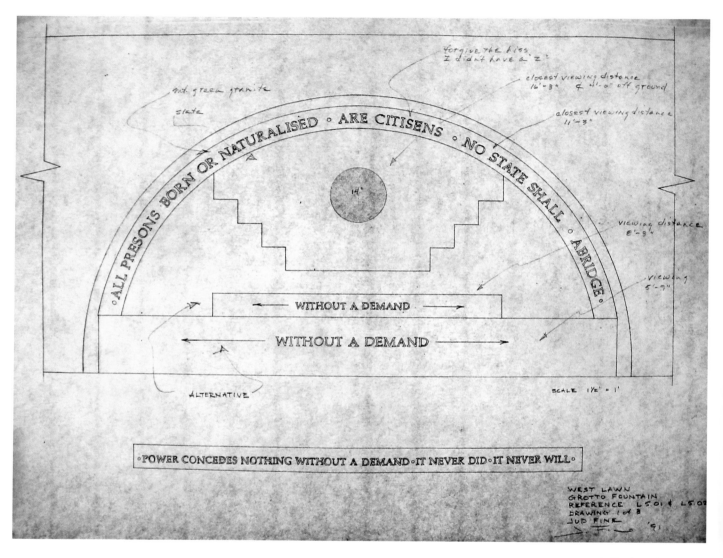

ALL PRESONS BORN OR NATURALISED · ARE CITISENS · NO STATE SHALL · ABRIDGE ·

WITHOUT A DEMAND

WITHOUT A DEMAND

·POWER CONCEDES NOTHING WITHOUT A DEMAND·IT NEVER DID·IT NEVER WILL·

forgive the kiss I didn't have a "z"

closest viewing distance 16'-3" & 41'-0" off ground

closest viewing distance 11'-3"

mt. green granite

slate

14'

viewing distance 8'-3"

viewing 5'-9"

ALTERNATIVE

SCALE 1½" = 1'

WEST LAWN
GROTTO FOUNTAIN
REFERENCE L5.01 & L5.02
DRAWING 1 of 3
JUD FINE
'91

▲ *Fine's early concept.*

▶ *Jud Fine selected the text for the Grotto Fountain, intended to provide a "snapshot" of the evolution of civil liberties in the United States.*

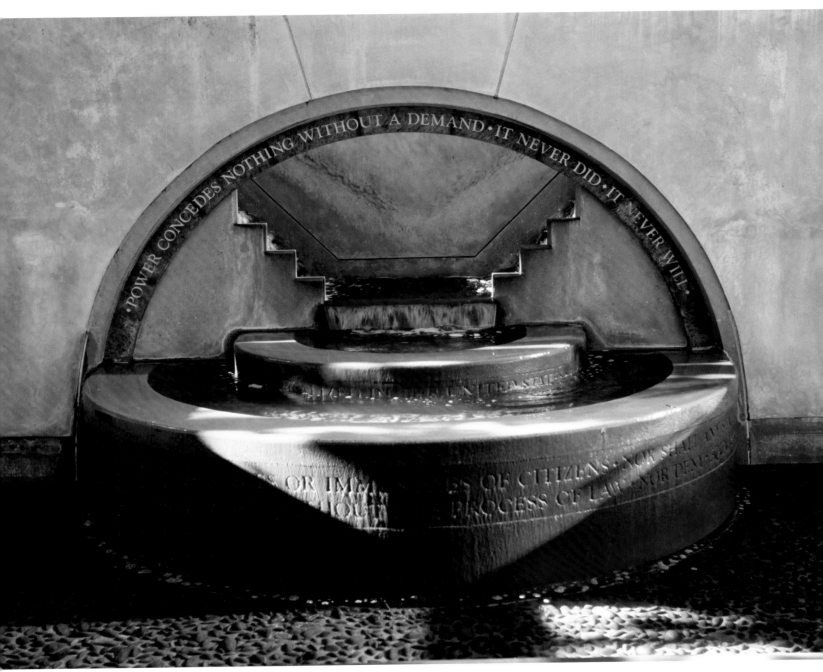

POWER CONCEDES NOTHING WITHOUT A DEMAND · IT NEVER DID · IT NEVER WILL

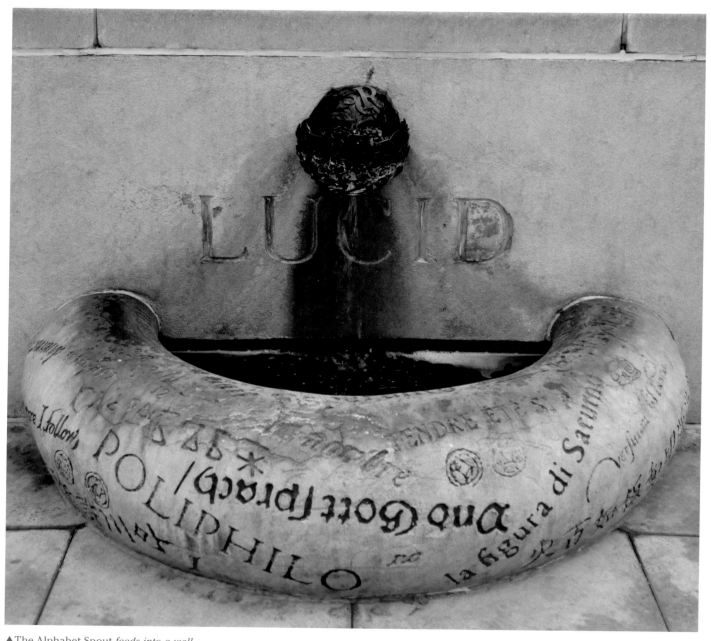

▲The Alphabet Spout *feeds into a well*
emblazoned with text.

▲▲ *Fine's study of a peregrine falcon.*
▲ *The completed work.*

▲ *A waterspout representing an*
osteolepiform rhipidistian, *an extinct ancient fish.*

▲▲ *Fine's art plan.*

▲ *Sections of the original model for Fine's Well of Scribes.*

▶ *Jud Fine's reimagined Well of Scribes featured a geographical map of significant library fires, including the 1986 blaze at the Central Library.*

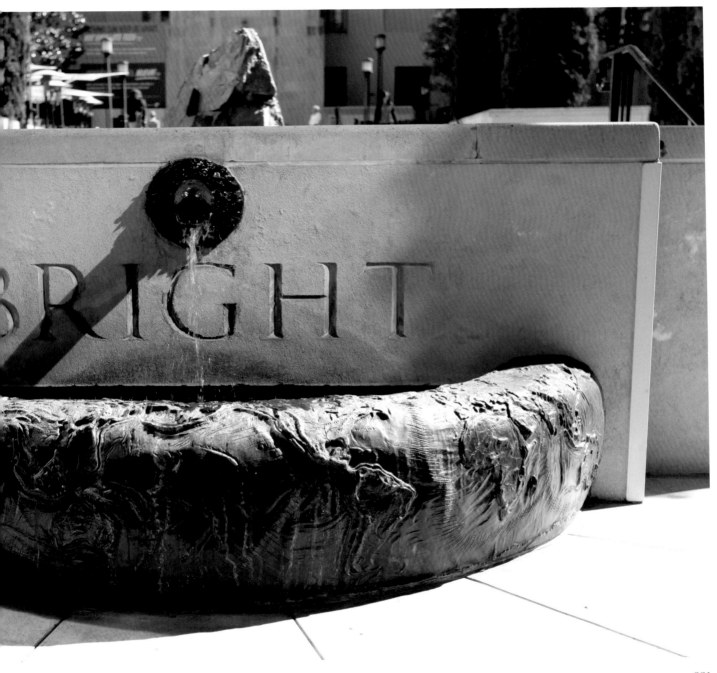

¾" TREADED FEMALE (STAINLESS STEEL)

SCREWS SEALENT

NIPPLE TO BE
ABSOLUTE RIGHT
ANGLES TO WALL
FACE

7"∅

3" DIA. OPENNING IN WALL

COUPLING

¾" RED BRASS TREADED
NIPPLE

2'-3"

1'

1'

TEXT 5"

2"

2'-1½"

SCALE 3" = 1'

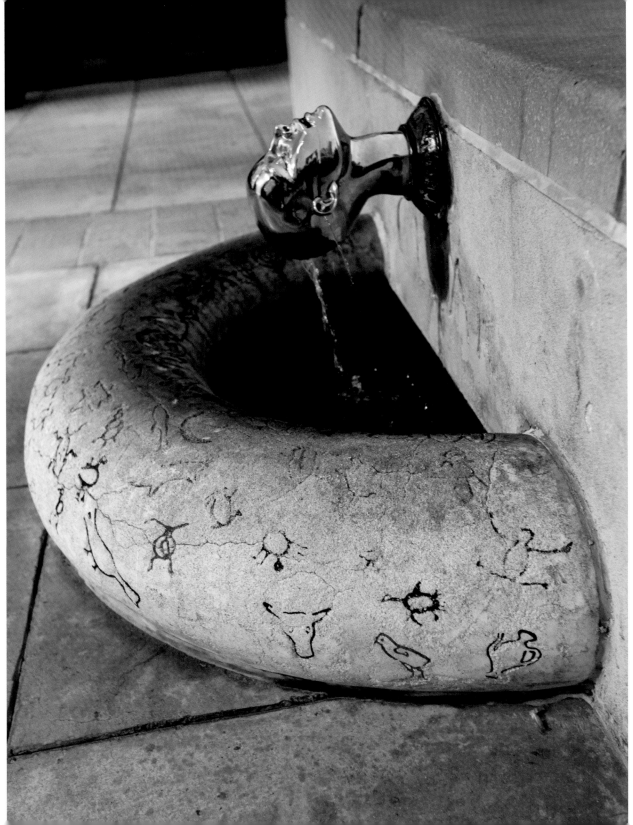

◀ *Fine chose a stainless steel female head as the waterspout to symbolize the "summit" of intelligence.*

◀◀ *Design.*

223

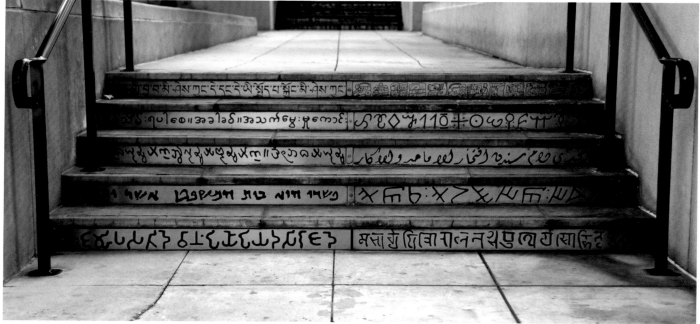

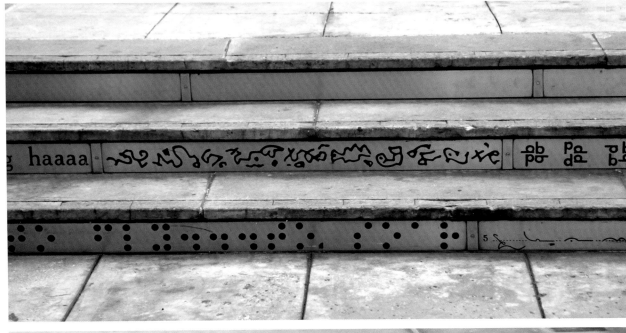

Fine designed each
section of steps to
reflect a different period
in the development of
communication.

◀ The Post Literate.

◀▼ The Archaic.

◀ ◀
Growth of Print.

◀ ◀ ▼ Emergence
of Writing;

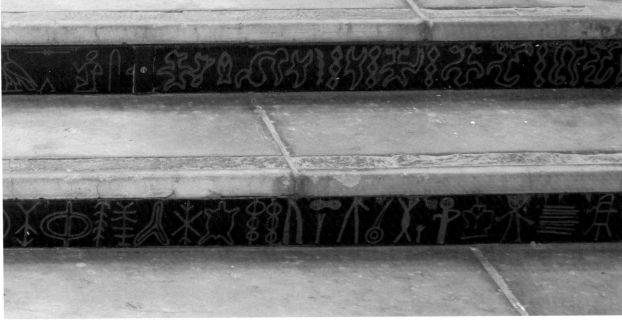

Laddie John Dill and Mineo Mizuno—*Nature's Analogy*

When Laddie John Dill was commissioned to create a fountain with a historical connection to Los Angeles, he found a geological solution to the challenge.

To maximize the use of space, he imagined a circular fountain on the north side of the property that featured cement, glass, and ceramic geometrical shapes. Mineo Mizuno was recruited to craft the ceramic forms at his Atwater studio.

"I found out that a small creek ran through the area way before downtown Los Angeles was built. I decided to use for coloration the minerals and oxides that are indigenous to the area," Dill explained. "We wanted to it to be very quiet and have a zen like feeling to it, with a slow kind of river-like form that goes around."[15]

The artist compared the design of the base of the fountain to the aperture of a camera. "We originally had glass tiles in the bottom of the fountain, but people were actually stealing them, so we replaced them with stone."

A Los Angeles native, Dill attended the Chouinard Art Institute and often used the Central Library as an important resource for his early work.

"What was exciting for me is when we had the opening and there were a lot of kids there and they immediately put their hands in the water and moved it around so it looked like they were putting their hands in paint because of all the color."

▶ *Laddie John Dill designed the* Nature's Analogy *fountain to have a geological connection to the history of Los Angeles.*

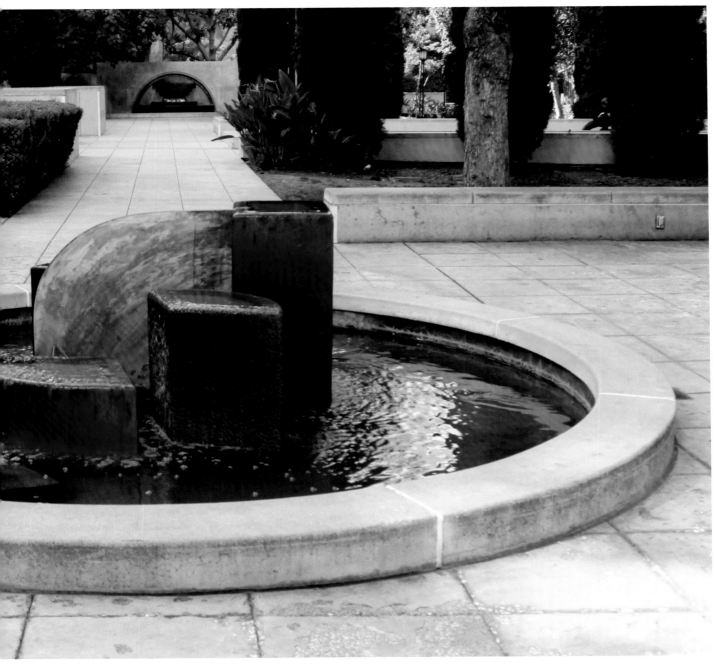

Robert Coffee—*Teen'Scape*

Four years after Hardy Holzman Pfeiffer Associates completed its work on the Library, architect Robert Coffee was commissioned to create a library within a library and a unique escape for teenagers.

Within the walls of what had once served as the Fiction Room, Coffee imagined Teen'Scape, a contemporary space that was empathetic to the needs of an emerging generation, while still honoring the significance of Bertram Goodhue's structure.

"The analogy I've always used is it was just the opposite of building the old ship in the bottle, we were doing a new environment inside a historical room," he said.[16] Historic preservation rules meant the architect was restricted from altering the original ceiling, walls, or historic parquet floor.

The architect was hired after Assistant Library Director Pat Kiefer attended a lecture by Coffee on the advances in library architecture. "I received a call to ask if I'd be interested in doing a project like that, and it was really new and cutting edge," he remembered. "One of the ideas we had was that Teen'Scape was an education arcade or carnival of knowledge."

Coffee worked closely with Georgette Todd, director of Young Adult Services, to get feedback from teens who would use the space before beginning the design process. "We actually met with a couple groups of teenagers," he explained. "We scheduled different work sessions with them after school and put together a questionnaire that we got responses to."

The architect responded to requests for computer stations, televisions, and more comfortable furniture and created a series of learning environments within the same space. He lowered the ceiling to create a more intimate experience. "They wanted living-room-style furniture, something a little more eclectic and able to be moved around," he said.

Coffee based his idea for the computer area on his own childhood memories of gathering in fast food restaurants with friends and compared his design to an early Internet cafe.

For the color scheme, the architect drew inspiration from Julian Garnsey's work. "If you look at that ceiling, it's really beautiful but it does combine some really nice juxtapositions of complimentary colors, and so we took that same thing but we just made it a little more vibrant."

Coffee also extended his vibrant architectural imprimatur to the Popular Books Library and the Adult Literacy Center, further adding to the renewal of the city's beloved Library.

▲▲▲

The architects and artists who worked to bring the Central Library's new wing to life understood what Bertram Goodhue, Carleton Winslow, Lee Lawrie, and so many others had fought for and accomplished decades earlier. At the dawn of a new millennium, the contemporary artists who worked on the expansion would come to share a profound connection with their visionary predecessors. They helped empower the historic Library, which had served generations, to bridge its storied past with a vital future. The Central Library represents the spiritual heart of Los Angeles. Even surrounded by skyscrapers, its power, purpose, and visual presence have not been overcome. One of the most identifiable architectural icons in Southern California, it remains an integral part of a resurgent downtown.

▶ *Teen'Scape was designed by architect Robert Coffee.*

BIBLIOGRAPHY AND CHAPTER NOTES

Bibliography

Amero, Richard W., and Michael Kelly. *Balboa Park and the 1915 Exposition.* Charleston: History Press, 2013

Broder, Patricia Janis. *Dean Cornwell: Dean of Illustrators.* New York: Balance House, 1978

Cobb, William Holmes. *The American Challenge, as Reflected in a Study of the Coat of Arms of the United States of America.* Beverly Hills, 1943

Cram, Ralph Adams. *My Life in Architecture.* Boston: Little, Brown, and Company, 1936

Dearinger, David B. *Paintings and Sculpture in the Collection of The National Academy of Design.* New York: Hudson Hills Press, 2004

Fine, Jud, and Harry Reese. *Spine: An Account of the Jud Fine Art Plan at the Maguire Gardens, Central Library, Los Angeles.* Los Angeles: Los Angeles Library Association, 1993

Gee, Stephen. *Iconic Vision: John Parkinson, Architect of Los Angeles.* Santa Monica: Angel City Press, 2013

Goodhue, Bertram Grosvenor, Hartley Burr Alexander, Ralph Adams Cram, George Ellery Hale, Lee Lawrie, Charles Howard Walker, and Charles Harris Whitaker. *Bertram Grosvenor*

Goodhue: Architect and Master of Many Arts. New York City: Press of the American Institute of Architects, 1925

Goodhue, Bertram Grosvenor. *Mexican Memories: The Record of a Slight Sojourn Below the Yellow Rio Grande.* New York: G.M. Allen, 1892

Harm, Gregory Paul, and Lee Lawrie. *Lee Lawrie's Prairie Deco: History in Stone at the Nebraska State Capitol.* Austin: Gregory Paul Harm and Susanne Patricia Harm, 2008

Hyers, Faith Holmes. *Hand Book of the Central Building, Los Angeles Public Library.* Los Angeles: Los Angeles Public Library, 1927

Lawrie, Lee. *Boy Wanted.* Lee Lawrie Papers (unpublished memoir). Library of Congress

Lawrie, Lee. *Sculpture.* Cleveland: J.H. Jansen, 1936

Luckman, Charles. *Twice in a Lifetime: From Soap to Skyscrapers.* New York: W.W. Norton, 1988

Oliver, Richard. *Bertram Grosvenor Goodhue.* New York; Cambridge, Mass.: Architectural History Foundation; MIT Press, 1983

Schmertz, Mildred F., and Nicholas Polites. *Hardy Holzman Pfeiffer Associates: Buildings and Projects, 1967–1992.* New York: Rizzoli International, 1992

Shand-Tucci, Douglass. *Ralph Adams Cram: Life and Architecture.* Amherst: University of Massachusetts Press, 1995

Soter, Bernadette Dominique, and Joan Muench. *The Light of Learning: An Illustrated History of the Los Angeles Public Library.* Los Angeles: Library Foundation of Los Angeles, 1993

Wyllie, Romy. *Bertram Goodhue: His Life and Residential Architecture.* New York: W.W. Norton, 2007

A Note on the Notes:

The Los Angeles Public Library Special Collections contain a wealth of information revealing the rich history of the Central Library. The correspondence among Bertram G. Goodhue, Lee Lawrie, Hartley Burr Alexander, and Everett R. Perry can be found in the Library of Congress and at the Ella Strong Denison Library at Scripps College in Claremont, California.

Abbreviations used for common sources:

AAA: Dean Cornwell papers, 1893–1981. Archives of American Art, Smithsonian Institution

AB: *American Builder*

AAFA: Bertram Grosvenor Goodhue Architectural Drawings and Papers, 1882–1980, Avery Architectural and Fine Arts Library, Columbia University

ESDL: Hartley Burr Alexander Papers, Ella Strong Denison Library, Scripps College, Claremont, California

LAT: *Los Angeles Times*

LAHer: *Los Angeles Herald*

LAPLM: Minutes, Los Angeles Public Library, Board of Commissioners

LAPLSB: Los Angeles Public Library, Scrapbook

LAE: *Los Angeles Express*

LMU: Charles Luckman Papers, Department of Archives and Special Collections, William H. Hannon Library, Loyola Marymount University

LOC: Lee Lawrie Papers 1908–1990, Library of Congress

NYHT: *New York Herald Tribune*

NYTrib: *New York Tribune*

NYT: *New York Times*

UCSB: Carleton Monroe Winslow Sr. papers, Architecture and Design Collection. Art, Design & Architecture Museum; University of California, Santa Barbara

Chapter Notes

Introduction

1. Goodnow, Marc. "Originality of Design is Seen in Los Angeles Library," AB, June 1, 1928, p. 118
2. Gage, Merrell. "The Art of Los Angeles Public Library, An Appreciation," *Artland*, August 1926, p. 3
3. Goodhue, Bertram. Letter to Hartley Burr Alexander, Mar 1, 1924, ESDL

Chapter 1

1. Perry, Everett R. *Dedicatory Exercises of the Central Library Building, Los Angeles*, July 15, 1926, ESDL
2. Gee, Stephen. *Iconic Vision*, p.150
3. "New Library in Demand," *LAT*, Jan. 28, 1904, p. A2
4. Lummis, Charles F. "The Humanities. The Public Library," *LAT*, June 19, 1921, p. III-39
5. "Want New Library," *LAHer*, Sep. 7, 1904, p. 5
6. "50,000 Sq. Ft. Will Be Space Occupied by L.A. Library," *Los Angeles Examiner*, June 22, 1913, p. 1
7. Goodnow, Marc. "Originality of Design is Seen in Los Angeles Library," *AB*, June 1, 1928; 45, 3. p. 118
8. Monnette, Orra E., president of the Board of Library Directors; Frances M. Harmon, chairman of the Committee on New Library and Site; Everett R. Perry, librarian. Letter Feb. 6, 1917 to City Council, City of Los Angeles, LAPLM, Feb. 20, 1917
9. "Library Building Urged. Plans for Type of Structure Needed Prepared by Local Architects," *LAT*, Mar. 20, 1921, p. V-1
10. Lummis. "The Humanities..."

11. "Cryer is Elected Mayor of Los Angeles," *LAT*, June 8, 1921, p. I-1
12. "Normal Hill is Library Choice," *LAT*, Nov. 9, 1921, p. II-1

Chapter 2
1. Public Library, California Graphic, p. 10, LAPL Scrapbook (LAPLSB)
2. "Architect for Library Named," *LAT*, Dec. 22, 1921, p. II-7
3. "Use Local Talent Is Cryer's Demand," *Los Angeles Express* (*LAE*), Dec. 22, 1921, LAPLSB
4. "Only Half of Big Fee Goes East," *LAT*, Dec. 24, 1921
5. "Protest Library Architect Choice," *LAE*, Dec. 23, 1921, LAPLSB
6. Ibid.
7. "Architects Bid Held Invalid," *LAT*, Jan. 27, 1922, p. II-3
8. "Library Plan Bids Received," *LAT*, Feb. 22, 1922, LAPLSB
9. "Ask Action on Library Plans," *LAT*, June 22, 1923, p. II-1
10. Goodhue, Bertram. Letter to F.W. Blanchard, President Municipal Art Commission, June 4, 1923, LAPLM, June 27, 1923
11. Municipal Art Commission of Los Angeles. Letter to the Board of Library Directors, June 26, 1923, LAPLM, June 27, 1923
12. Goodhue, Bertram. Letter to Hartley Burr Alexander, Feb. 18, 1924, ESDL
13. "Library Plan Is Still In Air," *LAT*, July 7, 1923, p. II-1
14. "Library Site Needs Outlet," *LAT*, May 20, 1923, p. II-1
15. "Mitchell Quits Art Body," *LAT*, July 8, 1923, p. II-9
16. Goodhue. Letter to Hartley Burr Alexander, Feb. 18, 1924, ESDL
17. Goodhue. Letter to Hartley Burr Alexander, Mar. 14, 1924, ESDL
18. Francis L.S. Mayers. Letter to Everett R. Perry, May 19, 1924. LAPLM, May 26, 1924
19. "Contract Let For Edifice," *LAT*, Aug 17, 1924, p.5
20. LAPLM, Sep. 18, 1924
21. "Library Contract Is Given," *LAT*, Oct. 9, 1924, p. A-1
22. Ibid.
23. Perry, Everett R. *Dedicatory Exercises of the Central Library Building, Los Angeles*. July 15, 1926, ESDL
24. Ibid.

Chapter 3
1. Goodhue, Alexander, et al. p. 27
2. Los Angeles Public Library. *Thirty-seventh Annual Report of the Board of Directors of the Los Angeles Public Library, For the Year Ending June 30, 1925*, p. 6
3. Oliver, Richard. *Bertram Grosvenor Goodhue*, p.10
4. Cram, Ralph Adams. *My Life in Architecture*, p. 69
5. Lawrie, Lee. *Boy Wanted*, LOC
6. Ibid.
7. Goodhue, Alexander, et al. p. 33
8. "Twelfth-Night in Mr. Goodhue's Office," *Pencil Points*, Feb. 1922, p. 25
9. Wyllie, Romy. "Henry Washington to C.H. Whitaker, Feb. 15, 1925, Family Archives." In *Bertram Goodhue: His Life and Residential Architecture*, p. 17
10. Goodhue, Bertram. Letter to Frazer Gibson, Jan. 2, 1913, AAFA
11. "Young Boswell Interviews Bertram Goodhue," *NYHT*, Feb. 6, 1923, p.11
12. Goodhue, Alexander, et al. p. 30
13. Cram. *My Life in Architecture*, p. 69
14. Goodhue, Alexander, et al. p. 32
15. Goodhue, Bertram Grosvenor. *Mexican Memories*
16. Amero, Richard W., and Michael Kelly. *Balboa Park and the 1915 Exposition*, p. 30
17. Kent, William Winthrop. "Domestic Architecture of California," *The Architectural Forum*, Mar. 1920, Number 3, Volume XXXII, p. 98
18. "Goodhue to Work Alone," *NYT*, Aug. 14, 1913, p.8
19. Goodhue, Alexander et al. p. 45
20. Ibid. p. 26

21. Oliver, Richard, *Bertram Grosvenor Goodhue*, p. 224
22. Ripley, Robert. Interview with author, Sep. 2, 2015
23. Goodhue, Alexander et al. p. 44
24. Lawrie, Lee. Letter to Hartley Burr Alexander, Apr. 29, 1924, ESDL
25. Lawrie, Lee. Letter to Hartley Burr Alexander, Sep. 19, 1924, ESDL
26. Lawrie, Lee. *Boy Wanted*, LOC

Chapter 4
1. Hyers, Faith Holmes. *Hand Book...*, p. 11
2. Goodhue, Lydia. Letter to Carleton M. Winslow, May 28, 1924, UCSB
3. Gage, Merrell, "The Art of Los Angeles Public Library, An Appreciation," *Artland*, Aug 1926, p. 3
4. Ibid.
5. Winslow, Carleton M. Biographical Sketch, UCSB
6.–11. Ibid.
11. "City Seal 22 Years Old This Week; 1914 Designer Tells Significance," *San Diego Union*, Apr 12, 1936, Carleton M. Winslow, Personal Miscellany Scrapbook, UCSB
12. LAPLM, Jan. 13, 1926
13. Los Angeles Public Library Official Seal, LAPL Special Collections
14. Cobb, William Holmes. *The American Challenge, as Reflected in a Study of the Coat of Arms of the United States of America*. Beverly Hills, 1943
15. Letter from the Corner Stone Committee, LAPL to Board of Library Directors, LAPL, Nov. 28, 1924
16. LAPLM, May 3, 1925
17. Winslow, Carleton M. Letter to Everett Perry, Nov. 22, 1930, LAPLM, Nov. 26, 1930
18. Winslow, Carleton M. Letter to Lydia Goodhue, Feb. 17, 1927, UCSB

Chapter 5
1. "Where Simplicity Means Beauty," *Sunset Magazine*, Dec. 1926, p. 17
2. "Where Simplicity..., p. 33
3. Goodhue, Bertram. Letter to William Lethaby, Mar. 7, 1924, AAFA
4. Mumford, Lewis. "American Architecture Today," *Architecture* 58 (Oct. 1928), p. 190
5. Wyllie, Romy. Interview with author, Sep. 5, 2015
6. Goodhue, Alexander, et al. p. 43
7. Perry, Everett R. Letter to Hartley Burr Alexander, Apr. 8, 1924, ESDL
8. Hyers. *Hand Book ...*, p.11
9. Winslow, Carleton M. "The Los Angeles Public Library," *Western Architect*, Feb. 1926, p. 21
10. LAPLM, Sep. 24, 1925
11. Winslow, Carleton M. Letter to Board of Library Commissioners, Sep. 28,1928. LAPLM, Sep. 24, 1925
12. Nelson, H. A. Letter to Board of Library Commissioners, Nov. 10, 1925, LAPLM, Nov. 10, 1925
13. Winslow, Carleton. "The Los Angeles..." *Western Architect*, p. 21
14. Goodhue, Bertram. Letter to Hartley Burr Alexander, Mar. 1, 1924, ESDL
15. Winslow. "The Los Angeles…" *Western Architect*, p. 22
16. Hyers. *Hand Book...*, p. 27
17. Hyers. *Hand Book...*, p. 33
18. Strickley, J.K. "Original Lighting Effects at New Public Library," *Artland*, Sep.1926
19. Wyllie, Romy. *Bertram Goodhue*, p.40
20. Ibid.
21. Goodhue, Bertram. Letter to Hartley Burr Alexander, Mar. 1, 1924, ESDL
22. LAPLM, Feb. 24, 1926
23. LAPLM, June 16, 1926
24. Millier, Arthur. "Of Art and Artists, New Public Library Superb Work of Art," *LAT*, July 18, 1926, p. C20

25. Gage, Merrell. "The Art of Los Angeles Public Library, An Appreciation," *Artland*, Aug. 1926, p. 8
26. Goodnow, Marc N. "Originality of Design is Seen in Los Angeles Library," *AB*, June 1, 1928, p. 118
27. *Thirty-Eighth Annual Report of the Board of Directors of the Los Angeles Public Library, For the Year Ending June 30, 1926*, p. 6

Chapter 6
1. Hyers. *Hand Book...*, p. 17
2. Goodhue, Bertram. Letter to Lee Lawrie, Mar. 13, 1924, ESDL
3. Goodhue, Bertram. Letter to Hartley Burr Alexander, Feb. 18, 1924, ESDL
4. Alexander, Hartley Burr. Curriculum Vitae, Composed from Memory, Memoranda, and Mementos, October 1935, ESDL
5.–10. Ibid.
11. Harm, Gregory Paul and Lee Lawrie. *Lee Lawrie's Prairie Deco*, p. 32
12. Alexander, Hartley Burr. Nebraska State Capitol, Goodhue Correspondence Notes, ESDL
13. Lawrie, Lee. Letter to Hartley Burr Alexander, Nov. 28, 1925, ESDL
14. Goodhue. Letter to Hartley Burr Alexander, Mar. 1, 1924, ESDL
15. Ibid.
16. Hyers. *Hand Book...*, p. 18
17. "Story of the Inscriptions. Prepared for the Client for Publicity," ESDL
18. Goodhue. Letter to Hartley Burr Alexander, Mar. 1, 1924, ESDL
19. Ibid.
20. Hyers. *Hand Book...*, p. 18
21. Perry, Everett R. Letter to Hartley Burr Alexander, July 9, 1924, ESDL
22. Winslow, Carleton M.. Letter to Hartley Burr Alexander, Nov. 12, 1924, ESDL
23. "Story of the Inscriptions. Prepared for the Client for Publicity," ESDL
24. Lawrie. Letter to Hartley Burr Alexander, Jan. 6, 1927, ESDL
25. "Story of the Inscriptions, Prepared for the Client for Publicity," ESDL
26. Goodhue. Letter to Hartley Burr Alexander, Mar. 1, 1924, ESDL
27. Perry, Everett R., "The Lee Lawrie Sculptures of the Los Angeles Public Library," *Journal of the American Institute of Architects*, Vol. XVI, May 1928, No. 5, p. 169
28. Goodhue. Letter to Hartley Burr Alexander, Mar. 1, 1924, ESDL
29. Ibid.
30. Lawrie. Letter to Hartley Burr Alexander, Jan. 6, 1927, ESDL
31. Hyers. *Hand Book...*, p. 18
32. Ibid.
33. Los Angeles Public Library. "Thematic Synopsis of the Sculpture and Inscriptions, Prepared for the Architect," ESDL
34. "Story of the Inscriptions, Prepared for the Client for Publicity," ESDL
35. Hyers. *Hand Book...*, p. 20
36. Goodhue. Letter to Hartley Burr Alexander, Mar. 1, 1924, ESDL
37. Los Angeles Public Library, "Thematic Synopsis of the Sculpture and Inscriptions, Prepared for the 38. Architect." ESDL
38. Lawrie. Letter to Hartley Burr Alexander, Jan. 23, 1926, ESDL
39. Lawrie. Letter to Hartley Burr Alexander, Nov. 28, 1925, ESDL
40. Hyers. *Hand Book...*, p. 16
41. Ibid. p. 17
42. Lawrie. Letter to Hartley Burr Alexander, Jan. 23, 1926, ESDL
43. Goodhue. Letter to Hartley Burr Alexander, Mar. 1, 1924, ESDL
44. Lawrie. Letter to Hartley Burr Alexander, Sep. 16, 1929, ESDL
45. Hyers. *Hand Book...*, p. 21
46. Alexander, Hartley Burr. Letter to Lee Lawrie, May 20, 1936, ESDL
47. Bertram Goodhue Associates. Letter to Everett R. Perry, Jan 18, 1926, ESDL
48. Alexander, Hartley Burr. Letter to Carleton M. Winslow, Feb 6, ESDL
49. Winslow. Letter to Hartley Burr Alexander, Feb 1, 1926, ESDL

Chapter 7
1. Hyers. *Hand Book...*, p. 16
2. Hyers. "The Significance of Our New Library," *The Municipal Employee*, Aug. 1926
3. "Twelfth-Night in Mr. Goodhue's Office," *Pencil Points*, Feb. 1922, p. 25
4. Goodhue, Alexander, et al. p. 34
5. Wolcott, Anne Lee Lawrie. *Recollections, 1990*, LOC
6. Kiselewski, Joseph. "My Four Years with Lee Lawrie," *National Sculpture Review*, Summer 1963, p. 26
7. Lawrie, Lee. *Sculpture*, Foreword
8. Lawrie. *Sculpture*, p. 26
9. ibid.
10. Lawrie, Lee. *Boy Wanted*, LOC
11. bid.
12. Goodhue, Alexander et al. p. 33
13. "Lee Lawrie's Sculpture For The Nebraska State Capitol," *The American Magazine of Art*, Vol. 19, No.1 (Jan., 1928) p. 13
14. Ibid.
15. Goodhue, Alexander, et al. p. 35
16. "Lee Lawrie's Sculpture For The Nebraska State Capitol," *The American Magazine of Art*, Vol. 19, No.1 (Jan, 1928) p. 16
17. Alexander, Hartley Burr. "The Sculpture of Lee Lawrie, An Appreciation of his Latter Work," *Architectural Forum*, May, 1931, p. 597
18. Goodhue, Bertram G. Letter to Everett Perry, Nov. 2, 1923, LOC
19. Goodhue. Letter to Everett Perry, Nov. 13, 1923, LOC
20. Lawrie, Lee. Letter to Bertram G. Goodhue, Feb. 18, 1924, LOC
21. Goodhue, Bertram G. Letter to Lee Lawrie, Feb. 19, 1924, LOC
22. Lawrie, Lee. Letter to Hartley Burr Alexander, Nov. 19, 1924. ESDL
23. LAPLM, Jan. 14, 1925
24. Lawrie, Lee. Letter to Hartley Burr Alexander, June 1, 1927. ESDL
25. Hyers. *Hand Book...*, p. 14
26. Hyers. *Hand Book...*, p. 15
27. Hyers, Faith Holmes. "Sculptured Figures of Ancient Sages to 'Guard' New Library," *LAE*, Mar. 11, 1926, p. 14
28. Winslow, Carleton M. Letter to Lydia Goodhue, Feb. 17, 1927, UCSB
29. Lawrie. Letter to Bertram Goodhue Associates and Carleton M. Winslow, Sep. 12, 1927, LAPLM, Sep. 14, 1927
30. Ibid.
31. "Sculpture Now Complete, Lee Lawrie's Work Now Finished, Gives Library Rare Distinction Among Nation's Buildings," *LAT*, June 15, 1930, p. B15
32. Ibid.
33. Hyers, Faith Holmes. "New Art Treasures for Los Angeles," *California Arts & Architecture*, Jan. 1931, p. 23
34. Perry, Everett R. Letter to Lee Lawrie, June 19, 1930, Los Angeles Public Library
35. Lawrie. Letter to Hartley Burr Alexander, Jan 23, 1928, ESDL

Chapter 8
1. Hyers. *Hand Book...*, p. 23
2. Hyers. "Variety of Ornamental Styles to Decorate Edifice," *LAT*, Jan. 10, 1926, p. B3
3. Winslow, Carleton M. Letter to Board of Library Commissioners, Dec. 14, 1925, LAPLM, Dec. 16, 1925
4. "The Color Plates and the Art of Julian E. Garnsey," *California Southland*, UCSB
5. Hyers. "Variety of Ornamental..."
6. "The Color Plates...," *California Southland*, UCSB
7. Hyers. "Variety of Ornamental..."
8. Hyers. *Hand Book...*, p. 24
9. "The Color Plates...," *California Southland*, UCSB

10. Garnsey, Julian E. Letter to Carleton M. Winslow, Jan. 12, 1926, LAPLM, Dec. 20, 1926
11. LAPLM, Apr. 28, 1926
12. Millier, Arthur. "Of Art and Artists: New Public Library Superb Work of Art," *LAT*, July 18, 1926, p. C20
13. LAPLM, Mar. 24, 1926
14. LAPLM, June 23, 1926
15. Gage, Merrell. "The Art of Los Angeles Public Library, An Appreciation," *Artland*, Aug. 1926, p. 8
16. "Sculpture Now Complete, Lee Lawrie's Work Now Finished, Gives Library Rare Distinction Among Nation's Buildings," *LAT*, June 15, 1930, p. B15
17. LAPLM, Feb. 1, 1933

Chapter 9
1. "Huge Paintings for Los Angeles Near Completion in London Studio," *The Deseret News*, Jan. 10, 1931, Section Three, p. VII
2. Cornwell, Dean. Handwritten Biography, Dean Cornwell papers, 1893–1981. Archives of American Art, Smithsonian Institution (AAA)
3. Cornwell, Dean and Patricia Janis Broder. *Dean Cornwell*, p. 6
4. Ibid.
5. Untitled article, AAA
6. Cornwell and Broder. p. 18
7. Cornwell and Broder. p. 22
8. Cornwell, Dean. Letter to Everett R. Perry, Dec. 7, 1926, LAPLM, Dec. 15, 1926
9. Goodhue, Bertram G. Letter to Hartley Burr Alexander, Mar. 14, 1924, ESDL
10. Lawrie, Lee. Letter to Everett R. Perry, Nov. 24, 1926, LAPLM, Dec. 1, 1926
11. Millier, Arthur. "Art and Artists: Interest to Artists," *LAT*, June 12, 1927, p. 22
12. LAPLM, June 1, 1927
13. Los Angeles Public Library Board of Commissioners. Letter to Dean Cornwell, Feb 1, 1933, LAPLM, Feb. 1, 1933
14. LAPLM, June 1, 1927
15. "L.A. Library Mural Award Will Be Made," *LAE*, June 5, 1927, p. 2
16. Millier, Arthur. "Art and Artists: Dean Cornwell Gets Library Mural Job," *LAT*, June 19, 1927, p. 24
17. Cornwell, Dean. Letter to Everett R. Perry, July 18, 1929, LAPLM, July 31, 1929
18. "Library Mural Paintings Huge," *LAT*, June 7, 1931, p. B8
19. Sugrue, Thomas. "Murals Painted In 5-Year Task Without Profit," *NYHT*, Feb. 26, 1933, p. 15
20. Cornwell, Dean. Letter to Everett R. Perry, July 18, 1929, LAPLM, July 31, 1929
21. Ibid.
22. LAPLM, Aug. 7, 1929
23. Sugrue, Thomas. "Murals Painted In 5-Year Task Without Profit," *NYHT*, Feb. 26, 1933, p. 15
24. Winslow, Carleton M. Letter to Everett R. Perry, Feb. 29, 1932, UCSB
25. *Forty-Fourth Annual Report of the Board of Library Commissioners of the Los Angeles Public Library, For the Year Ending June 30, 1932*, p. 6
26. Sugrue. "Murals Painted…"
27. Library Board of Commissioners. Letter to Dean Cornwell, Feb. 1, 1933, LAPLM, Feb. 1, 1933
28. Craven, Thomas. "Politics & The Painting Business," *American Mercury*, Dec. 1932, p. 463
29. Millier, Arthur. "New Frescoes for Los Angeles," *NYT*, Oct. 1w6, 1932, p. X10
30. Sugrue, Thomas. "Murals Painted..."

Chapter 10
1. Sears, Urmy M. "The Herter Murals In Los Angeles, California's History-Pageant Painted by Her Greatest Artist Found in Catacombs of the Public Library," *Arts & Architecture*, 1929, LAPL Rare Books Dept. Architecture clippings file
2. Ibid.
3. "Sergeant Herter, Son of Artist, Dies of Wounds," *NYT*, June 28, 1918, p. 3
4. LAPLM, Jan. 12, 1927
5. Herter, Albert. Letter to Mrs. Salazar, contained in LAPLM, June 13, 1927
6. Herter, Albert. Letter to Everett R. Perry, Dec. 7, 1927. LAPLM, Dec. 14, 1927
7. Herter. Letter to Everett R. Perry, Mar. 21, 1928, LAPLM
8. Ibid.
9. Dearinger, David B. *Paintings and Sculpture in the Collection of The National Academy of Design*, p. 266
10. Redmon, Michael. "History 101," *The Santa Barbara Independent*, June 7, 2001, p. 35
11. LAPLM, Dec. 12, 1928
12. Millier, Arthur. "Art and Artists: Fechin Color Is Inimitable," *LAT*, Apr. 8 1928, p. C18
13. Sears. "The Herter Murals…"
14. Herter. Letter to Everett R. Perry, Oct. 19, 1929, LAPLM, Oct. 23, 1929
15. Herter. Letter to Everett R. Perry, Oct. 7, 1929, LAPLM, Oct. 9, 1929
16. LAPLM, Apr. 12, 1929
17. LAPLM, Jan. 15, 1930
18. "Art and Artists: Library Murals End Trek," *LAT*, June 1, 1930, p. B16

Chapter 11
1. Teoman, Betty Gay. Interview with author, Jan. 2, 2016
2. "Central Library to Be Razed, Commission Says," *LAT*, Mar. 31, 1967, p. SF7
3. Braude, Marvin. Councilman Press Release, Jan. 5, 1967, UCSB
4. Townsend, Dorothy. "Huge L.A. Library System Gets a Chief," *LAT*, Aug. 21, 1970, p. D5
5. Luther, Claudia. "Panel Wants It Replaced: 'Save Library' Plea Losing," *LAT*, Apr. 5, 1974
6. Dreyfuss, John. "Library Woes: L.A. Wrote the Book," *LAT*, Feb. 3, 1980, p. 1
7. Herbert, Ray. "Three Sites Recommended for New Central Library," *LAT*, Jan. 16, 1976, p. C1
8. Herbert, Ray. "Library Renovation Cost Put at $38.3 Million," *LAT*, Mar. 2, 1977, p. D1
9. Herbert, Ray. "Council Again OKs Library Expansion," *LAT*, July 6, 1979, p. D1
10. Burnett, Samuel M. Letter to Charles Luckman, June 5, 1978, LMU
11. Bach, Margaret. Interview with author. Dec. 17, 2015
12. Marten, Michael. "Council Questions Choice of Luckman for Library Study," *Los Angeles Herald-Examiner*, July 28, 1979, p. A-1
13. Ibid.
14. Herbert, Ray. "Council Puts Off Library Project Architect Choice," *LAT*, July 28, 1979, p.A30
15. Luckman, Charles. *Press Conference at the Los Angeles Press Club*, Aug. 1, 1979, transcript, LMU
16. Ibid.
17. Luckman, Charles. Letter to Joseph Becker, Aug. 20, 1979, LMU
18. Herbert, Ray. "Council Kills Plan to Expand, Renovate Central Library," Sep. 27, 1979, *LAT*, p. B3
19. Comrie, Keith. Interview with author. Jan. 6, 2016
20. Welborne, John. Interview with author, Jan. 6, 2016
21. Phelps, Barton. Transcript of speech "Financing and

Construction of a New Central Library," presented to Central City Association, Apr. 22, 1981, Barton Phelps private archive.

22. Maguire, Robert. Interview with author, Jan. 12, 2016
23. Bradley, Thomas. Letter to Ruthann Lehrer, Los Angeles Conservancy, Mar. 13, 1981, John Welborne private archive
24. Maguire, Robert, Interview with author, Jan. 12, 2016
25. Helfeld, Edward. Interview with author, Jan. 6, 2016
26. Pfeiffer, Norman. Interview with author, Sep. 3, 2015
27. Chambers, Marcia. "22 Injured as Los Angeles Library Burns," *NYT*, Apr 30, 1986, p. A14
28. Ibid.
29. Morrison, Patt and Cathleen Decker. "One Year Later, Wounds of the Library Fire Slow to Heal," *LAT*, Apr. 28, 1987, p. 1
30. Woo, Elaine, "A Day to Beam at Central Library," *LAT*, Mar 16, 1991, p. VYB1
31. Franey, Lynn. *San Diego Union-Tribune*, Oct. 4, 1993, p. A-3
32. Ibid.

Chapter 12
1. Pfeiffer, Norman. Interview with author, Sep. 3, 2015
2. Teoman, Betty Gay. Interview with author, Jan. 2, 2016
3. Harris, Scott. "Design Panel to Advise City on Public Projects," *LAT*, Dec. 9, 1987, p. C1
4. Harris, Scott. "Dispute Over Library Ends; Architect's Plan Accepted," *LAT*, Apr. 22, 1988, p. D1
5. Kibby, Charles. Interview with author, Oct. 26, 2015
6. Petropoulos, Renée. Interview with author, Oct. 18, 2015
7. Preston, Ann. Interview with author, Nov. 4, 2015
8. Statom, Therman. Interview with author, Jan. 7, 2016
9. Bunn, David. Written answers sent to author, Dec. 5, 2015
10. Niemi, Ries. Interview with author, Oct. 19, 2015
11. Maguire, Robert. Interview with author, Jan. 12, 2016
12. Welborne, John. Interview with author, Jan. 6, 2016
13. Campbell, Douglas & Regula. Interview with author, Jan. 4, 2016
14. Fine, Jud. Interview with author, Nov. 10, 2016
15. Dill, Laddie John. Interview with author, Jan. 8, 2016
16. Coffee, Robert. Interview with author, Nov. 9, 2015

▲▲▲ ▲▲▲

IMAGE CREDITS

Arnold Schwartzman photographed the Los Angeles Central Library for several months between 2015 and 2016, focusing on its dramatic art and architecture. The history of the Central Library and its visual impact would be impossible to tell if not supplemented by the historic-image contributions of the individuals and institutions listed below. The majority of historic photographs were discovered in the extensive collection of the Los Angeles Public Library Photograph Collection and the Library's Special Collections. Additionally, a few historic publications provided the only images available of important aspects of the Central Library history. The pages of the image contributions are listed at the end of each entry. Any oversights are unintentional and will be corrected in future editions.

Los Angeles Public Library

Los Angeles Public Library Photo Collection: 15, 19, 22, 24, 60, 61, 64–65, 67, 68, 78, 79, 147, 149, 157, 187, 194

Los Angeles Public Library, Scrapbook: 23, 25, 40–41

Los Angeles Public Library, Special Collections: 42, 43, 55, 56, 143, 145

Other Sources

Archives of American Art, Smithsonian Institution. Dean Cornwell papers, 1893–1981: 144, 152

Ella Strong Denison Library, Scripps College, Claremont, California: 32–33, 89, 93, 94, 95, 101, 134–135

Jud Fine: 212, 215, 217, 218, 221, 222, 224

Richard Gardner and Frank Famiglietti: 45, 124–125

Nicholas Goodhue and Romy Wyllie: 35

Los Angeles City Art Collection, Public Art Div.: 153, 162, 163, 166, 167

Library of Congress, Washington, D.C.: 18, 113, 171

Los Angeles Dept.of Public Works, Bureau of Engineering: 80, 82

Los Angeles City Archive: 58, 72, 74, 76, 90, 118–119

Luckman Salas O'Brien: 188, 189

Robert Maguire: 191

Minnesota Historical Society: 127

Pfeiffer Partners, Architects: 184–185, 197, 198–199, 200, 202

UCLA Library; Special Collections, *Los Angeles Times*: 84–85

University of California, Santa Barbara; Art, Design & Architecture Museum; Carleton Monroe Winslow Sr. papers: 47, 48–49, 50

Publications

American Architecture of the Twentieth Century, Vol. 2., by Oliver Reagan. 1927: 28, 59, 62–63

Architect and Engineer of California 50, July 1917: 20–21

Architecture 27, by Cram, Goodhue & Ferguson. May 1913: 36–37

Bertram Grosvenor Goodhue by Bertram Goodhue et. al., 1925: 42

The California Southland, May 1926: 129

The International Competition for a New Administration Building for The Chicago Tribune, 1923: 57

The publication of this book would not have been possible without the generous contribution and passion of Councilman Tom LaBonge, a great friend of the Los Angeles Public Library System and the Central Library, in particular. The authors thank him, not only for his support of this book, but also for his unfailing passion for Los Angeles and preserving its history. We extend our utmost thanks to Los Angeles City Librarian John F. Szabo for his astute Foreword to this book and for his dedication to preserving the world's cultural heritage through public libraries. These men believed in this project from the start, and we are grateful. —AS and SG.

Sincere thanks to Stephen Gee for his excellent collaboration and friendship in making this book a memorable experience, and to our publishers, Paddy Calistro and Scott McAuley, for their superb attention to every detail of this book. Grateful thanks to the dedicated and patient Central Library staff: Juli Kolb, Ani Boyadjian, Christina Rice, Terri Garst, Mark Carreon and his crew from the General Services Department, and the Security department. Many thanks also to R.O. Blechman, Richard Gardner, and Frank Famiglietti. —A.S.

This book was made possible through the efforts of many people. It was a great privilege to collaborate with Arnold and Isolde Schwartzman, and to work with Paddy Calistro and Scott McAuley at Angel City Press on a second book. I would like to say a personal thank-you to Jo for her incredible support.

I also am very grateful to John Szabo's incredible staff at the Los Angeles Public Library, including Ani Boyadjian, Sheila Nash, Eileen King, Emma Roberts, and Christina Rice.

I am thankful to the many people I interviewed including: Margaret Bach, David Bunn, Douglas and Regula Campbell, Robert Coffee, Keith Comrie, Laddie John Dill, Patricia Evans, Jud Fine, Edward Helfeld, Murray O. Kane, Charles Kibby, Robert F. Maguire III, Ries Niemi, Renée Petropoulos, Norman Pfeiffer, Barton Phelps, Ann Preston, Robert Ripley, Therman Statom, Betty Gay Teoman, John Welborne, and Romy Wyllie.

Many archives contributed to this project. Thanks belong to Michael Holland and Todd Gaydowski, Los Angeles City Archives; Elizabeth Christopher, Archives of American Art, Smithsonian Institution; Judy Harvey Sahak and Dorran Boyle, Ella Strong Denison Library at Scripps College; Jeff Bridgers, Jonathan Eaker and Barbara Orbach Natanson, Library of Congress; Clay Stalls, William H. Hannon Library, Loyola Marymount University; Jocelyn Gibbs and Alexandra Adler, University of California Santa Barbara Art, Design & Architecture Museum; Rochele Gomez, Los Angeles City Art Collection; and Nicole Richard, Avery Architectural & Fine Arts Library, Columbia University. I am also grateful to Christina Chan, Nicholas Goodhue, Susan Nash, David Trilling, Charlotte He, Ron Johnson, Ruth and Bill Mellor, Mark Nakata, Ken Bernstein, Jerome Anderson, Barbara Sayre Casey, Arnold Kraakmo, Katerina Sinitskaya, Pamela Mosher, Danielle Hargate, Sally Bettinson, Susan Kwan, Jeffrey Burbank, Sheila and Gordon Richards, Patricia Casado, Shirley Wilson, Sheila Tepper, Glenda Cooper, Ali Abbas, Detlof von Winterfeldt, Isaac Maya, Michael Navarrete, Frank Simons, Diane Harstedt, Jillian Boettcher, Antoinette Byron, Jim Schneeweis, and Jed Smith. —S.G.

INDEX

238

Los Angeles Central Library:
A History of its Art and Architecture
by Arnold Schwartzman and Stephen Gee

Foreword by John F. Szabo

Hardcover ISBN 978-1-62640-036-8

Softcover ISBN 978-1-62640-037-5

Library of Congress Cataloging-in-Publication Data is on file.

Design and photography by Arnold Schwartzman
Art production by Isolde Schwartzman

Printed in Canada

ANGEL CITY PRESS

Published by Angel City Press
2118 Wilshire Blvd. #880, Santa Monica, California 90403
+1.310.395.9982
www.angelcitypress.com

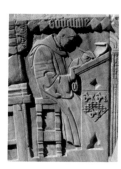

◀ *The main text*
of this book is set in
Cheltenham Roman,
designed by
Bertram G. Goodhue
in 1896.

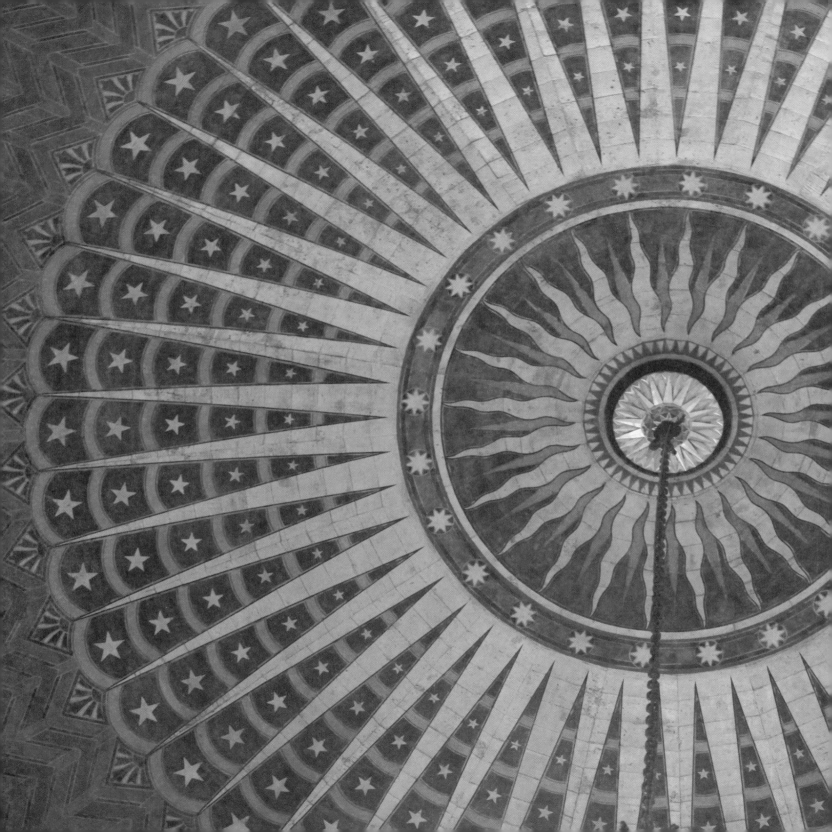